Polaroid
Transfers

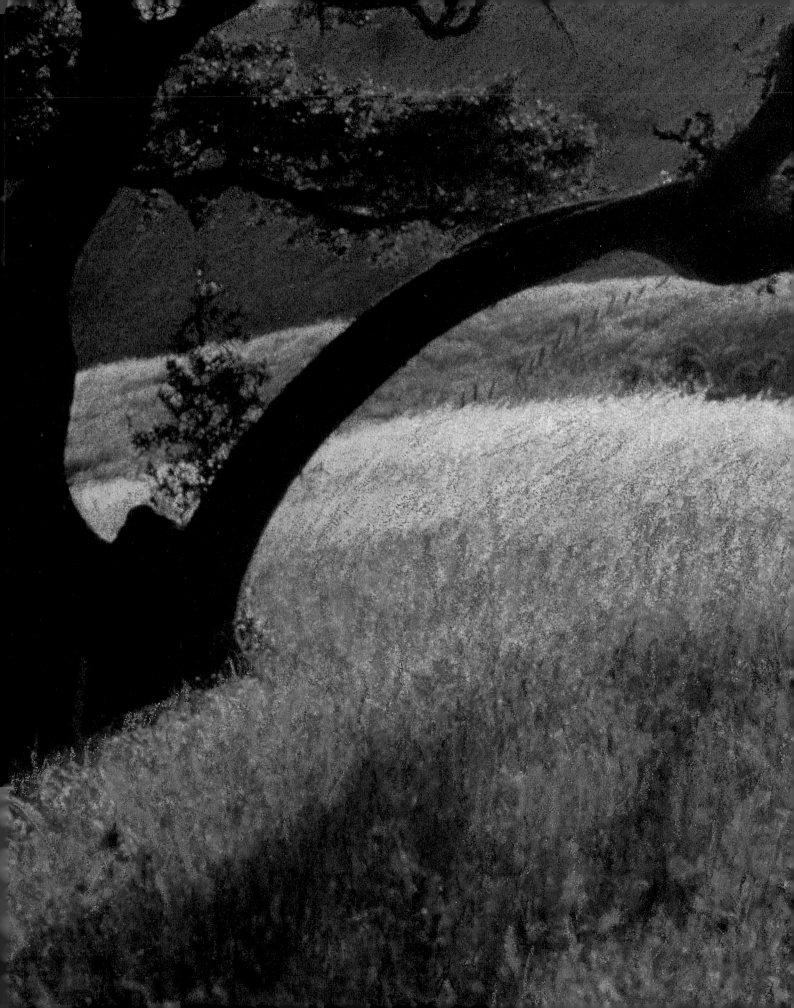

Polaroid Transfers

**A Complete Visual Guide
to Creating Image and Emulsion Transfers**

Kathleen Thormod Carr

**Amphoto Books
an imprint of Watson-Guptill
Publications/New York**

Author portrait by Mary Walsh.
4 x 5 image transfer, made and
handcolored by author.

Kathleen Thormod Carr has worked as a freelance and fine-art photographer since 1972. Her photographs have been exhibited widely at galleries and museums, and purchased for such private collections as the Polaroid Collection. She has been published in numerous books and periodicals, including *Outdoor Photographer*, *National Geographic Traveler*, *Esquire*, *Cosmopolitan*, *Utne Reader*, and *Islands*. Carr is a creative-uses consultant for Polaroid and has been teaching Polaroid-transfer workshops since 1993. Her home and studio are in Sebastopol, California.

Picture information:
Half-title page: "Berries II." 4 x 5 image transfer, exposed 32 times in camera; handcolored with Prismacolor pencils.

Title page: "Late Summer, California." 8 x 10 image transfer, handcolored with pastel pencils.

Acknowledgments: "Heliconia." 8 x 10 image transfer on handmade paper, handcolored with pastels and pastel pencils.

Contents page: "The Archway." 3 x 4 image transfer with liftoff, which follows edge of contrast change and produces dimensional image.

Pages 10 and 11: "The Gateway." 4 x 5 image transfer; handcolored slide sandwich.

Pages 80 and 81: "Forest." 8 x 10 image transfer, handcolored with pastel pencils.

Pages 112 and 113: "Unwilling Annunciation, 1995." By John Reuter. 20 x 24 image transfer, with dry pigment and pastel.

Copyright © 1997
by Kathleen Thormod Carr
First published 1997 in New York
by Amphoto Books,
an imprint of Watson-Guptill
Publications, a division of
BPI Communications,
1515 Broadway, New York, NY 10036

Senior editor: Robin Simmen
Designer: Wynne Patterson
Production manager: Hector Campbell

Library of Congress Cataloging in Publication Data
Carr, Kathleen Thormod.
Polaroid Transfers : a complete visual guide to creating image and emulsion transfers / Kathleen Thormod Carr.
p. cm.
Includes bibliographical references and index.
ISBN 0-8174-5554-X (pbk.)
1. Photographic emulsions. 2. Transfer-printing. 3. Polaroid Land camera I. Title.
TR280.C35 1997
771'.4—dc21

Manufactured in China

3 4 5 6 7 8 9/05 04 03 02 01 00

Acknowledgments

First, I would like to acknowledge Stephen Clark for encouraging me and helping with the proposal, outline, and preliminaries. Sally Tomlinson devoted many evenings and weekends to editing my writing, and offered her expertise in art when reviewing the Gallery submissions. Babette Altar helped edit the artists' statements. Shoshana Alexander's editing skills were invaluable in helping me reorganize the text and clarify the instructions.

Mary Walsh, a co-explorer in researching different transfer techniques to include, tried out my written instructions to see if she could follow them; she also provided her lovely hands for photographs in the step-by-step procedures. Bob Stender gave me the run of his studio for the procedure and product shots and set up the lighting. His hands were in shots of the enlarger procedure, and he copied all of my original transfers onto slide film.

Diana Lee, an accomplished artist, created the color wheel, the filtration chart, and the drawing of the Polaroid pack-film holder; she also shared her knowledge of artists' materials with me. Jerry Ballaine, a well-known landscape painter, helped clarify information about artists' materials, as well as those at Riley Street, my local art-supply store. Val Valandani and Lynette Sheppard gave useful feedback after reading the manuscript.

I am deeply grateful to my partner, Phil Monette, who not only served as my faithful lab assistant, "Beaker," but also spared me from doing countless household chores during the last weeks before the book deadline. His love, support, and great sense of humor made it possible and more enjoyable to keep writing.

Special thanks go to some of the people at Polaroid for their ongoing support, willingness to answer technical questions, and finding information for me. In particular, Kevin Mahoney, Ron Gulaskey, Mike Doukas, Candace DeLeo, and Rich DeFerrari, who answered numerous questions and even proofed the manuscript while on vacation. Charles Berger of UltraStable, Randy Green at EPS/Muse X, and Urban Digital Color provided technical information and samples of their printing processes.

Many manufacturers and suppliers offered information and materials for evaluation: Binney and Smith (Liquitex acrylics), Blair Art Products, Caba Paper Company, Canson-Talens, Inc. (Rembrandt pastels), Caran d'Ache, ColArt Americas, Inc. (Winsor & Newton and Derwent), Crestwood Papers (Arches, Rives), Daniel Smith Artists' Materials and Supplies, Steve Pfaff at Daylab Corporation, Decart (Deka), DecoArt, Golden Artists Colors, Hunt Manufacturing Co. (brayer rollers), Krylon, Lineco (archival supplies), ProTapes and Specialties, Rosco (lighting gels), Savoir Faire (Sennelier, Lascaux), Salis International (Dr. Ph. Martin's), and Sureguard (McDonald's Pro-tecta-cote).

And last, but certainly not least, I want to acknowledge my editors, Robin Simmen and Liz Harvey, and the designer, Wynne Patterson.

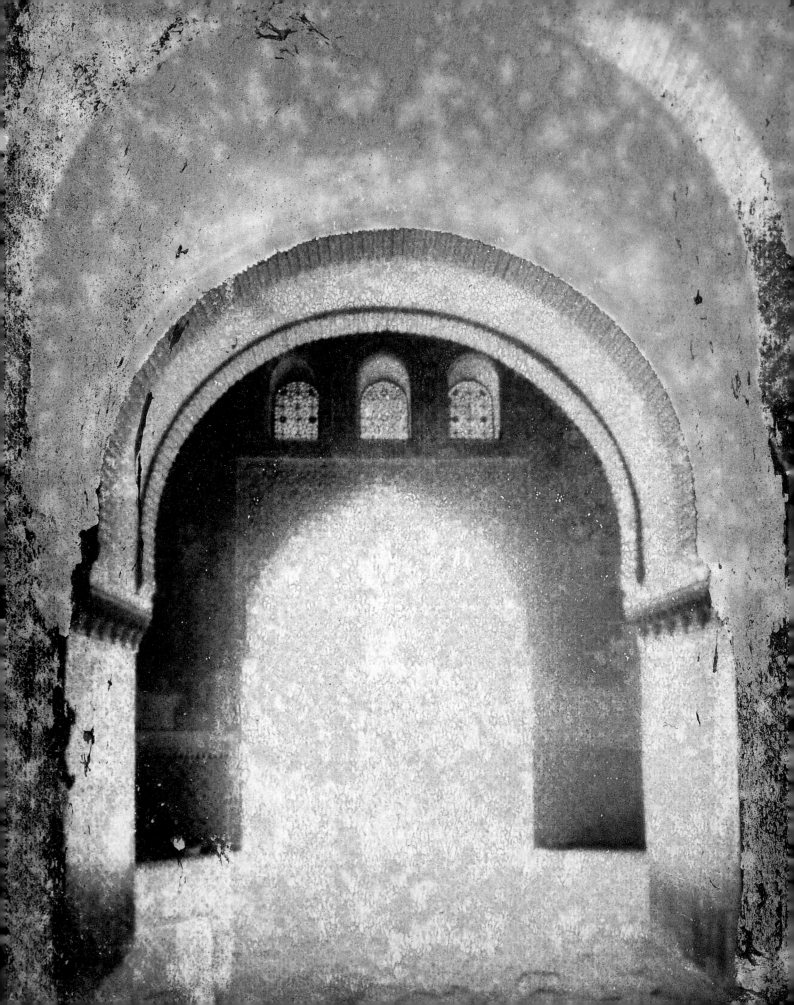

Contents

Introduction

In the mid-1960s, as the story goes, a researcher at Polaroid Corporation's Cambridge headquarters inadvertently left a Polacolor ER negative lying face down on a counter's surface. When he picked it up later, he discovered that the image had transferred to the countertop. He and other researchers began playing with this "image-transfer" process until Polaroid's founder, Dr. Edwin Land, found out about it and discouraged the experimentation in no uncertain terms. Thus, the transfer process went underground. When it resurfaced in the 1970s, word spread, and soon professional and amateur photographers alike found that the technique gave their images a unique look. Transferring images onto surfaces as varied as fabric, wood, and watercolor paper, they discovered that their conventional photography took on the delicate hues of old fresco painting.

Image transfer is often described as a "crossover" art form, one that blurs the distinction between conventional photography and handcrafted art, such as painting. Unlike the precise images of photographic prints, image transfers suggest a moody, dream-like world. From a creative point of view, image transfers are appealing because they offer a way to individualize and further personalize photographs. A wide range of subject matter, from portraits to landscapes, can take on the vintage look of old photographs or of fine-art prints, or lend a distinctive look to commercial advertising.

In 1991, another variation with Polacolor ER film was discovered in Europe: emulsion transfers. A pioneer was Paris photographer Christophe Madamour, who discovered the technique late one night in his kitchen as he was pushing the limits of Polacolor film. By 1993, Polaroid's technical specialist, Mike Doukas, had learned about the "emulsion-lift" technique in Europe, and he set out to make the process safe. The Fall/Winter 1994 issue of Polaroid's *Test* magazine featured emulsion transfers, and Polaroid began including the technique in its seminars. Photographers started experimenting with the wild effects of removing the top image layer of Polacolor ER prints, stretching and sculpting the transparent emulsion, and placing it on a multitude of surfaces that included glass, stone, and Mylar. The new, innovative technique of emulsion transfer has taken the transfer process farther than anyone thought possible, opening up unlimited possibilities for the creative imagination.

I first discovered Polaroid image transfer at a San Francisco meeting of the American Society of Media Photographers (ASMP) in 1991. A representative from Polaroid demonstrated this alternative photographic process at the meeting, and each participant had the opportunity to create several transfers. Most of the transfers I made were successful. I was excited about the artistic possibilities the process offered and bought a Vivitar slide printer.

But in the months that followed, I made every mistake possible. At least it felt that way. I was disappointed with the quality of my transfers. Not knowing how to get better results and having no one to advise me (I

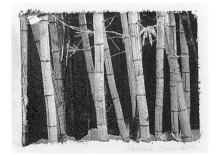

"Bamboo." 3 x 4 image transfer, with handcolored green leaves.

didn't realize Polaroid had a Technical Assistance Department), I wasted a great deal of film expanding my knowledge of the transfer process.

Because I was already teaching workshops in landscape and nature photography, I realized what a benefit personal instruction in image transfer could be. The many Polaroid-transfer workshops that I've offered have been a delight for me. While helping others avoid the struggles I experienced during my learning process, I've learned much from my students in terms of ideas and discoveries.

Although workshops in image and emulsion transfers are now available, not everyone has access to personal instruction. I wrote this book to fill that gap and to make accessible the ideas and creative solutions that I, other transfer artists, photographers, students, and the Polaroid Corporation, have developed.

This book is a complete visual guide to creating image and emulsion transfers, as well as an introduction to the work of some of the world's most noted transfer artists. In Part 1, "Creating Polaroid Image and Emulsion Transfers," you'll learn how to select the basic equipment and supplies you'll need to begin; how to make your own image and emulsion transfers easily; and how to alter your transfers via creative techniques.

Part 2, "Further Explorations," offers more information for those who want to move beyond the basics to do advanced work. This section includes information about equipment and film, as well as step-by-step procedures for working in large formats with the Daylab 11 slide printer, enlargers, and cameras.

Part 3 is a gallery of the work of 20 internationally acclaimed Polaroid transfer photographers and artists, including an overview of their backgrounds and approaches. Exploring their various styles, techniques, and subject matter will further stimulate your imagination and inspire you to launch your own explorations. In "Resources," you'll find a directory of the artists in the Gallery and elsewhere in the book. This section also contains information about suppliers and manufacturers of equipment, film, and materials; information on transfer workshops; and publications containing Polaroid transfers.

Working with transfer images is an exciting and rewarding endeavor for beginners working in their kitchens and professional photographers. As you'll learn, there is no one "correct" method to create transfers. Polaroid transfers are a living art form, being developed by all of us who are exploring the myriad directions that these processes can lead to. I encourage you to use image and emulsion transfers to express your own creativity. Explore, experiment, break the "rules"—and have fun doing it.

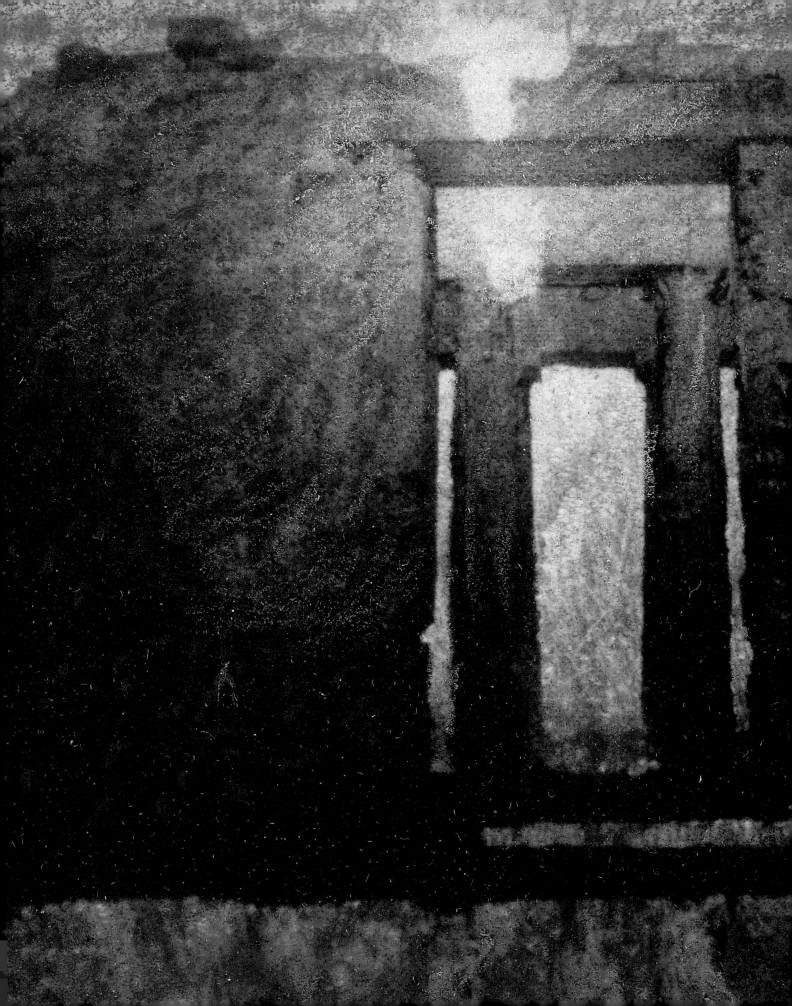

Creating Polaroid Image and Emulsion Transfers

Getting Ready

Many people have told me that the first time they saw Polaroid image and emulsion transfers, they were completely enchanted and wanted to find out how these processes are done. About half of my workshop participants have never been involved in photography or any other art form but want to create transfers. They bring old family slides and travel pictures, or borrow images to use. Because the processes are relatively easy, these people often leave my workshops with masterpieces after just one afternoon of hands-on experience.

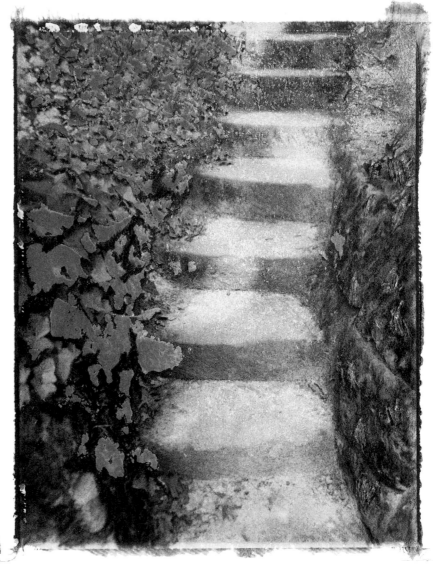

"Steps I." 4 x 5 image transfer with liftoff, scraped, handcolored with Prismacolor pencils.

The other workshop participants are professionals who have been working in photography or as artists in various media for many years, and who want to explore further techniques. So in response to the needs of beginners, intermediates, and professionals, I've poured almost everything I know about Polaroid image and emulsion transfers into this book. No matter what level you are at, you, too, can, in little more than an afternoon of application, have the pleasure of making your own masterpieces.

Creating a Transfer

Basically, to create an image or emulsion transfer, you expose an image onto Polaroid Polacolor ER (extended range) peel-apart film via one of three methods: using a camera with a Polaroid film holder to expose an image directly onto Polaroid film; using an enlarger to project a slide, transparency, or negative onto Polaroid film; using a slide printer to transfer

35mm slides or negatives onto Polaroid film. Whichever method you choose, the key ingredient is the Polaroid film holder. Polacolor ER print films have three main parts: a light-sensitive negative containing dyes, a positive that receives the image from the negative, and a foil pod containing enough developing reagent to develop one picture. As you pull the Polaroid film through the steel rollers in the film holder, the pod is broken, and the developer spreads evenly over the film. The dyes then migrate from the negative to the positive (see the drawing below).

To create a Polaroid image transfer, instead of letting the Polaroid film develop fully onto the positive print for the usual 60 to 90 seconds, you pull apart the film early, after 10 to 15 seconds. Next, you place the Polaroid negative face down on another surface, such as dampened watercolor paper, and press it with a roller. The dyes from the negative continue developing and in the process are "transferred" onto the chosen receptor surface. After 1 to 2 minutes, you slowly peel the negative off the receptor surface. Discard the negative. (Because little dye is left in the negative, you can't use it for another transfer—unless only a faint ghost image is desired.) You can then manipulate the resulting image on its new surface by scraping and rubbing the still-wet dyes of the emulsion before it dries. And after the transfer dries, you can further apply your creative touch by handcoloring the transferred image.

Polaroid emulsion transfers have been called the next step in the creative process of transferred and manipulated images. Emulsion transfers are much bolder and more colorful and dynamic than the subtle Polaroid image transfers. Although you work with the same equipment and film for emulsion transfers as for image transfers, the results are completely different. Instead of using the negative, you use the positive part of the Polacolor ER peel-apart film. During this process, the image is exposed, and the print is fully developed for 60 to 90 seconds. Next, remove the transparent emulsion layer by soaking the developed print in hot water. Once the emulsion is loose, in cold water separate it from its backing. At this point, you can transfer the thin emulsion membrane to almost any surface;

Here, you see one negative and the corresponding positive sheet in Polaroid's pack-film holder. The negative has been exposed and the white tab pulled, just before it tears loose from the arrows tab. When you pull the white tab, the negative is positioned under the pressure plate facing the corresponding positive. When you pull the arrows tab, the pod of developer, the negative, and the positive are brought together between the rollers. They break the pod, and a thin layer of viscous developer is spread evenly between the negative and positive sheets. Both sheets have a light-proof backing, so you can do the processing in daylight. Then after the recommended processing time passes, you separate the positive and the negative.

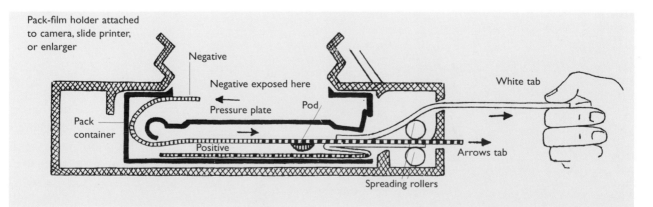

Pack-film holder attached to camera, slide printer, or enlarger

Negative

Negative exposed here

Pressure plate

Pod

White tab

Pack container

Positive

Arrows tab

Spreading rollers

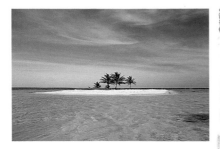

"Island Paradise." Original 35mm color slide.

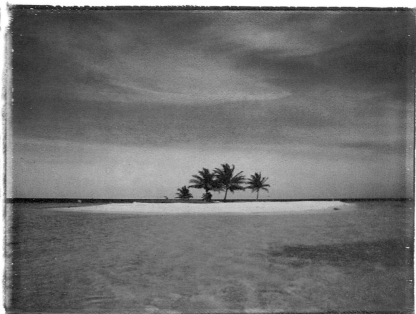

"Island Paradise." 4 x 5 dry image transfer, handcolored with pastel pencils.

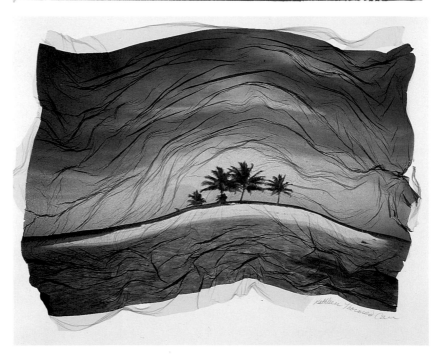

"Island Paradise." 8 x 10 emulsion transfer, handcolored with pastel pencils.

sculpt, stretch, wrinkle, and tear it into different shapes; and handcolor it if you want to.

One of the best parts about both the image- and emulsion-transfer processes is that you don't need a great deal of expensive photographic equipment and supplies, or a darkroom. You also don't need a photography background since the technical basics are quite simple. Starting with good images (35mm slides are the best to begin with for slide printers) does help, but a variety of subjects and images will work beautifully.

Basic Supplies

The necessary supplies for creating both image and emulsion transfers are relatively simple and inexpensive. If you work with kitchen utensils, be sure to keep them separate from your culinary utensils after using them for photographic processes. If you're starting from scratch, you might want to consider Polaroid's Image and Emulsion Transfer Kit, which contains most of the supplies that you need. You can order it through your local photography dealer or mail-order catalogs, or you can gather your own supplies (see "Resources" on page 154). Here is what you'll need:

Two 8 x 10-inch or 11 x 14-inch trays (approximate sizes) These can be photographic trays, or glass or stainless-steel baking pans that won't rust. The trays are for holding water and a vinegar bath.

Roller Get at least a 4-inch roller. Ideally (although this isn't a necessity), it should be larger than the size of the transfers that you'll be making since you'll be using the roller to press the Polaroid negative onto the receptor surface. Brayer rollers, the best choice, are printmaking rollers that come in soft and hard rubber and acrylic, beginning with a 3-inch size. While the soft-rubber rollers are the most expensive type, most people find they work best, but this is a matter of taste. You can also try a marble, pastry rolling pin if you have one.

Squeegee This is used to remove excess water from the receptor surface. A high-quality photographic squeegee, such as the one Saunders makes, is great; however, I use inexpensive household squeegees from the grocery store for my workshops. A plastic spatula for applying bondo or fiberglas resin, available at any hardware store, also works well.

Scissors Any household scissors will do for cutting off the end of the film.

Hard, smooth working surface A textured surface produces uneven results when you roll the negative onto the receptor surface.

White distilled vinegar Common household vinegar is used for a final bath to restore the pH, and to brighten and clarify colors in image transfers.

Warming tray or hair dryer These two devices are optional but quite helpful. Using a 1950s hors d'oeuvres warming tray is the best option I've found for keeping the water temperature constant during the image-transfer process. Make sure that the warming tray won't melt the water tray if it is plastic. I've found that photographic trays usually work fine. I simply place the warming tray under the tray filled with water. I also use either the warming tray or a hair dryer for drying Polaroid positive prints

quickly, for drying wet transfers, and for keeping dry transfers warm during development. Sometimes you can find old warming trays at thrift stores and garage sales. (Caution: Using an electrical appliance around water can result in electrocution.)

Colored gel filters These are optional but effective. Especially useful are an amber-colored lighting gel or a red 20 or 30 color-correcting (CC) or color-printing (CP) filter to replace color lost during the image-transfer process.

Latex surgical gloves These optional items protect your hands from the chemicals used (at an alkaline stage) in image transfers. But with practice and by being careful, you can avoid getting chemicals on your skin.

The following additional supplies are needed for emulsion transfers only:

Self-adhesive shelf paper This can be clear, colored, or patterned—it doesn't matter. You simply use shelf-liner paper, such as Contac, to seal the backing paper of the positive print so that it won't dissolve in the hot water while the emulsion is loosening. You then throw the shelf-liner paper away.

Tongs You need a pair of tongs to pull the positive print out of the hot water after the emulsion has loosened. I prefer photographic tongs with rubber tips, but metal or plastic kitchen tongs will also do. Caution: The water temperature is 160°F, so using your fingers is dangerous: you could get burned.

Thermometer capable of reading 160°F A quick-reading meat or candy thermometer is best for checking the temperature of the hot water. Most photographic thermometers don't record a high enough temperature.

Electric frying pan or electric kettle An electric frying pan is ideal for maintaining a hot-water temperature of 160°F. If you have such a pan, you can substitute it for one of the trays. (It isn't necessary, however, to keep the water at a constant temperature of 160°F. You can reheat the water with a kettle.)

Timer or watch This item must be capable of timing 3 to 4 minutes, which is the length of time that you keep the positive print in hot water.

Clear acetate sheet This is an overhead projection sheet that can be found at any copy store. You use it to transport the emulsion when you can't put the receptor surface in the cold water. The surface might, for example, dissolve or be too big.

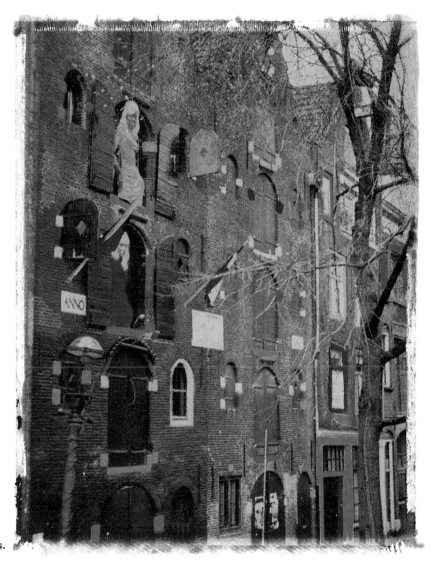

"Church, Red Light District, Amsterdam." 4 x 5 image transfer, handcolored with Prismacolor pencils.

Choosing a Method

As mentioned earlier, the three methods of creating transfers are: using a slide printer, projection printing with an enlarger onto Polaroid film, and using a camera that takes Polaroid peel-apart film. The third approach requires a Polaroid camera or a large-format camera with a Polaroid "back"; this is a film holder that attaches to the camera. (Because most people begin by using a slide printer, for simplicity's sake I discuss working with both the enlarger and camera method—see Chapter 6, "Advanced Techniques: Equipment and Procedures," on page 82.)

Using a Slide Printer

I find that using a slide printer is the easiest and most versatile method of creating image and emulsion transfers. The equipment is quite affordable,

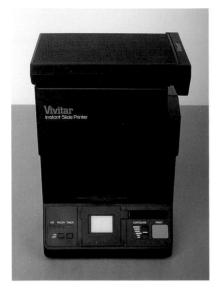

The Vivitar slide printer, available from the 1970s to early 1997, was an economical choice for learning to create transfers.

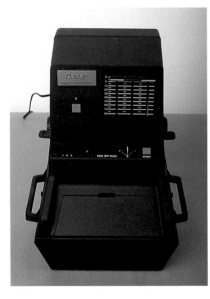

The Daylab Jr. slide printer, introduced in 1997, has a number of options and features (prototype pictured).

you can set up almost anywhere, and you can make as many versions as you like of a single image from a 35mm slide or negative. Each transfer is unique because the Polaroid negative is destroyed in the process.

Various slide printers are available, and each has its advantages and disadvantages. With beginners in mind, I focus on two relatively inexpensive, easy-to-operate slide printers in this chapter, the Vivitar slide printer and the relatively new Daylab Jr. slide printer. Each is demonstrated in the step-by-step procedures for learning image and emulsion transfers.

Vivitar Slide Printer

This is the most economical and easiest-to-use slide printer for beginners, although it is also suitable for advanced work in the 3¼ x 4¼-inch size. The Vivitar has a built-in Polaroid pack-film holder for 669 film, a fixed-focus lens, and a filter holder for using colored gels. The printer also uses flash exposure, and has an adjustable exposure setting and a built-in timer. Because the 35mm format is a longer rectangle than the Polaroid film format, you can't get a full-frame image with the Vivitar; however, you can compose on the printer's viewing screen and choose which edges you'll lose.

The Vivitar runs on four "C" batteries. In the 1970s, the Vivitar was sold with an SB-6 adapter to utilize 110-volt electricity. The company no longer makes this adapter, but you might be able to find a used one. If not, don't be discouraged. Many electronics and some appliance stores can hardwire the Vivitar to utilize 110-volt electricity in addition to batteries. The specifications for hardwiring are: the AC-to-DC power supply must be Output 4.3 VDC 600 MA; the Input, 117 V 60 Hz 4 watts. Polaroid has recently phased out the Vivitar slide printer (Vivitar produces the units for Polaroid), replacing it with the Daylab Jr. slide printer. However, used Vivitars should be easy to find.

Daylab Jr. Slide Printer

This unit, which is competitively priced with the Vivitar, offers a few additional features, such as a dichroic color head that enables you to dial in filtration without using gels. The Daylab Jr. runs on electricity rather than batteries, and has flash-exposure capability and an exposure-compensation dial. This slide printer also has a timer that you can set for 30-, 60-, or 90-second processing times, depending on the Polaroid film you're using. The Daylab Jr. has the same 3 x 4-inch base as the Daylab 11, but in some models the base is attached to the Daylab Jr. When you want to make larger transfers, you can trade in the Daylab Jr. head (you can unscrew the base if attached) toward a Daylab 11 with the 4 x 5-inch or the 8 x 10-inch base and relevant film holders. Trade-ins are done through the Daylab Corporation only, not through Polaroid.

Choosing a Film

The Polaroid films that work most consistently for both the image- and emulsion-transfer processes are the Polacolor ER peel-apart films with type numbers that end in "9." These films are designated 669, 559, 59, and 809 according to their size. Balanced both for daylight and for electronic flash, they have a film-speed rating (ISO) of 80 and produce a properly developed print in 60 seconds at 75°F. Polacolor ER 108 can also be used.

Polacolor ER 669 film, whose 3¼ x 4¼-inch size fits the Vivitar and the Daylab Jr. slide printers, comes in boxes of 16 exposures (two twin packs of 8). Polacolor Pro 100 film can also be used for image transfers only, with unique results. The images have more contrast, and there is a charteuse color coating over the image that can be washed off, is desired.

Storing Polaroid Film

The following information was taken from Polaroid's technical-data sheets for its Polacolor ER films. Store unopened film in a cool place and refrigerate it if possible. Whatever you do, don't freeze the film. Always let the film warm to room temperature (approximately 2 hours if refrigerated) before opening the package. Opening the package too soon can lead to undesirable condensation. To keep film fresh, don't break the seal until you are ready to use it. Never leave film in the direct sun or in any other hot environment, such as your car's glove compartment.

Once you open the film, you must protect it from high humidity, damaging fumes, and direct, strong light. It is best to store film flat rather than on its side, a position that can result in an uneven distribution of the developer inside the pods.

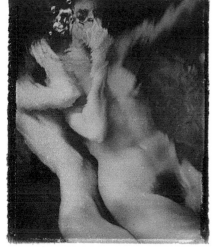

"Two Nudes." 3¼ x 4¼ black-and-white image transfer from a slide of an 11 x 14 black-and-white photograph.

Black-and-White Transfers

If you want to make black-and-white image transfers, you need to use the color Polaroid ER films, and then filter for warm or cool tones. You can't use Polaroid 55 or Polapan 100 films for image transfers because the silver doesn't migrate to the receptor surface the way the color dyes do. You can make a black-and-white image transfer several ways:

• Photograph directly onto black-and-white slide film, such as Polaroid 35mm Polapan or Polagraph instant slide film or Agfa Scala film.

• Copy a black-and-white print onto 35mm black-and-white or color slide film.

• Use a black-and-white negative for transferring (the resulting image transfer will be a black-and-white negative image).

To produce black-and-white emulsion transfers, you can follow the above procedures. In addition, you can use Polapan Pro 100 films with a modified procedure (see Chapter 4, "Creative Techniques," on page 47).

"Shadow Puppet." 4 x 5 image transfer on handmade paper; negative image from black-and-white negative; handcolored with metallic Prismacolor pencils.

Receptor Surfaces

Many surfaces can receive a transferred image. A guideline for image transfers is to avoid slick surfaces, such as glass and glazed ceramic tiles, or rough surfaces, such as bark and coarse fabric. In either case, the dyes won't be able to enter the material and transfer. Acid-free or neutral-pH materials are the most durable.

Hot-pressed watercolor paper is a popular and easy-to-use surface, especially for image transfers. Because the surface is fairly smooth (but not too smooth), the dyes adhere well. Cold-pressed and rough watercolor papers have more texture than hot-pressed papers. Handmade papers, rice paper, and bark paper (made from tree bark) work well for both image and emulsion transfers. Natural fabrics, such as silk, cotton, muslin, canvas, hemp, and leather, are excellent, as are wood, veneer, bisque-fired ceramic tile, and clayboard. Clayboard is a rigid art panel that has an acid-free, fine-tooth coating of absorbent kaolin clay. Light colors without strong patterns are best. This way, the transferred image is visible because colors and patterns show through the image.

You must also consider the weight or thickness of a paper. The thinner the paper, the more the transfer will tend to curl when drying; and even after flattening, it might have a rippled look. This is why I find that the easiest receptor surface for beginners to use is a hot-pressed watercolor paper. Good choices include Arches or Fabriano, 140 lb. weight. A 90 lb. paper will ripple, and a 300 lb. paper is better suited for large pieces. I still use 140 lb. Arches hot-pressed watercolor paper as my standard for both image and emulsion transfers.

You can apply emulsion transfers to almost any surface. In addition to the materials mentioned above, an emulsion transfer will stick to any-

You have a variety of receptor surfaces to choose from, including handmade papers, fabrics, and glass.

thing slick, such as glass, bottles, mirrors, Plexiglas, plastic, sheet metal, foils, Mylar, glazed ceramics, sculptures, and rocks, to name a few possibilities. Because you can stretch and sculpt the transfer to fit most shapes, curved surfaces work well. If, however, the surface is too rough, such as bark or stone, you might end up with gaps where the emulsion doesn't adhere.

Once the emulsion dries, if air pockets exist underneath the delicate emulsion membrane, it can crack and break where the emulsion isn't attached. Be aware that it is important to mount fabrics securely. The dried emulsion will crack if bent. Experiment with the unlimited choices of receptor surfaces. Be creative and wild (see Chapter 4, "Creative Techniques," on page 47).

Ultraviolet and Protective Coatings

Transfers on surfaces that might be touched or exposed to moisture, humidity, wide fluctuations in temperature, dust, such environmental gases as paint fumes, and other atmospheric pollution require protection from a coating or spray. You have a wide variety of nonyellowing varnishes and coatings to choose from; these come in gloss, satin, and matte finishes.

Any dye process, whether for photography, offset printing, or fabrics, will fade over time, especially if it is exposed to sunlight. Exposure to ultraviolet (UV) rays from sunlight and fluorescent bulbs can readily damage your finished transfers. So don't display your transfers in direct sunlight because the dyes will invariably fade.

Fortunately, you can protect transfers from harmful UV rays several ways. Using UV protective sprays and framing with UV filtering glass or Plexiglas are the most common methods. (See Chapter 7, "Fine Art and Commercial Applications," on page 101 and "Resources" on page 154 for more information about UV protection and coatings.)

Now that you have an overview of what you need, all you have to do is gather the materials and begin. You're embarking on a great creative adventure that can result in anything from gifts to gallery exhibits, to a distinctive commercial assignment. Stay in touch with others working with these processes. I find that part of the fun is sharing discoveries and getting "hot tips." In addition to in-person and telephone contact, you can utilize several online discussion forums about transfers. Look in alternative-photography and instant-photography message boards on the Worldwide Web and on such server forums as America OnLine and Compuserve. Most of all, have fun!

Making Polaroid Image Transfers

This chapter will teach you the basics of the image-transfer process, as well as how to handle some of the common difficulties that can arise. The step-by-step procedure outlined here uses a Vivitar slide printer and Polacolor ER 669 film to create a wet image transfer on 140 lb. hot-pressed watercolor paper. In my classes I always begin with this combination of equipment, film, and process because it guarantees the easiest success. I also use a warming filter in order to compensate for the cyan (blue-green) cast that image transfers typically exhibit.

If you already have an enlarger, another slide printer, or a camera you would like to use instead of the Vivitar, follow the instructions for operating this equipment in Chapter 6, "Advanced Techniques: Equipment and Procedures," on page 82. For the Daylab Jr., follow the instructions in Chapter 3, "Making Polaroid Emulsion Transfers," on page 39. Complete the step-by-step process for making an image transfer discussed here, but substitute the operating instructions for your equipment in place of the Vivitar's operating guidelines in the second step.

A wet transfer simply means that the watercolor paper that receives the image—the receptor surface—has been soaked in water. This enables the dyes to transfer more readily, as well as to have less of a tendency to lift off than they would if the surface were dry. Liftoff, which occurs when part of the emulsion peels off with the negative, sometimes produces magical effects, sometimes not. In this chapter, you'll learn ways to avoid liftoff.

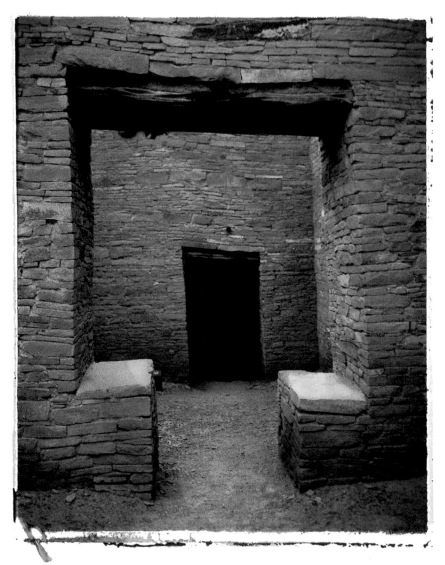

"Chaco Canyon Doorway." 8 x 10 image transfer, handcolored with pastel pencil.

The Wet-Transfer Process, Step-by-Step

In order to understand the entire wet-transfer process and minimize frustration, read the following instructions completely through before you begin the actual process using the Vivitar slide printer.

Gather the necessary equipment and supplies

• 35mm slides

• Vivitar slide printer

• Polacolor 669 film

• Hot-pressed watercolor paper, 140 lb., 100 percent rag

• 8 x 10-inch tray

• Roller (a 4 to 6-inch brayer is best)

• Squeegee or 4-inch wide, plastic putty knife

• Scissors

• White distilled vinegar (optional)

• Warming tray or hair dryer (optional)

• Amber or light red filter gel (optional)

Load the film

1. Follow the instructions that come with both the film and the Vivitar slide printer.

2. When removing the 669 film from its package and loading it into the film holder (on top of the Vivitar), don't squeeze the film pack. If you don't handle it by the edges only, you could damage the film. (Notice the thumb in the circle with the line through it on the packaging.)

3. Slide the pack into the holder at a slight angle with the film area facing down.

4. Push the film pack down into position.

5. Make sure that all the white tabs are showing. (If they're folded under, you won't be able to pull the film out.)

6. Check the rollers; if they are dirty, remove them, and clean them with water and a lint-free cloth or soft paper towel. Then dry and replace the rollers, close and latch the film holder, and completely pull out the black safety paper.

Set the controls for the Vivitar

1. Turn on the Vivitar slide printer.

2. Make sure that the viewing light comes on.

Compose your image

1. Place your 35mm slide on the view-

ing area with the emulsion (dull) side down and the shiny side up. The image shouldn't be backward—unless you expressly want it to be. Because the proportions of the Polaroid film are different from those of 35mm slide film, you'll lose some of the edges of the slide image in your transfer.

2. Use the cropping bar to move the 35mm slide back and forth on the viewing area until you get the composition you like.

Set the exposure

1. Be aware that the best exposure setting for image transfers made from average-density slides is one increment above the normal setting.

2. Look at the overall density of your slide: how dark or light it is. If it is dark or the colors are deeply saturated, add more exposure by moving the exposure indicator up one more line. Conversely, if you have a light slide and want your transfer image to be darker, move the indicator down.

3. Tip: If you want your transfer image to be lighter than the slide or lighter than a previous transfer, move the indicator up. Remember, up toward the sun where it is lighter translates into a lighter image, while down toward the earth where it is darker results in a darker image.

Select a filter

1. Because you pull apart the negative early, some of the red and yellow dyes are lost during the transfer. You have the option of using a warming filter to adjust for normal color balance. An amber-colored lighting gel, which is similar to an 81B filter, or a 20CC or 30CC red filter will do the trick.

2. Remove the filter holder that is located in the slot above the viewing

area, open it up, sandwich the gel between the top and bottom, and replace the filter holder. (The handle should point down.) If you don't have a filter holder, mount the gel in a plastic slide mount. Then insert it in the slot in the same horizontal orientation as your slide.

3. Caution: If you place the filter slide in the slot vertically, your transferred image will be square with black lines along two sides.

Expose the Polaroid film
1. Remove the slide from the viewing area and, without turning or flipping the slide, place it shiny side up in the slot above the filter holder, or above the slide mount with the filter.

2. Push the blue "Print" button. You'll see a flash. The green "OK" light will go on and off, and the red "Ready" light will go off and come back on. The viewing area will dim and brighten again.

3. Caution: If these things don't happen, you won't have exposed the Polaroid film (see "Common Difficulties" on page 33 for information on how to proceed).

Pull the white tab on the film
1. Pull this tab firmly and at moderate speed straight out—not up or down, or to the side.

2. Two tabs will appear: a larger tab with arrows above another white tab. Don't pull either one at this point.

Prepare the watercolor paper
1. Soak your 140 lb. watercolor paper in a tray of warm water until the paper is limp. The water temperature should be approximately 75°F to 100°F. This step takes from 15 to 30 seconds. The hotter the water, the less time the paper needs to soak.

2. Remove the paper, and then drain it by holding one corner until it stops dripping.

3. Place the paper on a hard, smooth surface.

4. Squeegee the paper until you remove all excess water.

5. Tip: If your tap water is hard, use distilled or bottled water. The pH of the water should be around 7 for best results.

Pull the larger tab with arrows
1. Pull this tab straight out at moderate speed and with no hesitation. This tab pulls the film through the internal rollers, dispersing the chemicals evenly over the surface of the film. This begins the development process.

2. Caution: If you hesitate part way through, you'll get a red line through the film where it stopped.

3. From this point, you have 10 to 15 seconds before you need to peel apart the film.

4. Tip: Handle the film by the edges only. If you hold it where the film is developing, your finger pressure can make white ovals on your transfer.

Immediately cut off the end of the Polaroid film
1. During the 10 to 15 seconds before peeling, you can choose to cut off the end of the film opposite the pod or

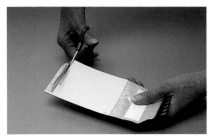

tab end. This is where excess chemicals have collected.

2. The residue chemical is a caustic gel, so cut off the end of the film over a trash receptacle in order to avoid touching it. (You can also cut off the end after you separate the film.)

3. Tip: If you don't cut off this end, a brown stain will appear at that end of your transfer.

Peel apart the film and place the negative on the watercolor paper
1. About 10 to 15 seconds after pulling the Polaroid film through the rollers, separate the film quickly, starting at the tab end.

2. Place the negative face down and centered on the damp watercolor paper. Use your hand to press the transfer onto the paper. If you wait too long to position the negative, the dyes might dry out.

3. Tip: The longer you wait to separate the film, the more dyes will transfer to the positive, thereby making less available to transfer to the watercolor paper. This will cause your transfer to look washed out. However, if you peel before 10 seconds have passed, the dyes might not have time to begin their migration, and you could fog the film (see page 28 for more information about development time).

Roll the negative with the roller
1. Move the roller back and forth over

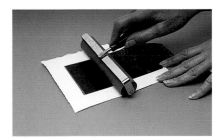

the negative approximately six times. Be sure to cover every part of the negative.

2. To avoid sliding the negative across the paper, you should make gentle contact first. Begin in the center of the negative, rolling out to each end.

3. Increase to medium pressure.

4. Tip: If you roll the negative too lightly, the emulsion won't make full contact with the textured paper, and you'll get white specks in your transfer. But too much pressure can distort dark areas. If you see emulsion squirting out, you're applying too much pressure.

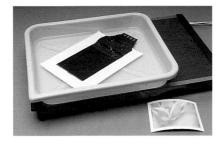

Let the transfer develop for 1 to 2 minutes
1. Keep the negative warm during development to prevent the image from lifting off when you peel the negative later. Float the paper with the negative on top in a tray of water warmed to approximately 100°F.

2. You can keep the temperature constant several ways. Use a warming tray under the water tray, or place an immersion heater in the water.

Other options are putting the negative and paper directly on the warming tray, preheating the work surface by placing a heating pad under a sheet of acrylic or beveled glass, or using a hair dryer on a medium setting to blow evenly over the back of the negative from about a 6-inch distance.

3. Be careful not to get the negative too hot. If the temperature is too high, you can also increase liftoff.

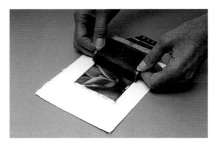

Slowly peel the negative off the paper
1. Peel very slowly by folding the negative back over itself little by little. You can put a 4-inch wide, plastic putty knife on the negative and fold the negative over the knife. Then slide the knife down as you peel.

2. To completely avoid liftoff, peel the negative under water.

3. If you want liftoff, peel the negative quickly.

4. Tip: When you get near the end of the peeling process, the film edge can flip up and scrape the emulsion on your transfer. To prevent this, place a finger on an unpeeled corner of the film to anchor it until you peel the negative completely free of the paper.

Use a vinegar bath to brighten and clarify whites and colors
1. After the transfer has partially or completely dried, you might want to add an optional but recommended step. Soak the transfer in stop bath or

a solution of 1 part white distilled vinegar to 4 parts water. Both should be at room temperature, approximately 68°F. (Using a photographic indicator-type stop bath isn't recommended because it will result in a yellow-stained transfer.)

2. Agitate the transfer for 30 to 60 seconds with your fingers or by rocking the tray.

3. Tip: If bubbles begin to appear on your image, add more water to the bath, take the transfer out sooner, or make sure the next transfer is drier before putting it in the bath.

4. Rinse the transfer for 3 to 5 minutes under a gentle stream of water at room temperature. You can use a print washer instead, or change the water in a tray eight times in order to clear the residue vinegar.

Dry the Transfer
1. Air-dry the transfer on a drying screen; a clean window screen laid flat with air circulating underneath works well. If you need to dry a transfer quickly, use a hair dryer, a warming tray, or a microwave oven on half power. The transfer might buckle if you dry it too quickly.

2. You can flatten prints in a dry-mount press set on low (180°F), by ironing them on the reverse side at a low setting, and/or by placing them under weights.

3. You can opt to handcolor the prints with watercolors, pastels, pencils, or acrylics, and/or spray with a protective ultraviolet-inhibiting lacquer (see Chapter 5, "Handcoloring Transfers" on page 69).

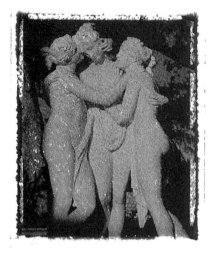

"The Three Graces." 3¹/₄ x 4¹/₄ wet image transfer on cold-pressed watercolor paper, for soft, textured effect.

The Dry-Transfer Process

Beginners consider making a dry transfer to be generally more difficult than making a wet transfer. This is because liftoff occurs frequently, even to the point of all of the emulsion lifting off. There is no reason for becoming frustrated needlessly. Once you master your wet-transfer technique, you'll find dry transfers much easier to successfully complete. The procedure for both transfers is basically the same, with only two differences. For dry transfers, you use dry paper. Also, instead of floating the paper and negative on warm water during development, you keep the dry transfer warm using a warming tray, hair dryer, the sun, or whatever will keep the transfer at a temperature of around 100°F. Remember, because peeling quickly increases liftoff dramatically, you should remove the negative quite slowly (unless you want liftoff).

Dry transfers provide a sharper, more photographic look than wet transfers, especially on smooth surfaces. Whether you choose to do a wet or dry transfer depends on the subject matter and what effects you want to achieve in your transfer. Also, some papers and surfaces would be ruined if soaked.

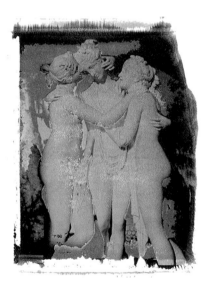

"The Three Graces." 3¹/₄ x 4¹/₄ dry image transfer, with faster peel for liftoff of more image.

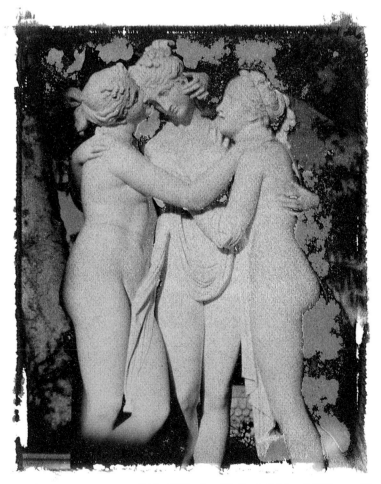

"The Three Graces." 3¹/₄ x 4¹/₄ dry image transfer, with slow peel for less liftoff and image denigration.

Helpful Hints

There are as many nuances in methods for creating Polaroid image transfers as there are photographers and artists working with them. There is no single "correct" technique to follow.

In addition, such variables as the designated receptor surface, the humidity and temperature of the workspace, the age and batch of the films, the surges in electrical current, and the water used can all have an impact. These factors can effect different results on different days, and even on the same day. Experiment with several approaches to see what works for you. I've gleaned the following suggestions for creating successful Polaroid image transfers from my own experience, from that of other photographers and artists, and from Polaroid's Technical Assistance Department (see "Resources" on page 154).

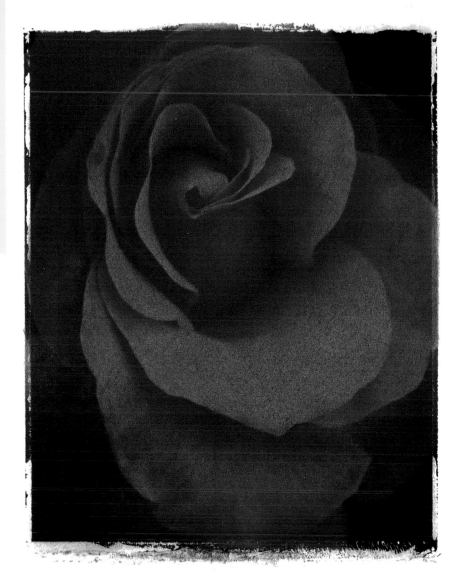

"Red Rose." 8 x 10 image transfer, handcolored with pastel pencils.

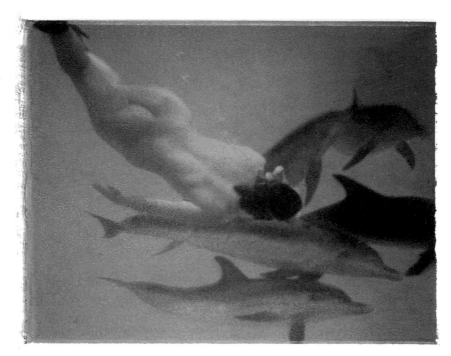

"Nude & Dolphins." 8 x 10 image transfer, handcolored with pastel pencils; slide of original 11 x 14 black-and-white print that was hand-colored with Marshall's oils.

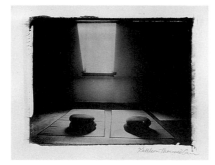

"Meditation Room, Minor White's Home." 4 x 5 image transfer; negative peeled apart from positive after 10 seconds.

The type of slide film you use will affect the color densities and hues in your resulting transfer. Highly saturated films, such as Fuji Velvia, produce more colorful image and emulsion transfers than less saturated films. Old Ektachrome films from the 1970s, for example, will transfer a lot less color and tend to be more cyan.

Peeling Apart the Negative and Positive Film

Although 10 to 15 seconds is the recommended time to wait before peeling apart the Polaroid film, you might want to experiment with varying the time in order to produce different effects. The film dyes transfer in layers of color in the film—the yellow dyes migrate first, then the magenta, and finally the cyan (blue-green). Because some of the yellow and magenta have already "transferred" to the Polaroid positive by the time the cyan migrates, many image transfers have a cyan cast. You can correct this by using a warming filter, such as an amber-colored filter, or a 20 or 30 red CC or CP filter when making the exposure.

The longer you leave the negative and positive together, the more dye will migrate, until you get a fully developed positive print at 60 seconds at 75°F. Remember, the longer the developing time before separating, the more washed out the transfer will be. If you peel before 10 seconds, the dyes might not have enough time to start migrating, and the film might fog. If the room is much warmer or cooler than 75°F, increase the amount of separation time if the room is cooler than 75°F, and shorten it if the room is warmer. Follow the recommended temperature and processing times for regular processing that come in each box of film.

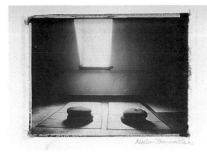

"Meditation Room, Minor White's Home." 4 x 5 image transfer, washed out; negative peeled apart from positive after 30 seconds.

"Meditation Room, Minor White's Home." 4 x 5 image transfer, pale, but with liftoff that didn't come off, but resettled on the transfer, producing a veil-like effect; negative peeled apart from positive after 30 seconds.

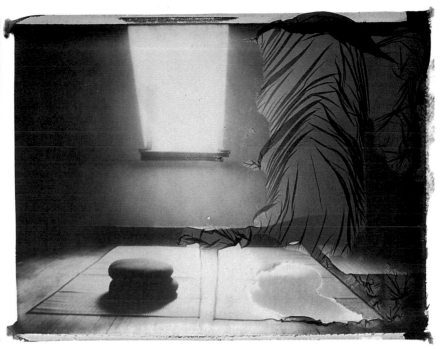

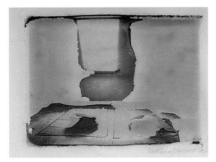

"Meditation Room, Minor White's Home." 4 x 5 damp image transfer on prewashed silk, with lots of liftoff.

Applying Heat During Development

For both wet and dry transfers, keeping the transfer warm, about 100°F, produces the best results. There is less likelihood of liftoff, the dyes transfer more evenly, and the color palette appears warmer. For wet transfers, soaking the receptor surface in water warmer than 95°F, and keeping it warm for the initial contact of the negative are ideal. A heated piece of Plexiglas or smooth tile works well for this. As mentioned earlier, I keep the temperature constant by putting the water tray on an hors d'oeuvre warming tray. For dry transfers, I place the receptor surface directly on the warming tray, with the negative side facing up during development.

Applying Additional Weight or Pressure During Development

Sometimes you can improve a transfer by applying weight during development. The extra weight flattens the image, ensuring that the emulsion comes fully in contact with the receptor surface. After rolling, try placing a heavy weight on top of a transfer for 1 to 2 minutes. Do this only for making transfers out of water. You can also try varying the pressure when rolling, or using rollers with different degrees of hardness and weight. Generally, soft rubber pushes the emulsion dyes into the texture of the receptor surface more thoroughly and gives the transfer a smooth look.

Another approach is to put a piece of paper between the negative and your roller, which can even out the pressure when you roll and provide a smooth result. The darker areas might require more pressure than the lighter areas to adhere to the emulsion because they contain more dye.

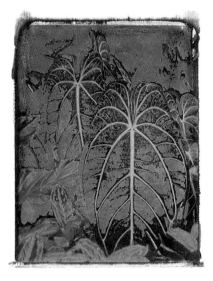

"Hawaiian Taro Leaves." 4 x 5 image transfer on watercolor paper, with lightly handcolored lower leaves; fast peel for lots of liftoff.

If you're having trouble with liftoff, you might want to use the back of a metal teaspoon or your hands to increase pressure in the dark areas.

Reducing Liftoff During Development

Liftoff is completely unpredictable and unrepeatable. Controlling where the liftoff will occur or how large an area will lift off is quite difficult, but it usually happens in dark areas and stops at the edge of a contrast change to a lighter value. When a dark area of an emulsion lifts off, a turquoise color shows through. But when a light area of an emulsion lifts off, no color change occurs.

The simplest strategy for reducing liftoff is to make sure that the transfer is warm (approximately 100°F) when the negative is developing. Also, if your receptor surface can be soaked, you can submerge both the negative and the receptor surface in a tray of warm or room-temperature water and then peel off the negative very slowly under the water. (See Chapter 4, "Creative Techniques," on page 47 for more information on liftoff for special effects.)

Extending the Contact Time During Development

In just 1 to 2 minutes, almost all of the color dyes transfer; leaving the negative on the receptor surface longer can increase color saturation and overall contrast. Photographers have left the negative in contact with the receptor surface for periods of time from 1 minute up to several hours. The longer the length of contact, the richer and more saturated the blacks are. The key to extending the contact time is to prevent the negative from drying out. If this happens, it will stick to the paper, which will then rip when you remove the negative.

Photographer Christopher Grey's Lysol trick resulted from his experimentation with the contact time of negatives. He explains:

> After placing the wet transfer paper onto the working surface and removing the excess water, coat the paper with Lysol disinfectant spray. Let it sit for at least 15 seconds to penetrate, then wipe the excess from the surface. Be careful not to wipe too much; the paper must be wet enough to sustain a 30-minute contact, but not so wet that liquid oozes freely from the sides when rolling. Proceed with the transfer in the usual way. Roll the dyes (preferably using a soft rubber roller) into the receptor surface for 2 minutes. Then leave the transfer alone for 30 minutes before peeling it apart.

Grey claims that this method produces a smoother texture and more finely detailed transfer with truer color than other methods. This is because Lysol, being alkaline, helps the dyes become more mobile, and brings out more information from the dyes when you transfer an image onto a receptor surface. This Lysol method also extends the longer trans-

fer time—30 minutes or more—without the negative drying out. I've tried using the Lysol spray with contact times of 2 minutes also (1 minute of rolling) with improved results. When I discussed this method with Rich DeFerrari, Technical Photographic Specialist at Polaroid's Technical Assistance Department, it became clear that the transfer should be rinsed in running water for 3 to 5 minutes in order to clear out the residue alkalinity from the paper. This is done for the same reason that rinsing the excess vinegar from the vinegar bath is done: the paper will last longest with a neutral pH. No testing has been done about potential staining of the paper with Lysol over time, however. (For more information, read Grey's booklet, "Understanding the Polaroid Image Transfer Process," 2nd edition revised, page 10. See "Resources" on page 154.)

Controlling the pH Content

You'll achieve the best results if the water has a neutral pH and doesn't contain any minerals. So distilled water is ideal. In fact, Polaroid strongly recommends using distilled water. If you use tap water, check its pH content with Hydrion papers (litmus paper), which are available at most drugstores. This step is particularly important if you use well water. A pH content ranges from 1 to 14. A neutral pH is 7. If the reading is lower than 7, you can increase the alkalinity of the water by adding an alkaline substance, such as Lysol or baking soda, to the water, and retest. If the reading is higher than 7, you can increase the acidity of the water by adding vinegar or glacial acetic acid.

Some photographers feel that changing the pH in either direction improves their transfers (probably because their water doesn't have a neutral pH). They use "special, secret ingredients." These include such substances as vodka, rubbing alcohol, Lysol, ammonia, and vinegar. Some transfer artists add vinegar directly to the warm-water tray and soak their paper in it, as well as float the transfer on water with vinegar added. I often peel dry transfers under water in the vinegar bath to save a step. (If your water source is acidic, don't try this.)

Using a Vinegar Bath After Making the Transfer

When the normal processing of Polacolor ER film is interrupted by your prematurely separating the negative and the positive, the acid layer is removed, and the pH goes up to 13, a very alkaline level. To return the pH of the image transfer to a neutral level, put it in a vinegar bath, which is made of 1 part white distilled vinegar and 4 parts water, at room temperature for up to 30 to 60 seconds. This will also brighten and clarify the colors and restore reds.

It is important to follow the vinegar bath with a water rinse for 3 to 5 minutes in order to wash the excess vinegar out of the paper. If the paper remains too acidic, the cellulose chains in the paper fiber will be attacked.

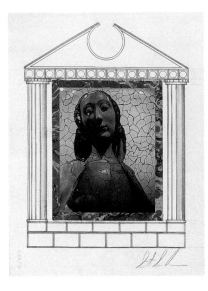

"Madonna." 4 x 5 image transfer on marbled paper. By Steve Sonshine.

If the paper's pH is above 8.5, the alkalinity will swell the fibers to a damaging extent. As mentioned earlier, Polaroid suggests using distilled water when making both image and emulsion transfers; however, rinsing the finished image transfer with tap water is fine. You can use a pH testing pen to check the receptor surface after rinsing. This pen, which is also valuable for testing other kinds of receptor surfaces, is available from Light Impressions and University Products (see "Resources" on page 154).

Controlling the Edges of the Image Transfer

The uncontrolled ooze of excess developing chemicals around the outside of a transfer causes the unique signature look of uneven and unrepeatable borders. Although many photographers and artists prefer this effect, you can prevent it several ways if you wish. First, make sure that your rolling pressure isn't too heavy and that your receptor surface isn't too wet, which will cause border areas to bleed excessively. Using masking tape or rubber cement, you can outline the area on the receptor surface where you'll place the transfer. Of course, you must position the negative precisely in the right spot for this to work. Other methods of eliminating uneven edges are to cut a window mat to cover the edges of a finished transfer, or to transform the edges by creating borders via handcoloring. You also can adhere marbling or other papers, veneer, or other materials to cover the edges.

Using Unflavored Gelatin

Soaking paper in gelatin can contribute to richer blacks and more saturated colors, and less liftoff in image transfers for improved results. According to Rich DeFerrari in Polaroid's Technical Assistance Department, the gelatin mimics the surface of the Polaroid print, and the dye adheres more easily to the gelatin than to the paper. And the more dye that can adhere, the more color saturation will be present in the transfers. In addition, the gelatin helps produce a sharper image because less water soaks in. Water soaking into the paper contributes to the soft, painterly quality of wet transfers. The following recipe appears in Polaroid's "Inspiration, A Step-By-Step Guide" (see "Resources" on page 154):

1. Mix together hot distilled water and unflavored gelatin, such as Knox gelatin. Use one envelope of gelatin to 2 cups of water, following the directions on the package. Mix well.

2. Add Kodak Photo-flo to the mixture, using the concentration recommended on the bottle. (This is 1 part Photo-flo to 200 parts water, or 1 capful Photo-flo to 20 ounces of water.)

3. Allow the mixture to cool to 100°F to 130°F before use. Place in a tray.

4. Soak the watercolor paper in the mixture for 1 minute.

5. Remove the paper, and put it on a flat surface. Squeegee until evenly damp. Don't let the paper dry out.

6. Place the negative on the paper, and roll with a roller. Keeping the negative around 100°F, let it develop for 2 minutes. Peel off the negative slowly.

7. Tip: The gelatin mixture will thicken as it cools. Keep it warm, and add more distilled water to the mixture as needed to keep it a thin consistency.

8. Soak the image transfer in a vinegar bath (4 parts water to 1 part white distilled vinegar) for up to 1 minute, and rinse with water for 4 to 5 minutes. If you don't rinse out the gelatin, it will stain the receptor paper.

9. Air-dry and spray with protective coating (optional). Handcolor with watercolors, pastels, pencils, or acrylics if desired.

Common Difficulties

Although the image- and emulsion-transfer processes are fairly easy, problems can arise. And unless you figure out what is causing the trouble, you can grow quite frustrated and waste a great deal of film. Some of the most common difficulties that my students and I have experienced with image transfers, and their solutions, follow.

Film-Related Problems

These difficulties arise when the film is still in or is being pulled out of the Polaroid film holder. It doesn't matter whether the film holder is attached to a slide printer or camera, or is positioned below an enlarger. These problems have nothing to do with making the image transfer itself.

Different results with different film batches

Because film batches vary, sometimes you might find that the wonderful results you achieved with one box of film are unimpressive with the next box. If possible, buy one box first, and if you like it, buy as many boxes or cases as you can afford. Film batches are identified by the expiration date and type of film. You can refrigerate—but not freeze—the film for a longer shelf life. For transfers, using the film before the expiration date isn't as critical if the film has been stored properly and hasn't dried out. I recently used some 669 film that expired 2½ years ago (!), and the transfers were fine.

No white tab shows out of the Polaroid film holder

Occasionally the white tab on Polaroid pack film is folded over on itself and doesn't show. Open the film holder, unfold the white tab, and close

"Estero, Point Reyes, California."
8 x 10 image transfer, handcolored
with pastel pencils.

the film holder. To avoid this problem, when loading the film, make sure all of the white tabs are showing before closing the film holder.

After you pull the white tab, no tab with arrows appears
Sometimes with pack film, the arrows tab doesn't come out of its flap. This is above the white tab on the Vivitar slide printer, and below the white tab on the Daylab Jr. slide printer. Generally, dirty rollers interfere with the appearance of the arrows tab. So be sure to check the rollers after each pack of film you use, and clean them when needed with warm water only and a soft, lint-free cloth or paper towel. Also, chemical buildup at the corners of the flap can prevent the arrows tab from coming out. Clean the corners of the flap. Usually the arrows tab is crumpled and can be retrieved with fingernails or tweezers while you hold the flap open. It helps to have three hands, so have someone hold the flap open for you until you get the hang of it. After retrieving the arrows tab, you can pull it normally, and you won't have any problem processing the film.

If you can't find or retrieve the arrows tab, open the film holder, then pull the tab out. Be aware that you'll lose that piece of film. However, I've had good luck in threading the arrows tab through the rollers so that the tab comes out of its flap on the film holder, which saves the piece of film. If you feel up to the challenge, try it. But if you happen to lift the film pack in the light during this process, you'll lose one exposure. If you can open the film holder in the dark, you won't lose any film. Of course, you won't be able to see what you're doing in the dark, but after several tries you develop a feel for how to thread the arrows tab.

Two white tabs are pulled in a row, without your having pulled the arrows tab
With pack film, this usually occurs because the arrows tab hasn't appeared (see preceding solution). But sometimes you might just get confused or have a momentary lapse of awareness and pull two white tabs in a row. Any time something like this happens, stop. Don't pull any more tabs; this just compounds the problem. If you've pulled two white tabs in a row, you have two pieces of film that are lined up to come through the rollers simultaneously. Try pulling the two arrows tabs at once, bringing both pieces of film out together, and discard both of them.

The gel chemistry will squish all over the rollers, so you'll need to clean them and any other part covered by gel. Open the film holder, remove the rollers, clean all affected parts with water, and reinsert the rollers. If the film jammed in the rollers, try pulling it back through the rollers from inside the film holder. Clean out the flap and anywhere else there might be gel, being careful to touch the gel as little as possible. Wash your hands immediately if you touch any chemicals. Close the film holder, making sure that the next white tab shows, and proceed with the next exposure.

After the image or slide is exposed onto the Polaroid film, the film is black

If the Polaroid film is black, you haven't actually made the exposure. This can happen for several reasons. With the Vivitar slide printer, some common factors are:

• You left the slide on the Vivitar's viewing screen rather than placing it in the slot. Contact between the slide and the sensors at the back of the slot signals the printer to make a flash exposure. If no slide is in the slot, the machine won't work.

• Certain slide mounts, usually older cardboard mounts, don't make proper contact when in the slot. It helps to have the filter holder in place even if no filter is in it. You can also push the slide in more firmly. If you don't have a filter holder, use a second plastic slide mount with or without a filter, and put it in with the slide you're exposing. (Make sure they're both horizontally aligned in the slot or you'll get a square image with black sides.)

• If the batteries are low, a weak flash might cause a dim or partially black exposure. The red "Ready" light will come back on very slowly after you've made the exposure if the batteries are low. See if changing the batteries eliminates the problem.

When you use a slide printer, a camera, or an enlarger, the following factors might also account for black film:

• You didn't remove the black safety paper after loading the film pack. For an 8 x 10-inch image, you might not have removed the paper envelope after loading the film into the film holder.

• You didn't push the "Print" or "Start" button, so you didn't make the exposure.

• The image was extremely underexposed.

• You pulled the white tab before you made the exposure, not afterward. It is crucial to follow the proper sequence for exposing the image before pulling any tabs.

• You didn't pull out the dark slide to make the exposure.

• The shutter is faulty.

The slide or image is exposed onto the Polaroid film, but the film is white

This usually happens because the slide wasn't in the slot on the Vivitar or in either Daylab film carrier, or the enlarger carrier. Another possibility is that if you remove the black safety paper on the pack film before you load the film, one piece of film will be exposed. Also, with the Daylab, if you remove the dark slide with the setting on "View," or with the previewing door open, the film will be quite overexposed and will look white. The same applies to an enlarger: if the darkroom isn't dark, the light will cause the film to be overexposed. It is also possible that if you have a very light slide and overexpose it by having the exposure control dial on "Maximum," you'll get a white result.

A white, oblong strip appears down the middle of the image, on both the positive and negative

Here, you didn't pull out the white tab on the pack film all the way and discard it. Then when you pulled the tab with arrows, the white tab was pulled back into the pack, so the development in that area was blocked.

A red, yellow, and/or white streak appears on the image, on both the positive and negative

If you hesitate at all or stop midway when you pull the second tab with the arrows, an orange and white vertical line will appear in your image. Firmly pulling the tab at a moderate speed without stopping or slowing will produce the best results. Any time this kind of streak appears on both the positive and negative of the Polaroid film, it has happened either before or during the process of pulling the film out of the film holder, not during the transfer process.

A white spot appears in the Polaroid image, on both the positive and negative

Remember the thumb with the circle and line through it that is on Polaroid film packaging? If you hold the film in the film area instead of by its ends or edges, you'll put pressure on a spot, and the chemistry won't develop the image there. This can happen when you load the film, or when you handle an individual piece of film while it develops.

A thin layer of brownish developer appears on areas of the positive

Polaroid calls this problem, which is quite common with beginners, "goo-stick." It prevents the dyes from transferring, leaving matching white areas on the transfer. The main cause is prematurely separating the positive and negative, so extend the developing time another 5 seconds.

Also, if the goo-stick is at the pod end, you might not have pulled the film straight out of the film holder. When you pull the film through the rollers at an angle instead of straight out, the chemistry isn't spread evenly between the positive and negative. There is much less developer on the leading tab edge, so it is affected the most. To prevent this, pull both tabs firmly straight out—not up, down, or to the sides.

One or more picture corners are missing on both the positive and negative

If only one corner is missing, you've probably pulled out the white or arrows tab at an angle. Be sure to pull all of the tabs straight out. A less common cause is that the positive might be curling excessively because of an extremely dry environment. If this is the problem, increase the humidity in your workspace.

Orange or red marks appear along the edges

This condition usually results when you pull the white or arrows tab out at an angle. Make sure that you pull the tabs straight out.

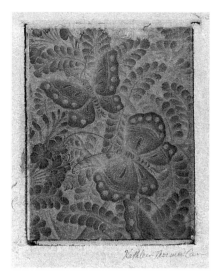

"Butterflies." 4 x 5 image transfer of a black-and-white negative, hand-colored with Prismacolor pencils.

A white half-circle appears on both the positive and negative in the center of the pod end

This problem, called a "u-break," usually occurs when the developer is too dry. Out-of-date film or poorly stored film is the primary reason. Sometimes extreme humidity will also cause a u-break.

A white- or yellow-dot pattern appears on both the positive and negative

Dirty processing rollers cause this problem. Be sure to remove and check your rollers after each box of film. The gel accumulates primarily on the edges of the rollers. Let the rollers soak if necessary, and clean them thoroughly with a soft, lint-free cloth or paper towel dampened with warm water. Use only water to clean, and be careful not to break the plastic bar under the rollers. If you do, you can purchase replacement rollers from Polaroid (see "Resources" on page 154). Cleaning the corners of the flap where the film comes out of the film holder is also a good idea. A dampened cotton swab or a miniature cotton swab made with a round toothpick and a small piece of cotton ball is useful for removing the gel. If these corners get too gummed up, the film won't come out properly.

White bubbles appear on the positive and negative

Pulling the film out too quickly can cause white bubbles to form between the negative and positive. When the developer pods are broken and the chemicals move forward as the film is being pulled through the rollers, air bubbles can be trapped if you pull the arrows tab too quickly.

Part of the Polaroid image seems blurry and distorted on both the positive and negative

Pulling the tab with the arrows out too slowly can cause this problem. Make sure that you get in the habit of pulling all of the tabs firmly, at moderate speed, and straight out. You also might want to check that the rollers are clean because built-up chemical residue can produce uneven pressure on the Polaroid film, with varying results. Dirty rollers can also cause the film to jam.

Dust marks or spots appear on both the positive and negative

This happens when there is dust on the slide or negative, or possibly on the filter. Use a blower or film cleaner to clean the film and filter.

Image-Transfer-Related Problems

You encounter these difficulties when you actually make the transfer—that is, when you place the Polaroid negative onto the receptor surface. The problems will show up only on the transfer itself. If you look at the positive, you won't see any indication of the problem.

White speckles appear on the image transfer but not on the positive

Usually this means that you aren't pressing hard enough when you roll the

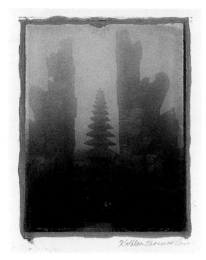

"Bedugal Temple." 4 x 5 image transfer, border handcolored with a gold Prismacolor pencil.

negative onto the receptor surface. This can easily happen if your receptor surface is textured or rough, and will happen more on dry transfers than on wet transfers. To prevent this, increase the pressure with your roller or try a softer rubber roller. If you see emulsion squirting out of the edges, you're rolling too hard. If you're making a dry transfer, you can also try dampening the receptor surface with a spritzer.

Emulsion squirts out on the corners of the image transfer
Here, you're rolling with too much pressure. This problem can also occur when your receptor surface is very wet. Squeegee more moisture out of the paper after soaking, or dampen rather than soak the receptor surface. Try a lighter touch with your rolling, or use a softer rubber roller.

A light or white ripple appears in the image transfer only, both wet and dry
This ripple results when part of the negative moves slightly during the rolling. It is important that the initial contact between the roller and the paper is gentle. It helps to press the negative down first with the palm of your hand, then gently begin rolling from the center to each edge. Once you've rolled over the entire surface, increase the pressure.

An off-register image with blue edges around one side of the subject
This problem is also caused by rolling too hard initially. The negative might have slid on the receptor surface or the receptor surface might have moved, creating a partial double image. Begin by rolling gently, as described above. Another solution is to tape the receptor surface to your work surface.

Black, gritty specks appear in the transfer but not in the positive
The hardness and pH content of the water can contribute to this problem. Use distilled water or neutral pH water with a low or no mineral content. You can adjust the water's pH content by adding a small amount of vinegar to increase acidity, or of baking soda to increase alkalinity. These specks can also be the result of a film-batch problem, but in that case an entire box of film would be affected. (I've seen them affect only part of a box.) Try developing fully for 60 seconds, then see how the normal print looks. Polaroid replaces defective film, so call the company if the problem persists (see "Resources" on page 154). Save the box with the batch date.

Diagonal lines appear across the image transfer and on the negative, but not on the positive
Separating the negative and positive too slowly and at a diagonal might produce uneven development. Sometimes this also can make lines, usually diagonal lines, appear. Pull the film out of the holder, wait 10 to 15 seconds, then separate the positive and negative quickly—and straight, not at a diagonal.

Making Polaroid Emulsion Transfers

This chapter opens with the basic, step-by-step procedure for creating Polaroid emulsion transfers using the Daylab Jr. slide printer, Polacolor ER 669 film, and hot-pressed watercolor paper. Like the Vivitar, the Daylab Jr. is an economical and easy-to-use slide printer. Although you can use other surfaces, hot-pressed watercolor paper is a great surface to learn on, and you can transfer to it directly in the cold-water tray. You can also create emulsion transfers using other equipment, such as the Vivitar slide printer, the Daylab II Multiformat slide printer, a camera, or an enlarger.

"Tulip Buds, Findhorn Garden, Scotland." 8 x 10 emulsion transfer, handcolored with pastel pencils; emulsion membrane stretched.

With an emulsion transfer, because the Polaroid film is developed completely, you don't need to add a warming filter (which is suggested for an image transfer), or any filtration for that matter—unless, of course, you want to be creative and change colors via filtration (see Chapter 4, "Creative Techniques," on page 47). Also, since the Polaroid film is developed for the full amount of time, you don't have to deal with a caustic gel. By the time the development is finished, the gel has been neutralized and is perfectly safe to touch.

Because the emulsion-transfer process is relatively new, there is less information available about it than about the image-transfer process. So you undoubtedly have far more opportunities for exploration and discovery. I've included the procedure for black-and-white emulsion transfers to get you started. Only your imagination will limit what you can do.

The Color Emulsion-Transfer Process, Step-by-Step

Use the Daylab Jr. slide printer and Polaroid 669 film. To make sure that you understand each step and the entire process, read completely through the following instructions before you begin.

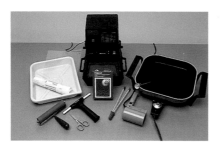

Gather equipment and supplies needed

- 35mm slides
- Daylab Jr. slide printer (prototype pictured)
- Polacolor 669 film
- 140 lb. hot-pressed watercolor paper
- Tray filled with room-temperature, distilled water
- Tray or electric frying pan filled with 160°F distilled water (or electric kettle)
- Brayer roller
- Squeegee
- Scissors
- Tongs
- Thermometer able to read 160°F
- Timer
- Vinyl-adhesive kitchen shelf paper (like Contac)
- 8½ x 11-inch clear-acetate or Mylar sheet (for the alternate method using acetate)
- Warming tray or hair dryer (optional)

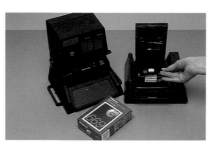

Load the film

Follow the detailed instructions that come with both the 669 film and the Daylab Jr.

1. When removing the 669 film from its package and loading it into the film holder (on the bottom of the 3 x 4 base), don't squeeze the film pack or you could damage the film.

2. Turn the 3 x 4-inch base upside down. (If the base is screwed to the enlarging head, turn the entire unit over.) Slide the film pack into the holder at a slight angle with the film area facing down, and push the pack down into position. Make sure that all of the white tabs show.

3. Check the rollers. If they are dirty, remove them, then clean, dry, and replace the rollers. Close and latch the film holder, and completely pull out the black safety paper.

4. Return the base to its usual position, so that the words "Daylab Instant Slide Enlarger" face you and the white film tab is on the right. The small, plastic orientation tabs on each

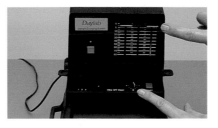

side of the base should line up with those on the enlarging head.

Set the controls on the enlarging head

1. Set the switch marked "1-2-3" to "2" for Polacolor 669 film. This sets the timer for the standard processing time of 60 seconds.

2. Set the color filters to "0-0-0." (If you want to add filters, first read the section on filtration on pages 86–87.)

3. Turn the exposure knob one increment below "0" in the minus (-) direction. If you have a dark slide or the transfer you made earlier is too dark, turn the exposure knob one or more increments in the plus (+) direction. Conversely, if you have a light slide or the transfer you made earlier is too light, turn the knob in the minus direction.

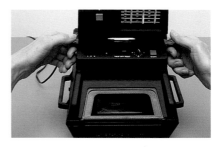

Compose the slide

1. Place your slide in the slide carrier, upside down and backwards (emulsion side up, shiny side down toward the Polaroid film, which is underneath in the base; the shiny side always faces the Polaroid film unless you deliberately want the image reversed).

2. Insert the carrier in the slot in the middle of the enlarging head.

3. Set the "View-Off-Print" switch to "View." The viewing light will come on.

4. Open the previewing door to see your image projected onto the white viewing area inside. This white surface is also known as the "dark slide" because it protects the unexposed film underneath from light.

5. Align the slide in the viewing area by moving the slide carrier in the opposite direction you want since it is a mirror image.

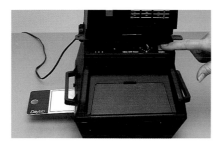

Expose the Polaroid film
1. Close the previewing door.

2. Turn the "View-Off-Print" switch to "Print."

3. When the green "Ready" light comes on, pull out the dark slide.

4. Press the "Print" button.

5. Push the dark slide all the way in.

Process the film
1. Pull the white tab.

2. Pull the arrows tab that appears below the white tab.

3. Push the "Timer" button (next to the "Print" button, which is in a different position than that shown on the prototype). Develop the film fully for 60 seconds at a room temperature of 75°F (if the room temperature is very different, adjust the development time accordingly.)

4. Separate the positive and negative by grasping one corner of the positive and peeling quickly.

5. Let the positive print dry for 8 to 24 hours, depending on the temperature and humidity of the room. For quick drying, use a hair dryer on "Medium" from about 3 inches away,

or an hors d'oeuvres warming tray for about 5 to 10 minutes. The surface of the positive print shouldn't be tacky.

6. Caution: Don't stack or touch the positive prints as long as they are tacky because the emulsion can be damaged.

Cover the back of the positive print with vinyl-adhesive paper
1. If you wish, you can cut off the white borders or cut the print into any shape. The white borders will become a light pink or blue during development, depending on the film type. This can add another level of interest to the transfer.

2. Cut the vinyl-adhesive paper slightly larger than the print. Remove the paper backing, and apply the sticky side to the back of the print. This seal prevents the back coating from dissolving in the water (and making a mess) when you soak the print.

3. Tip: The vinyl-adhesive paper without the paper backing doesn't stick well enough.

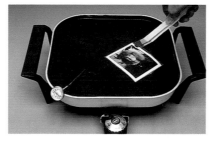

Soak the print in hot water
1. Heat a tray of water to 160°F, and fill another tray with water at room temperature.

2. An electric frying pan is ideal for keeping the water at a constant 160°F, but you can continuously reheat water with an electric kettle (pouring the water at a temperature of 180°F). It is important only that you start

with 160°F water in the tray. Distilled water is best.

3. Caution: Hot water can cause burns. Work carefully, and keep children away.

4. Immerse the positive print (with the adhesive-paper backing) face up in the hot water for 3 to 4 minutes until the emulsion starts blistering and lifting. Keep the water at a constant 160°F with the electric frying pan (or kettle). The water should be deep enough so that the print remains completely immersed. If you're using a tray, you can gently agitate it to keep the print submerged. If the print rises, push an edge under the surface with tongs. Don't touch the emulsion in the image area because it is delicate and will tear.

5. After 3 minutes, the print will begin lifting. If you're using an electric kettle and tray, the print will begin lifting after 4 minutes.

6. Using tongs, remove the print from the hot water by the edges, and place it in the tray of cold water.

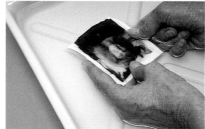

Separate the emulsion from the paper backing of the print
1. Starting at the edges of the print, gently push the emulsion toward the center with your index finger until the emulsion is completely free from the paper backing. It will separate as a single delicate and fragile membrane.

2. Leave the emulsion membrane

floating in the water, and discard the paper backing.

3. If a gel-like substance remains on the back of the emulsion, rub it off gently with your finger. (It isn't harmful.) Usually this substance stays on the paper backing, but with some film batches it doesn't (see "Common Difficulties" on page 46).

4. You can stretch the emulsion while it is in the cold water. The longer the emulsion sits in the cold water, the larger, thinner, and more stretchable it becomes—and easier to tear, accidentally or otherwise.

Arrange the emulsion on the watercolor paper
1. Place the watercolor paper under the floating emulsion in the cold-water tray.

2. With your thumbs, push two corners of the emulsion down on top of the watercolor paper.

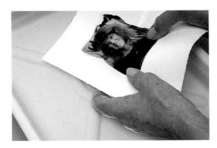

3. Slip your index fingers under the watercolor paper. Holding together the paper and the emulsion, lift them out of the water together.

4. Holding onto the top two corners, dunk the paper and emulsion in and out of the water several times to eliminate the wrinkles in the emulsion, if you want to remove them.

5. Repeat the dunking on all four sides of the image if necessary, always

holding two corners. Slow-running, room-temperature tap water can also flatten the emulsion.

6. Lift the emulsion and the watercolor paper out of the water, letting any excess water drain off.

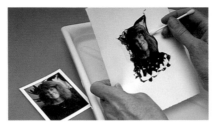

Manipulate the emulsion until you're satisfied with the image
1. You can stretch, wrinkle, tear, scrunch, fold, and/or sculpt the emulsion. You can use your finger, a cotton swab, or soft paintbrush.

2. If the emulsion starts to dry out at any time during this process, splash it with cold water. If you don't like what you've done, even after the transfer is dry, you can resoak it in cold water until the emulsion begins to lift and start again.

Lightly roll the image with a wet brayer roller
1. Move from the center out to each side of the image. This flattens all folds and ridges, as well as eliminates air bubbles and excess water.

2. Use only the weight of the roller. Applying too much pressure will stretch out your carefully manipulated image.

3. Caution: If the roller isn't wet or you don't start in the center and move outward, the emulsion might adhere to the roller and wrap around it.

Air-dry the emulsion transfer on a screen or hang it on a line
1. You can use clothespins to fasten the emulsion transfer to the line.

2. Caution: If you dry the transfer too quickly—for example, with a hair dryer—it will curl and ripple. Usually you can flatten the transfer later, but if the surface is too curly, as with thin papers, the fragile emulsion might crack and flake off.

3. When the emulsion transfer is dry, flatten it in a dry-mount press, if you have one, set on low (180°F), then place the transfer under a weight. You can also iron the back side of the transfer on a low setting before placing it under the weight.

Handcolor the emulsion transfer if desired
1. Handcolor the emulsion transfer with watercolors, pastels, pencils, or acrylics if desired (see "Handcoloring Transfers" on page 69).

2. Emulsion transfers are slicker than image transfers, and pastels will need to be sprayed with a fixative so they won't rub off. I use Blair's workable matte fixative because it changes the pastels the least. You can then use a UV inhibitor.

Spray the emulsion transfer with a protective coating
1. This step is optional. Keep in mind, however, that emulsion transfers are fragile, so it is a good idea to protect them.

2. You have several sprays to choose

from, including UV inhibitors, such as McDonald's Pro-tecta-cote and Krylon UV Clear.

Try an alternate method using acetate

Use this method when you can't put the receptor surface you've chosen into the cold-water tray because it will get destroyed by immersing it in water or because it is too big to fit in the tray (such as a large sculpture). An acetate sheet serves as a temporary receptor to transfer the emulsion membrane to your receptor surface, where you'll manipulate the image.

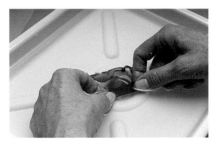

1. To accommodate the acetate sheet, flip over the emulsion membrane in the cold water, as if you were turning down a bedsheet. If you don't flip the emulsion over, it will be reversed when you transfer the image to another surface (see page 44).

2. Place the acetate sheet in the water under the floating emulsion.

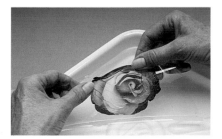

3. Arrange the emulsion on the acetate as you did on watercolor paper (review page 42. Manipulating on the acetate might be difficult because only the underside of the membrane, which is now on top, moves easily.)

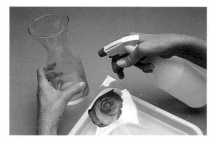

4. Prepare the receptor surface by lightly wetting it with a spritzer, if this won't damage the surface. The emulsion will transfer more easily if the receptor is dampened.

5. Turn over the acetate, so that the emulsion is on its underside.

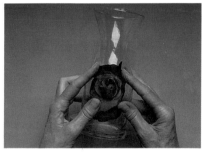

6. Place the acetate, with the emulsion underneath, onto the receptor surface.

7. Press the acetate with your fingers or the brayer roller, so that the emulsion adheres to the receptor surface.

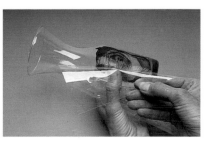

8. Remove the acetate by peeling from one corner.

9. As you peel the acetate, use your fingers to hold the emulsion down on the receptor surface if it starts to lift with the acetate.

10. Manipulate the emulsion with your finger, a cotton swab, or a soft paintbrush until you're satisfied with the image.

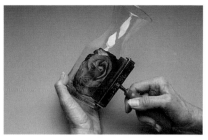

11. Using a wet roller (or wet fingers if the shape prohibits using a roller) and starting from the center, smooth out any air bubbles, creases, and extra moisture.

12. Air-dry the emulsion transfer (see page 42).

Helpful Hints

You can also manipulate the emulsion membrane on the acetate sheet. If your receptor surface is delicate, coarse, or unwieldy and you don't want a final reversed image, try turning over the slide or negative in the slide printer or enlarger. This method enables you to expose the image backward to begin with so that you can manipulate the emulsion membrane on the acetate sheet rather than on the receptor surface. With the Vivitar slide printer, the Polaroid film is above the slot that the slide goes into. By your turning over the slide or negative so that the shiny side of the slide faces down and the emulsion or dull side faces up, your image will be reversed. When you use this method, you don't flip the emulsion membrane over in the cold-water tray.

People sometimes resist rolling out the air bubbles and flattening the ridges of wrinkles after they finish the transfer because the roller can occasionally modify the meticulous shaping that they spent so much time creating. However, once dry, the ridges and air bubbles can easily crack and break off if you don't protect the transfer. With practice, you can learn to roll the transfer so gently that the shape isn't compromised. Rolling at this stage also pushes out excess water, thereby enabling the transfer to dry more evenly.

You might be able to make a few adjustments after rolling, but the drier the emulsion transfer is, the more likely it is to tear. When I use my fingers rather than a cotton swab or paintbrush for manipulation, I can more easily gauge if the emulsion is too dry to move without tearing. If it is, I add more water by spritzing the top of the transfer.

When you place multiple emulsion transfers on one receptor surface, it is easier to use the acetate sheet for transferring. You have more control over positioning this way. The key is to place the emulsion membrane in the top corner of the acetate, so you don't risk pulling up the other emulsion transfers with the acetate, especially if they are still wet.

Some photographers have mentioned that they think that fresh Polaroid film works best for emulsion transfers. Rich DeFerrari, Technical Assistance Specialist at Polaroid, has been invaluable in answering questions. He said that whether or not a film made good emulsion transfers depended more on the particular batch of film and how it had been stored than on whether the film itself was fresh or even outdated. You might also want to take another look at the "Helpful Hints" relating to image transfers discussed in Chapter 2 on page 27. You can apply a few of these hints to emulsion transfers. For example, using distilled water that doesn't contain any minerals and has a neutral pH is an important factor in making successful emulsion transfers, according to Polaroid.

The Black-and-White Emulsion Transfer Process, Step-by-Step

With photographers all over the United States and Europe continuing their explorations, new techniques and methods for creating emulsion transfers keep emerging.

Choosing a Film

The process for making black-and-white emulsion transfers using Polaroid black-and-white or sepia films is one such development. For black-and-white emulsion transfers only, you can work with either Polapan Pro 100 (Type 664, 3¼ x 4¼-inch pack film, ISO 100 for daylight or flash exposure; comes in boxes of two twin packs of 10 exposures each) or the new Polaroid Sepia film, which has an ISO 200 rating but is available in 4 x 5-inch sheet film only.

When you use Polapan 100 with tungsten exposure, as in the Daylab II slide printer or enlargers, the contrast flattens because of the film's reciprocity characteristic. When you increase the exposure time with non-flash exposures, a color and contrast shift and a loss of speed result.

Getting Started

Although similar to the basic emulsion-transfer procedure, the black-and-white emulsion-transfer procedure requires boiling water instead of 160°F water. Another difference is that the receptor surface is coated with a diluted acrylic-gel medium. This medium, which you can buy at any art-supply store, is ordinarily used to add body to or extend the drying time of acrylic paint, and

other purposes. Liquitex is an excellent brand, and a small jar will give you plenty to get started. You also need a foam brush, plywood, and artist's tape. I recommend learning on 140 lb. hot-pressed watercolor paper.

Atlanta photographer Floyd Grimm developed the steps below, which were published in an article in Polaroid's *Test* magazine, "Shades of Black & White: another way to look at emulsion transfer" (Spring/Summer 96, page 9). I've added a few comments from my experience.

1. Expose the film, and process it normally. At 75°F, process the film for 30 seconds; at colder temperatures, process longer (see the chart in the film instructions). Note: If using the Daylab II slide printer and Sepia film, turn the exposure-compensation dial all the way to the right. Because Sepia film is ISO 200, it requires less exposure time. No filtration is required; just turn the switch to setting #1.

2. After drying the Polaroid print so that it is no longer tacky, trim the image just inside the white border. If any white border shows, the image won't separate. Note: You don't need to cover the back of the print with vinyl-adhesive paper (Contac) since the backing paper on this type of film doesn't dissolve.

3. Heat the water in a covered pan on the stove (or in an electric frying pan) until boiling. Leave the burner on. Remove the lid, and submerge the Polaroid print. The water should stop boiling in a few seconds, and the emulsion should start to separate and curl toward the center in approximately 2 minutes.

4. Caution: If the emulsion doesn't completely separate from the base, place the print into a tray of warm water. Peel the emulsion from the base,

using your index finger to push the emulsion free. Don't let the white base mat peel off and stick to the emulsion. If this happens, return the image to hot water for a little longer. If the white base continues to stick, keep removing the emulsion. Some of the white base can be rubbed off later.

5. With tongs, remove the emulsion from the water, replace the lid on the pan for the next lift, and repeat the directions above.

6. Prepare the emulsion for transferring using the acetate sheet. Soak the receptor paper.

7. Squeegee off the paper, and coat the receptor surface with a dilution of 3 parts acrylic-gel medium (matte or gloss) and 1 part water. The dilution should be a bit less viscous than white glue. You don't need much because you have to cover only the area under the actual transfer.

8. Transfer the emulsion to the receptor paper, and roll lightly with the brayer roller. Brush off excess gel medium with a foam brush, brushing from the center of the image to the edges. Gel medium will be on both sides of the emulsion. For multiple transfers, continue the above procedure until the image is complete.

9. With artist's tape or water-activated, gummed paper tape, tape the paper to a sheet of plywood on all sides and allow the print to air-dry naturally. (This is particularly important when using lightweight etching papers because they buckle when they dry.) Once the print has dried, you may continue to add images as long as the paper is still taped in place. Follow step #7. (I use a drying screen instead to air-dry my transfers from both sides for 140 lb. watercolor paper and some handmade papers.)

Common Difficulties

My students claim that making emulsion transfers is easier to learn than making image transfers. Nevertheless, problems can arise. And unless you know how to correct them, you might unnecessarily waste film and get frustrated. In addition to the potential difficulties involving image transfers that also relate to emulsion transfers, you might encounter problems that are specific to emulsion transfers. But these, too, have solutions.

The emulsion won't detach from the paper backing

To solve this problem, make sure that the water is hot enough and deep enough, and that you leave the print in the hot water long enough. If the water isn't deep enough, the middle of the print can float on top of the water and not get enough heat. Then push the print down at the edges with tongs. Make sure that the print stays completely under the water. If you push in the middle of the print, you might rip the emulsion. You can also agitate the print by gently rocking the pan or tray or using tongs to stir the water. If the emulsion won't detach once it is in the cold water, put it back in the hot water for 1 or 2 more minutes. For a black-and-white emulsion transfer, also check to make sure you cut the white borders off the print.

A thick gel sticks to the loose emulsion membrane

This seems to occur when one of the coatings on the film is thicker than usual and swells up (different film batches have different thicknesses of the gel chemistry). The gel is nontoxic at this stage of complete print development, and you can easily brush it off with your finger. However, the gel might cause uneven stretching of the emulsion in the lighter areas of the image. This factor can greatly enhance an image or ruin it, depending on the image and whether or not the emulsion membrane tears. The best solution is to buy a box of film and try it. If you like the film and no gel forms, buy as much film in that emulsion batch (identified by date) as you can afford, and refrigerate it. (Don't freeze it.)

The emulsion rips too easily during the transfer

When the hot-water temperature is constantly above 160°F, the emulsion seems to become more fragile. Leaving the emulsion in the hot water longer than the recommended 3 to 4 minutes and/or leaving the emulsion in the cold water longer cause it to stretch. Then the emulsion membrane becomes thinner and more vulnerable to tearing.

The emulsion wraps around the roller when you roll out the ridges and bubbles

The roller needs to be wet; otherwise, it might stick to the emulsion, and, if you aren't looking, the emulsion might wrap completely around the roller. Make sure that you start in the middle and roll toward the edge. Also, you might be applying too much pressure.

Creative Techniques

Now that you've learned the basics of image and emulsion transfers, as well as how to troubleshoot when you have a problem, you are ready to start experimenting with creative techniques to enhance your transfers. Once you've made an image or emulsion transfer, you might find that you are happy with the result and don't want to do any more to it. If so, you can simply spray the transfer with a UV-inhibiting lacquer to protect it. But if you wish to further alter the transferred image either while you make it or after it is produced, you can explore a myriad of creative options.

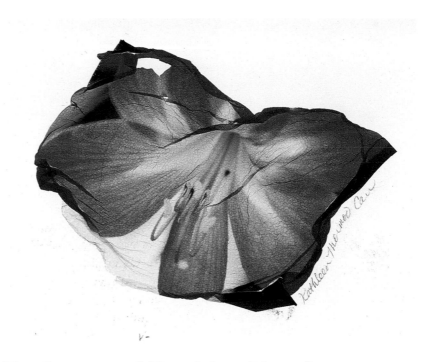

"Amaryllis." 3¹/₄ x 4¹/₄ emulsion transfer, with white borders cut off print; image took this shape when lifted out of water.

For Image and Emulsion Transfers

The following suggestions and examples only begin to discuss what you can do because techniques are being discovered every day. I describe some of the many possibilities you can experiment with, listing them in their logical order within the process. Techniques for both image and emulsion transfers come first, followed by techniques for image transfers only. The last section covers techniques for emulsion transfers only. No set rules exist, so don't limit yourself to what is covered here. Try anything that interests and excites you. Remember, these processes are still new and evolving, and your creative explorations and "happy accidents" might contribute to new directions.

Using Filters When Making the Exposure

With the Vivitar slide printer, you can put a colored gel in the filter holder to alter the color of your transfer. Although you can use any colored gel, I recommend the Rosco lighting-gel sampler books as an inexpensive option. These provide numerous colors of 1 x 3-inch gels, which are the perfect size to insert into the Vivitar. You can place your gel of choice on top of the slide when making an exposure, or put it in the filter holder, which is underneath the slide. The advantage of placing the gel on top is that you don't need to cut the filter out of the book in order to use it. Contact a camera store or a lighting supply house for theater or motion pictures, or call Rosco to get a sampler (see "Resources" on page 154).

Color-printing (CP) filters are good choices for transfers and come in five-unit increments of magenta, cyan, yellow, red, blue, and green.

The Kodak Color Print Viewing Filter Kit enables you to preview any color filtration you're considering using for your transfer.

Color-correction (CC) filters also come in five-unit increments in the same colors as CP filters, but they are expensive because they are optically pure. They're designed to go between a lens and the film or paper, and ordinarily used with enlargers and slide copiers.

But it is unnecessary to go to such expense for making transfers. Minor scratches and dust on the filters aren't usually visible on image transfers. They do, however, show up on emulsion transfers, so handle and store your filters carefully.

The best and easiest way to filter is with a dichroic color head, found on color enlargers and the Daylab slide printers, including the Daylab Jr. The Daylab enlarging head has a built-in, dichroic color system with cyan, magenta, and yellow filtration with up to 80CC units each. Dichroic-color-head enlargers offer even more CC units. You can use the colors singly or in pairs. Keep in mind, though, that using three together creates a neutral-gray density because of the color mixing involved.

The Kodak Color Print Viewing Kit is a good way to see beforehand what you'll get by adding filtration. It contains 10CC, 20CC, and 40CC gels of cyan, magenta, and yellow, as well as green (equal parts cyan and yellow), red (equal parts yellow and magenta), and blue (equal parts magenta and cyan) gels. You can hold a filter or combination of filters over your transfer and look through the filter(s) to get an idea of how the transfer will change. (For more information, see the filtration section on pages 86–87.)

Using Black-and-White Slides

When you work with black-and-white slides, the resulting transfers might have a cyan cast. To transform this bluish-green shade into a sepia tone, use warming filters, such as amber, red, or magenta filters. For a cooler look, use a blue filter. Slight filtration is probably all that is necessary; the more intense the color of the filter, the stronger the color shift will be. You might also want to vary the time you leave the Polaroid negative on the receptor surface to see how contrast and saturation are affected. Try adding 30 or 60 seconds to the contact time, and see what happens.

Using Black-and-White or Color Negatives

Working with negatives instead of slides for transfers can produce some rather interesting results. As you go through your negatives, look for images that appeal to you as negatives. What the positive prints look like is irrelevant because the transfers will look like the negatives. Graphic and abstract images work best. You can add filtration while exposing to add or alter color. Color negatives have a strong orange cast, which gives a strong sepia tone to the transfer. The colors will also be the complements of a subject's true colors. For example, a red vase will look green. Both the enlarger and the Daylab film carriers hold entire film strips. So you don't

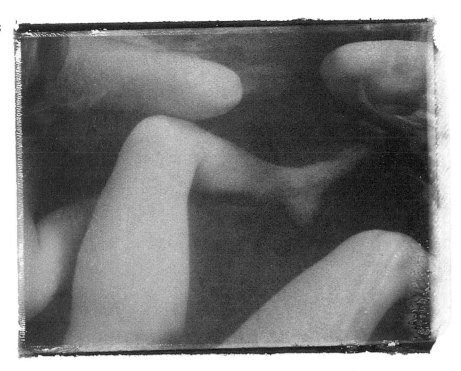

"Legs." 3 1/4 x 4 1/4 dry image transfer; original 11 x 14 black-and-white print copied onto slide film.

"Yin Yang Series #7." 4 x 5 emulsion transfer; two black-and-white negatives sandwiched.

"Yin Yang Series #6." Two 4 x 5 emulsion transfers from the same two black-and-white negatives sandwiched, with second transfer placed upside down next to the first.

have to cut your negative strips to use them for transfers. With the Vivitar, however, you need to cut and place an individual negative in a slide mount or in the filter holder.

Using Two Slides or Negatives Together for a Sandwich

This technique brings new life to old images. To make a sandwich, put two slides, two negatives, or a slide and a negative together, then expose them at the same time in a slide printer or enlarger. Because each slide or negative's dark areas block the light coming through its companion slide or negative, the dark areas dominate, obscuring any lighter areas found on the other slide or negative. You can preview the result by looking at the slide sandwich on a light table or holding it up to a light. Remember, you can lighten your transfer by increasing the exposure of the slides.

"Yin Yang Series #2." 4 x 5 image transfer on dampened leather chamois; two black-and-white negatives sandwiched.

"Yin Yang Series #1." 8 x 10 image transfer on dampened handmade paper; two black-and-white negatives sandwiched.

When using more than one slide or negative, you need to increase the exposure to at least double the standard exposure used for image transfers, especially if any of the slides included are dark. If the slides or negatives are light, experiment with the exposure until you find the setting that provides the best result. If the combination creates a normal-density image, try starting with a normal exposure for the process you're using. Each indicator line on a slide printer's exposure-adjustment dial is equivalent to half an *f*-stop. To double the exposure, move the dial two increments up toward the plus (+) mark.

If you need more exposure than the maximum indicator-line setting allows, push the "Print" button again without moving the slides or pulling any tabs to get the exposure. To increase your exposure even more, push the "Print" button as many times as you like. Wait until the red "Ready" light comes back on before pushing the "Print" button.

"Nudes Embracing." 3¹/₄ x 4¹/₄ image transfer, black-and-white slide and color slide double exposed.

"Nudes Embracing." 3¹/₄ x 4¹/₄ image transfer; black-and-white slide and color slide sandwiched.

Making Double and Multiple Exposures

You can create double and multiple exposures using slides or negatives in a slide printer or an enlarger, or you can use a camera to make multiple exposures of various subjects. Unlike a sandwich, a multiple exposure requires you to expose each slide or negative separately onto the same sheet of Polaroid film. (Caution: Don't pull any tabs until all the exposures are finished.) The order in which you expose the images doesn't matter. With this technique, the light areas of any of the slides or negatives (or subjects if in-camera) block out the dark areas. So the result looks quite different from a sandwich. And since you expose each image separately, you can align and crop each image individually.

The total number of exposure settings needs to equal one typical exposure setting for an image or emulsion transfer. Therefore, for each slide or image you use, you have to decrease the exposure, thereby underexposing it. Suppose, for example, you have two slides of equal density. Each slide should get ½ of the standard exposure. Similarly, if you were using three slides of equal density, each would get ⅓ of the standard exposure. If, however, you have a light subject in one image but want the dark pattern of the other image to show through, you must change the ratio so that the dark slide receives more than half of the exposure. For example, ⅔ exposure (dark slide) + ⅓ exposure (light slide) = 1 exposure. Try experimenting with varying the exposures in order to get the best results. In case you ever want to recreate your efforts, it is important to take notes or to label the slide mounts.

"Shadow Puppet." 8 x 10 image transfer on handmade paper, hand-colored; negative image from black-and-white negative.

Scratching or Manipulating the Polaroid Film

By using an X-acto knife, etching needles, scissors, a hatpin, or pen nibs—any sharp object—you can highlight or change an image before or after exposure. Keep in mind, though, that scratching the film before exposing the negative works only with sheet film. The yellow-sensitive layer breaks down, and the image becomes more blue and cyan. But scratching either sheet or pack film after you expose it and pull it through the film holder creates white lines on the film.

Making Two Transfers from the Same Piece of Film

When you set out to make an image transfer, wait approximately 30 seconds instead of the usual 10 to 15 seconds before pulling apart the negative and positive. This way, you'll get a slightly washed-out image transfer and a slightly washed-out positive that you can use for an emulsion transfer. For some images, such as some portraits, nudes, and flower shots, this pastel look can be quite effective. You can also place an image transfer and an emulsion transfer on the same receptor surface, overlapping the emulsion transfer onto the image transfer or some other image since the emulsion is lighter and more transparent.

Using Different Receptor Surfaces for Different Looks

You can take advantage of the many surface textures and colors available in order to provide your transfer with a unique look and quality. It is best to develop your transfer technique first, using hot-pressed watercolor paper before experimenting with other surfaces. These might call for more skill and, with image transfers, can create more liftoff. The fibers of handmade papers, for example, often stick to a Polaroid negative, thereby requiring extra care during the peeling process.

"Yin Yang Series #5." 4 x 5 emulsion transfer on handmade paper; two black-and-white negatives sandwiched.

"French Horn on Sheet Music." 4 x 5 emulsion transfer onto a copy of a piece of sheet music; original black-and-white slide.

For an image transfer, the surface needs to be porous enough for the dyes to stick, not too slick, yet not too rough. Otherwise you'll get a great deal of liftoff, often the entire image, especially with dry transfers. Vellum is almost too slick, but you can make it work if you are careful. Because vellum is semitransparent, you have the added interest of handcoloring and working on both sides of the transfer.

For both image and emulsion transfers, various papers, including cold-pressed and rough watercolor paper, printmaking papers, and rice paper are excellent surfaces to use. I especially like bark paper and some of the Thai and Japanese handmade papers. These papers can change and soften images, so choose images that a particular surface will enhance.

Sheet music, maps, text, artwork, old wallpaper, and a range of printed papers can also be exciting surfaces to transfer onto, especially if the content relates to the subject matter of the transfer. You might need to copy the original sheet music or map, for example, onto a thicker paper for transferring. Test the paper first before making your masterpiece.

The thickness, or weight, of a paper affects the final transfer. As stated earlier, thinner papers can buckle, especially if dried quickly. I like the 140 lb. papers, especially Arches hot-pressed watercolor paper for all three sizes of image and emulsion transfers because it doesn't buckle much, it is easy to tear into small pieces (I buy large sheets), and it is affordable. But if I'm doing a larger multiple-transfer piece, I prefer the stiffness of a 300 lb. or heavier stock.

If you have a problem with buckling or rippling after the transfer dries, dampen the back slightly. Then put the transfer in a dry-mount press on the low setting between sheets of paper for about 30 seconds. An alternative solution is using a clothes iron on the wool setting, placing a piece of paper on the reverse side of the transfer, and pressing the iron over it for

"Blue Mosque." 4 x 5 emulsion transfer on old metallic Victorian wallpaper; original image and sunset image sandwiched.

"Yin Yang Series #1." 8 x 10 image transfer, photomontage with dried roses placed on the transfer and rephotographed; two black-and-white negatives sandwiched.

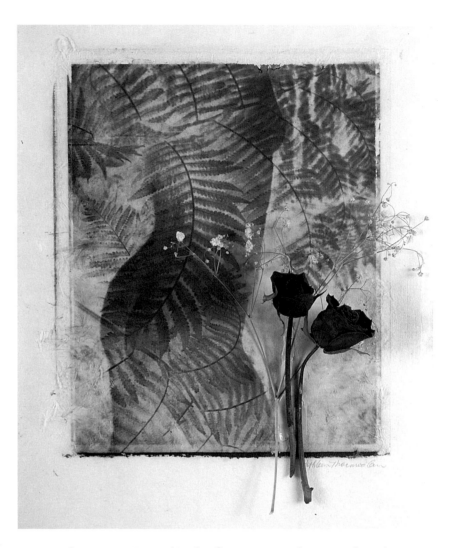

30 seconds or more. Immediately after ironing or heating, place the transfer under a heavy weight until flat.

It is best to use a surface with a neutral pH so that your transfer will last. The acid content of newsprint, for example, is so high that the paper will yellow and become brittle in a short period of time. You can test the acidity of a paper with a pH testing pen, available through University Products or Light Impressions catalogs (see "Resources" on page 154).

Natural fabrics, such as silk, muslin, canvas, hemp, cotton, and leather, also work well for both image and emulsion transfers. Synthetic fabrics, on the other hand, repel the dyes in image transfers. Make sure that the natural fabrics you select are free of any additives and conditioners that might remain from the manufacturing process. These affect the adhesiveness of the dyes for image transfers. Washing or cleaning the fabric first is a good idea.

Other surfaces, such as wood, veneer, bisque-fired ceramic tile, and clayboard, are also good choices. The variety of textures and colors in

these materials can enhance some images tremendously, and it is exciting to see how the results differ. The color and texture of any receptor will show through the relatively transparent image, so be sure the color isn't so dark or the surface so patterned that the image will be difficult to see.

You can apply emulsion transfers to a much broader range of surfaces than image transfers. In fact, emulsion transfers stick to almost anything. But remember that once an emulsion is dry, it is a thin, fragile, and brittle membrane. Any air pockets under the emulsion where it didn't adhere to the receptor surface can crack and break with movement or pressure, or possibly even with dramatic humidity changes. So use a roller or your fingers to smooth out and eliminate air bubbles before the emulsion transfer dries.

For rough surfaces, contour the emulsion into pockets and ridges, starting from the inside and working out toward the edges. Be sure to mount the fabric so that it won't move; the delicate emulsion will crack if bent too far. Very rough surfaces, such as some barks, may be problematic since the potential for the development of air pockets and ridges is so great.

Other surface possibilities exist for emulsion transfers. Mylar, different kinds of foils, sheet metal, enamel, mirror, glass, Plexiglas, other plastics, glazed tiles, and screens are among these. Imagine how you could transform your file cabinets, computers, doors, mirrors, and refrigerators.

Curved surfaces, such as sculptures, bottles, and ceramic pieces, are fun to use. However, emulsion transfers placed on anything utilitarian, including plates and mugs, wouldn't hold up to heat or washing. (The heat-transfer process available in some photo outlets and copy centers is more suitable for such objects.) However, if you sealed the surface completely with a water-based, nonyellowing polyurethane or acrylic sealer after making the transfer, personalized bathroom tiles and other items might be possible emulsion-transfer creations.

"Parrot Sequence." Four 3 1/4 x 4 1/4 emulsion transfers; color negative of parrot sandwiched with color slide of leaves, repeated by reversing the original twice. Collaboration with Suviro Wright.

Different surfaces require more or less moisture for optimal results. Your first step is to discover how a surface reacts to water before making the transfer. I recommend using a spritzer to dampen unsized and hand-made papers and other surfaces, like leather, which don't hold up to soaking. For image transfers on these surfaces, process your image as a dry transfer, peeling very slowly. Use a vinegar bath only if the surface can withstand a water rinse for 3 to 4 minutes. Thoroughly rinsing off the vinegar is important because residual vinegar makes the receptor surface too acidic and decreases its longevity.

Placing More Than One Transfer on a Receptor Sheet

You can create a collage by putting several transfers on one receptor surface. Dry image transfers are easier to place and process than wet ones, especially if you're assembling a large piece. You can overlap image transfers, but this sometimes produces muddy results. You can also cut, assemble, and glue transfers on a surface, which might work better for overlapping images. Since emulsion transfers are more transparent than image transfers, you can overlap them more successfully.

Sequencing two or more transfers can be quite effective. You can combine images on one sheet side by side, or exhibit individual transfers as a single piece by using a mat with several windows. Another possibility is incorporating one or more transfers as part of a mixed-media piece, combined with etchings, watercolors, acrylics, pastels, or even sculpture. Creative options abound. Take a look at Brian Kavanaugh-Jones's work on page 132. (For more information on emulsion-transfer techniques for placing more than one transfer on a receptor sheet, see page 67).

Segments #1 and #3 of Mosaic from 28-foot Mural. Multiple 4 x 5 image transfer, affixed to tiles. By Randy Kaneshiro.

Making a Mosaic of Multiple Transfers from One or More Images

When making a mosaic, you can present your subject through as few as two transfers or as many as your space and equipment allow. The most dramatic example of the mosaic technique I've seen is Randy Kaneshiro's 28-foot wall mural, made up of hundreds of 4 x 5-inch image transfers mounted on tiles. To achieve this effect, he used his enlarger to project the slide of his first subject onto the floor. Then he marked out a grid to indicate where to place the 4 x 5-inch film holder for each section of the single subject. Next, Kaneshiro made a separate exposure for each portion of the grid and transferred each onto watercolor paper. He then affixed each transfer to an individual tile. Earlier, he'd attached Velcro to the back of each tile so that, when assembling the mural, he had the option of adjusting the arrangement of the tiles. Repeating this procedure, he used up to 30 transfers for each of the multiple subjects of the mural.

Using Various Polaroid Films for Different Effects

Emilio Brizzi, whose work appears in the Gallery, has experimented widely with Polaroid films (see page 120). He often shoots an original photograph on one type of Polaroid film and reproduces the print onto another type of Polaroid film. He suggests the following techniques.

"Atlas, 1995." Emulsion transfer; original photograph shot on Polaroid 809 negative and processed with Polaroid 804 positive; image, reproduced on black-and-white film, printed, bronze-toned, and then copied onto Polaroid 559 film for emulsion lift. By Emilio Brizzi.

Positive-Negative Mismatch

Brizzi works with a Polacolor 809 negative and an 804 positive (brought together with a separate processor) to create a warm-toned print. He can also use this print for emulsion transfers. He reproduces the print on Polaroid 559 film for image transfers.

Polaroid 35mm Polablue Film

This high-contrast graphic film is designed to make "text dia's" (a blue background with white letters). When you use this film to reproduce a negative, you can obtain a blue-and-white slide if you expose it carefully. Brizzi exposes the blue images on Polaroid 59 or 559 film.

Sandwiching a Mask with a Black-and-White Negative

To make the mask, Brizzi scratches an unexposed black piece of film with an etching needle. Then after he sandwiches this mask with a black-and-white negative, he makes a black-and-white print. Next, he reproduces the print on Polaroid 559 film and makes an image transfer. Using the underdeveloped, yellow-red positive, he creates an emulsion transfer, which he lays over the image transfer.

Toning Black-and-White Prints for Reproduction as Transfers

Brizzi has used bronze toning to get a different tonality for some of his transfers.

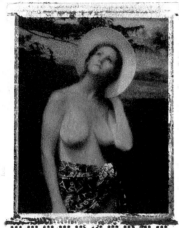

"Donna." 4 x 5 image transfer, made from a color slide on Polaroid 59 film. By Theresa Airey.

Creating "Pulled-Negative" Transfers

Fascinated with the unique coloring left on a Polaroid negative after making an image transfer, Theresa Airey, another photographer whose work appears in the Gallery, wanted to see if she could do something with it rather than simply dispose of the negative. She took the wet "pulled negative"; rinsed off the emulsion under hot, running water; and immediately copied the negative onto 35mm slide film on a copystand. From this slide, she then made image transfers and handcolored a few of them.

Sometimes after rinsing off a negative, Airey solarizes it with a 500-watt bulb on the copystand before copying it. This approach creates an even more distinct image. Take a look at Airey's transfer from a pulled negative on page 114. You can also make emulsion transfers from the slides of the pulled negatives.

Using Gold Spray Paint

This approach enables you to improve transfers made from overexposed slides. Christopher Grey offers this creative technique for overexposed original slides, which don't transfer well because the highlight tones and much detail are lost. The following instructions appear in his booklet, "Understanding the Polaroid Image Transfer Process" (pages 11-12).

For a dry image transfer with an overexposed original slide, take a piece of disposable paper larger than the receptor surface, and cut out an area equal to the size of the final image. Lay the cutout over the receptor surface in the area where you'll place the transfer. From about 2 feet away, gently spray gold metallic spray paint in the direction of the cutout. You only need a little, so don't apply an even or thick coat. When dry, remove the cutout mask sheet, and place the transfer directly on the painted area. Roll and separate in the usual way.

The gold paint, when applied lightly, can act as a pseudo skin tone, or give the impression of detail where there is none. If the application of paint is thick, however, it will prevent the dyes from adhering to the receptor surface. Silver-colored metallic paint works reasonably well with dry image transfers, but looks muddy after drying under the transfer. Gold loses only a little of its luster after drying. For emulsion transfers, don't bother with the mask since these transfers have such uneven edges. Just spray an area, and arrange the emulsion transfer on top.

Photomontage

You can make a photomontage by attaching two-dimensional objects, such as leaves, feathers, stickers, text, fabric pieces, or whatever you can think of, on your finished image or emulsion transfer. Avoid using rub-

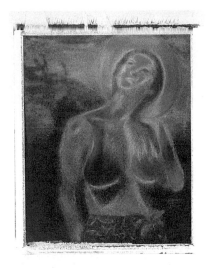

"Blue Donna." 8 x 10 image transfer, made from 35mm copy slide of pulled negative; lightly enhanced with Conte pastel pencils. By Theresa Airey.

ber cement or other adhesives that could damage your transfer or the object you're attaching. Light Impressions and University Products sell some pH-neutral, removable tapes and adhesives that are worth exploring (see "Resources" on page 154).

You can also place three-dimensional objects on your transfer, which produces other elements, such as shadows and creative lighting. Then by photographing the montage, and even making another transfer of the photographed montage, you can expand the creative possibilities of this technique (see Peter Dazeley's work on page 122.)

Digital Manipulation

By scanning your transfer with a flatbed scanner and using such software as Adobe Photoshop, Adobe PhotoDeluxe, or Fractal Painter on Macintosh and PC computers, you open the door to further manipulation. You can choose from a wide variety of desktop scanners. These range from the relatively inexpensive Polaroid Photopad, to top-of-the-line, high-quality scanners that cost several thousand dollars. Another possibility is to output a digitally manipulated image from your computer to negative or transparency film with a film recorder, and then create transfers from that image. John Reuter inputs his original photographs with a Polaroid CS 500 scanner, manipulates the images in Photoshop, and outputs with a Polaroid CI 5000 film recorder onto 4 x 5-inch transparency film, from which he makes image transfers. Take a look at Reuter's work on page 138, as well as that of Diane Fenster on page 126.

If your final result will be under 5 x 7 inches in size or you don't need high resolution, you can use a small file of under 10 megabytes. Working with larger images imposes different requirements. Depending on your computer setup, you'll need a great deal of random-access memory (RAM), hard-drive storage capacity, and speed (megahertz, or Mg). Consult some of the many computer books that deal with the scanning, manipulation, and reproduction of digital images. You can also take a class or workshop to learn more. Online message boards are a good source of information as well.

If you don't want to or can't get involved with computer manipulation and output, service bureaus can scan, sharpen, manipulate, and output your transferred images. You can choose the output size and, with some service bureaus, the surface. Iris prints, which are high-quality, inkjet, process prints, are becoming popular with artists as a way of enlarging transfers and creating limited editions. New service bureaus appear all the time, so compare quality, cost, and service. (For more information about Iris prints and other outputting options, such as EverColor or UltraStable Pigment Transfer prints and Lightjet 5000 prints, see Chapter 7, "Fine Art and Commercial Applications," on page 101 and "Resources" on page 154).

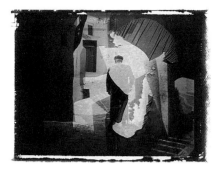

"Passage." 3¹/₄ x 4¹/₄ image transfer, with liftoff; an edge of emulsion didn't detach, producing a veil effect.

For Image Transfers Only

The following techniques are specific to image transfers. The creative possibilities of liftoff, manipulating wet emulsion dyes, and working with textures are quite exciting. Remember, these are just suggestions—starting points for your own explorations.

Too Much Emulsion Liftoff

This is one of the main areas of concern, especially among beginners. The more you perfect your technique, the less emulsion liftoff you'll have. The most common of the many possible causes and solutions are listed below. My favorite solution for reducing liftoff is peeling the negative off the receptor surface under water. If you're making a dry transfer, you'll still get sharp details. A tray of warm or cold water works. After developing, simply push the transfer under the water and peel. Make sure that you grasp the film corners because the paper end of the film might tear off.

Peeling the Negative from the Receptor Surface Too Quickly

Try a slow peel, remembering to fold the negative back over itself as you peel. Using a wide, plastic putty knife to peel the negative back over can help. If you see liftoff start, stop, and peel very slowly so the emulsion has a chance to snap back onto the receptor surface. Sometimes separating the stuck emulsion from the negative with an X-acto knife helps. You can also stop and start over, peeling from the opposite end of the negative.

Dry Transfers

Dampen the receptor surface with a spritzer and/or peel off the negative under water.

Not Keeping the Transfer Warm During Development

With wet transfers, keep the water around 100°F during the 1 to 2 minute development time; for dry transfers, use a warming tray or some other warm, flat surface. You might want to try a (nongreasy) griddle on the stove, or a piece of heated Plexiglas or a heated glazed tile. You can also use a hair dryer or, if you have nothing else, the palms of your hands.

Rough or Smooth Receptor Surfaces and Fabrics

Make sure that you've mastered your technique on hot-pressed watercolor paper before experimenting with other more textured surfaces.

Too Little Emulsion Liftoff

Once you're making technically perfect image transfers every time, you might want to get liftoff deliberately. Simply do the opposite of all the precautions listed in the preceding solutions for avoiding liftoff. One of the easiest ways to produce liftoff is to quickly peel the negative off its receptor surface after the negative has fully developed.

"Druid Temple of Leys." 3$^{1}/_{4}$ x 4$^{1}/_{4}$ image transfer, handcolored with pastel and Prismacolor pencils; liftoff on the standing stone would be hard to repeat.

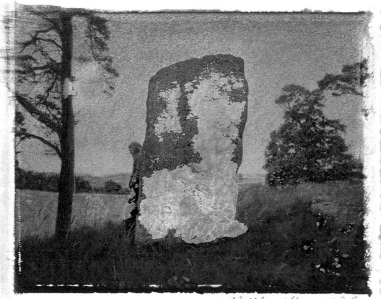

"Heliconia." 3$^{1}/_{4}$ x 4$^{1}/_{4}$ image transfer, illustrating both very slow and very fast peels.

Another surefire method to obtain liftoff is to make dry transfers. Don't wet the receptor surface before or during the transfer process. Another alternative is to let the negative develop onto the receptor surface without using heat. Both slick and heavily textured receptor surfaces tend to contribute to liftoff. By combining some or all of the above techniques, you'll get liftoff.

"Heliconia." 3$\frac{1}{4}$ x 4$\frac{1}{4}$ wet image transfer, rubbed with paper towel for faded look; handcolored with pastels and pencils.

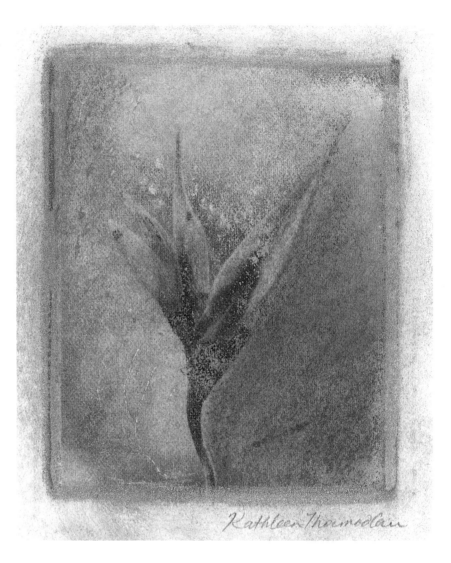

Kathleen Thormodlan

Manipulating the Emulsion

Once you transfer the image to the receptor surface, you can create liftoff or designs by scraping the wet emulsion with an X-acto knife. If you've made a dry transfer, you should get it wet first. This way, the emulsion will be gummier and more workable.

You can define the outline of objects fairly precisely with a steady hand. A cotton swab works well for rubbing the emulsion and for absorbing excess emulsion. By rubbing in the light areas, you won't get the turquoise liftoff color, but you can create highlights with cotton swabs. To lighten a sky or large area, hold the transfer under running water and rub lightly with a wet paper towel. If you want an old, faded look, rub lightly over the entire transfer with a dry paper towel. The transfer shouldn't be too wet. Alternately, after the transfer is dry, use sandpaper or steel wool to abrade some of the emulsion. To get finely scratched lines, work on the transfer with a pin or a sharp pointed knife when it is dry.

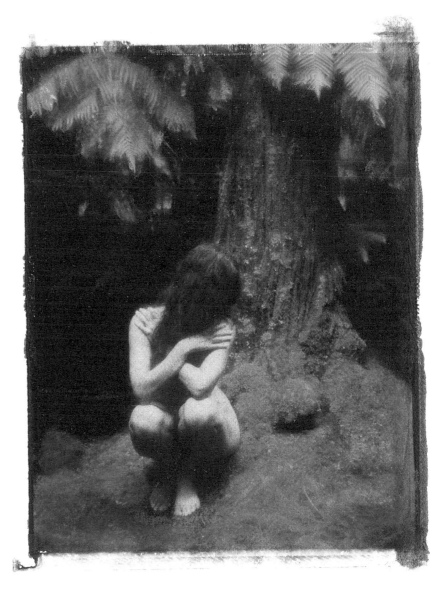

"Rainforest Nude IV." 4 x 5 dry image transfer, handcolored with pastel pencils.

"Rainforest Nude IV." 4 x 5 dry image transfer with liftoff.

"Rainforest Nude IV." 8 x 10 dry image transfer, rubbed with cotton ball and paper towel; lightly handcolored with pastel pencil.

Transferring onto Clothing

Many people ask about image transferring onto clothing. Photographer Patti Bose tested different fabrics to see how image transfers would hold up with cleaning. She discovered that washing removes the transfer and leaves stains from it in the fabric. And after Bose had a fabric dry-cleaned 20 times, little cracks appeared in the transfer. This produced a worn look that she didn't find objectionable. Of all the fabrics she tested, silk was the most durable. If you're planning to transfer onto clothing, I recommend not working with items that you wear frequently.

A better solution is to utilize the heat-transfer processes that copy centers, Kodalux, and other labs offer. These methods enable you to put your favorite image and emulsion transfers on T-shirts (or mousepads, hats, mugs, etc.). This process produces the best results because the colors are longer-lasting, and the resolution (dots per inch, or DPI) is finer. You can do this process yourself if you have a color inkjet printer. You can use

Photopad (an inexpensive Polaroid scanner that accommodates images up to 4 x 6 inches) or any other flatbed scanner to scan the transfer into your computer, manipulate it if you choose, and print it onto a heat-transfer paper. You can buy this paper in office-supply stores, through computer mail-order companies, and from the dealer who sold you your inkjet printer. Canon, Epson, and Hewlett-Packard inkjet printers work well, as do some others (see "Resources" on page 154). Try yours to see if it works.

Then once the image is on the transfer paper, simply iron it onto your shirt or pillowcase, for example. You can get more specific directions with the transfer paper or from the manufacturer of your printer. Keep in mind that you must flip or reverse the image in your computer; otherwise, when you turn the transfer paper over to iron on the image, it will be backwards.

Placing a Textured Surface Under the Receptor Surface

Try rolling the negative onto a receptor surface that you've placed on top of sandpaper, a screen, a doily, or some other textured object to give the transfer a unique look. This will require a receptor surface that is lightweight enough to let the texture show through, for example, thin papers or silk.

Placing Materials Between the Receptor Surface and the Negative

Before putting the negative on the receptor surface and rolling, try creating different patterns on the transfer by using various materials. Threads or Fiberglas strands, for example, block the transfer of the image wherever they're placed, leaving their white outlines visible on the transfer. Experiment, and keep in mind that this method might produce more liftoff.

Using a Microwave Oven

To get unusual and "scrambled" results, Christopher Grey suggests placing exposed Polaroid film in a microwave oven. Immediately after you make the exposure, quickly cut off any metal tabs or clips on the Polaroid material. Set the microwave on high power, and "cook" the film for 2 or 3 seconds. Peel the film at the end of the standard contact time, and transfer in the usual way. The results can be fascinating, but can't be duplicated (from his booklet, "Understanding the Polaroid Image Transfer Process," page 11).

For Emulsion Transfers Only

I really love playing with the following creative techniques for emulsion transfers. When I take the time to sense what the feeling of movement is in an image, I can easily expand and exaggerate that movement with emulsion transfers. Because this process is new, I don't have as many techniques to discuss as I do for image transfers. But I am sure that you'll discover your own as you experiment.

Cutting the Emulsion Before Removal from the Positive

During the process of making the emulsion transfer, the white border of the Polaroid print turns pink or blue, depending on the type of film. You can either cut the white border off the print or cut the print edges into a shape, such as an oval, heart, or triangle. I like to do this before I place the print onto the vinyl adhesive (Contac) so that I can leave approximately a ⅛-inch border of adhesive. Then if I need to submerge the transfer with tongs in the boiling water, I don't risk tearing the emulsion. Others prefer to cut the shape after applying the vinyl adhesive. You can also use an X-acto knife to cut into the image itself. During an emulsion-transfer workshop on Maui, one of my students, Ditmar Hoerl, tried a number of approaches, including slicing parallel lines across an image and then stretching the emulsion like an accordion while transferring it onto watercolor paper.

Stretching the Emulsion

The longer the emulsion stays in the cold water, the more it will stretch and expand. Keep in mind that as the emulsion stretches, it becomes thinner and more fragile. The light areas of an emulsion are thinner because they contain less dye than the dark areas, so you must be careful not to tear the emulsion in the light areas while you stretch it. If you unintentionally tear the emulsion, you can often repair it by moving the wet

"Armoire I." 4 x 5 emulsion transfer; print was sliced before being put into hot water, and torn while on watercolor paper.

emulsion on the receptor surface or acetate sheet to hide the tear, or by handcoloring the emulsion after it dries.

You can stretch either parts of or the entire surface of an emulsion. You can stretch the desired area in one direction to make the image longer or taller, or in all directions to increase its size. You can actually stretch a 4 x 5-inch image to 5 x 7 inches, and you can turn an 8 x 10-image to 11 x 14 inches if you are careful. You can stretch while the emulsion is floating in the cold water, or after it is on the acetate sheet or receptor surface. Remember, you can move the emulsion easily on a surface only if the viewing side is face up. If you've flipped the emulsion over, you'll have a hard time stretching or manipulating it without flipping it back, unless the surface is quite wet and/or slippery.

Wrinkling the Emulsion

This technique is a great deal of fun, and as you practice, you'll discover ways to create the effects you want. If you work on either the receptor surface or the acetate sheet, first get the overall shape you want by dunking the emulsion in cold water. After removing the emulsion with the receptor surface (or acetate) from the water, let the excess water drain off. If the emulsion is too wet, the wrinkling won't hold very well. On the other hand, if the emulsion is too dry, it will tear when you try to wrinkle or manipulate it. As you continue to make emulsion transfers, you'll learn what the best moisture level is.

"Bodo Cathedral, Norway." 4 x 5 emulsion transfer, wrinkled.

You can use your fingers to wrinkle the emulsion, but I find that I have more control when I use a wet cotton swab, especially with small emulsions. I can make delicate wrinkles or thick wrinkles, wiggly wrinkles or straight wrinkles. If I use two cotton swabs (or two fingers), I can push in opposite directions and make straight lines curve quite easily. When I hold the end of a cotton swab on the emulsion and twirl it, the emulsion forms a spiral-like twist in that spot.

Shaping the edges is also fun, and can really enhance the mood or movement of the image. I also like playing with the shapes of the borders (pink or blue). This accentuates and reinforces the feeling of movement and expression.

Tearing the Emulsion

The emulsion membrane can accidentally tear in the cold water or on the receptor surface when you've stretched the emulsion too far, or you can deliberately tear an area. Of course, the emulsion might not tear exactly as you planned, which gives you yet another opportunity to let go of your desire to control the creative process. Emulsion transfers, just like image transfers, seem to have a mind of their own. If you tear an image too much in the cold water, it might be hard to transfer because small pieces of emulsion tend to clump together and are difficult to unravel.

"The Sail." 4 x 5 emulsion transfer; emulsion stretched and torn with fingernails while on watercolor paper.

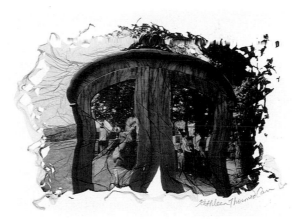

"Armoire in Field #2." 4 x 5 emulsion transfer, torn with fingernails while on watercolor paper.

"Ricqles Soda Can." 4 x 5 emulsion transfer. By Christophe Madamour.

I prefer to tear directly on the receptor surface or the acetate sheet after removing the emulsion from the cold water. I use my fingers to stretch it until its surface tears. Fingernails come in handy when you want to tear uneven or patterned edges, or to make the edges radiate out in pieces (see Brian Kavanaugh-Jones's work on page 132). One of my students developed a great technique of outlining the subject in the transfer with a knife and pulling the remainder of the transfer away slightly. This leaves a white border outlining the subject.

Folding Over the Edges

Another way to eliminate a square-edged look is to fold over one or more edges of the emulsion transfer onto itself. Simply grasp an edge of the emulsion transfer that is on the receptor surface or acetate, and fold it over. Another method is to let the transfer fold over on itself while you dunk it in and out of the water. This technique produces a double layer where the emulsion is folded, and can make prints of patterns and stripes interesting.

Placing More Than One Emulsion Transfer on a Receptor Surface

With this technique, it is important not to inadvertently pull up your first image when placing the second image side by side on the receptor surface. When you first try this, you'll find that waiting until the first emulsion transfer is dry simplifies the process. This is because the emulsion transfer will be firmly stuck to the receptor surface and less likely to be affected. You can use a spritzer to dampen the area of the receptor surface you need for the second emulsion transfer just before transferring. If your first emulsion transfer is still wet, don't put the receptor surface back in the water; if you do, your first transfer will float off.

The trick is to use an acetate sheet. Put the second emulsion on one corner of the acetate so that when you place it next to the transfer already on the receptor, the acetate doesn't touch or cover any of the first transfer.

Otherwise, the acetate could pull up the first image (see Ennio Demarin's work on page 124).

Layering Emulsion Transfers

Because of the transparent nature of emulsion transfers, layering them on top of each other, or on top of image transfers, photographs, artwork, etc., is more effective than layering image transfers. You can put an emulsion transfer, especially one that isn't too dark, over just about anything, and the underneath image will show through, except in dark areas.

You can layer emulsion transfers another way. First, gather a few finished emulsion transfers that you've applied to opaque receptor surfaces. Cut out the transfers, and then assemble several as a nontransparent collage (see Tina Williams's "Fractured Face" on page 111).

Emulsion Shattering

Developed by New Jersey photographer Tom Grim, emulsion shattering is a technique that uses dry ice to freeze the emulsion membrane. The emulsion is then shattered with a handy kitchen gadget. After removing the emulsion membrane from its paper backing in the cold-water tray, Grim places the emulsion onto a piece of plastic film wrap, such as Saran Wrap, that is larger than the emulsion. He then stretches or distorts the emulsion before freezing. He uses a 10-pound block of dry ice kept in a styrofoam cooler for a day's work. (Caution: handle dry ice carefully, and wear gloves or oven mitts to avoid frostbite.) A regular freezer won't get the emulsion cold enough; dry ice freezes to 60°F to 80°F below zero.

Next, Grim drapes the emulsion transfer over the dry ice with the plastic wrap face up. After about 60 seconds, the emulsion is frozen, and he carefully peels off the plastic wrap (without gloves or mitts). He starts at one corner, making sure not to touch the frozen emulsion itself. He then sprays a piece of hot-pressed watercolor paper with water and freezes it also. Grim places the frozen emulsion membrane onto the frozen watercolor paper and shatters the membrane with a small hammer, spoon, potato masher, or some other kitchen implement. The emulsion can be shattered into a few pieces or hundreds of pieces.

Since the emulsion can be left frozen for some time, there is opportunity to further manipulate the image and arrange the pieces. Grim freezes the blade of an X-acto knife (the emulsion would stick to a room-temperature tool), which he then uses to alter the image. Sometimes the emulsion looks frosted at this point. Once he's pleased with the image, he lifts the watercolor paper and shattered image off the dry ice and sets them on a countertop to thaw, which takes about 30 seconds.

Grim can manipulate the image even further while the emulsion is still wet. As it dries, it sticks to the watercolor paper. Grim doesn't roll the image with a roller and hasn't had any problems with air bubbles.

Hand-coloring Transfers

I think of this technique as a glorified "paint by number" on the transfer: the outlines and some colors are already there in each transfer, so all you need to do is fill in. You can stay within the lines or cover them up. You can handcolor so subtly that no one will know you've colored at all, or you can apply so much color that no one will be able to tell that there is a photograph underneath.

"Bolivian Mask." 4 x 5 image transfer, handcolored with pastels, watercolors, and Prismacolor pencils.

It is important to experiment with various handcoloring materials and methods in order to learn what works best for you. Once you know what you like, buy the largest selection of colors in that medium that you can afford. When I began handcoloring, I thought that 76 colored pencils would be more than I could ever want. But as my handcoloring became more developed, I realized that I was wrong. I find that the Berol Prismacolor 120 color set is much more satisfying for blending, matching colors, and all-around creativity.

Understanding Color Theory

Although unnecessary for beginners, eventually you might want to learn about color theory. Mixing color with pigment, which you use for handcoloring, differs greatly from mixing color with filtration, which requires light during the exposure of the Polaroid film. The three primary colors

You have many artists' coloring materials to choose from for hand-coloring your transfers.

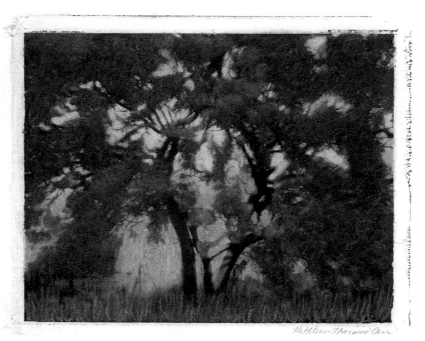

"Jacaranda Tree." 8 x 10 image transfer, double exposed in camera; handcolored with pastel pencils.

of pigment are yellow, red, and blue, from which you can mix all other colors. The three primary colors of white light are red, green, and blue, from which you can create all other colors.

Just to get started, it is important to understand something about complementary colors. On a pigment color wheel, two complementary colors sit opposite each other; examples of these are red and green, blue and orange, and yellow and purple. When mixed in equal proportions, complements create gray and muddy your colors. Placed next to each other, however, each makes its opposite color appear more vibrant. Some artists like to use complements instead of gray or black for shadows. Take a look at French Impressionist paintings to see how the masters handled light and shadow in terms of color.

The Best Time to Handcolor

Optimally, in most cases, you should handcolor an image or emulsion transfer after it is dry. You can apply watercolors with brushes while the transfer is wet, but the emulsion is still vulnerable and can be easily damaged. Emulsion transfers are, by their very nature, more colorful than image transfers, so you might not want to handcolor them. If you decide to handcolor an emulsion transfer, you'll notice that its surface is shinier than that of image transfers. This characteristic can interfere with the way some handcoloring media adhere to the surface (except watercolor and acrylics, which seem to work fine). So you can spray an emulsion transfer first with a reworkable matte fixative to give it tooth and texture, such as McDonald's Pro-tecta-cote 951 Retouch, which also offers ultraviolet

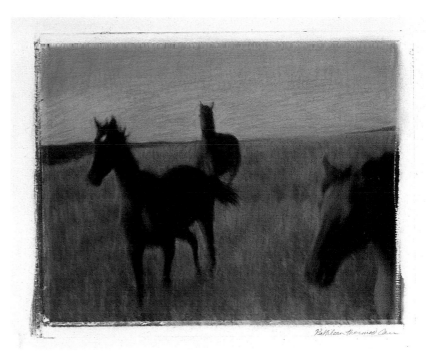

"Horses." 8 x 10 image transfer, handcolored with pastel pencils.

(UV) protection, or Blair's workable matte fixative. Be aware, however, that the colors sit more on top of the transfer when you use a protective spray first.

To try something different, handcolor the receptor surface before applying an emulsion transfer. With this approach, the colors show through the transparent emulsion and can look as though they're coming from within the subject rather than lying on top of it. Here, you'll probably want to choose a medium that doesn't wash off with water—although running colors could be an interesting effect to explore. Acrylics and permanent inks (once dry), oil pastels, crayons, and some colored pencils are stable choices for this technique. You can also color the receptor surface first for image transfers, but nonporous colors, such as crayons, will repel the dyes.

Handcoloring Media Options

Before you start handcoloring, if you plan to use more than one medium, you'll want to think about what you'll use and in what order you should apply the various media. Just as you can't mix oil and water, you can't combine some media, or, if you do, you have to put one down before the other. For example, you can't layer ink over oil. A general rule to remember is that you can apply oil paint on top of several media, such as ink and acrylic; however, if you place it under these media, the resulting artwork might look exquisite but won't last long. Never apply watercolor or any liquid-based medium over pastel. Also, pastel can cover colored pencil only if the layer of pencil isn't thick, hard, and waxy. If you have any

questions about the compatibility of various media, ask an expert at your local art-supply store.

The following discussion contains some of the standard media for handcoloring transfers and brands that I use or that other artists have recommended. The quality of artists' materials varies according to brand and grade. Student grade is usually the least expensive. Although working with the highest-quality materials possible is ideal, it isn't as crucial with transfers as it is with painting or drawing. You can buy sets that include from 12 to more than 100 colors, or you can purchase colors individually. Some of the most well-known and best-liked brands of artists' colors are Winsor & Newton, Sennelier, Rembrandt, Caran d'Ache, Lascaux, Liquitex, Grumbacher, Marshall's, and Golden (see "Resources" on page 154).

With regard to techniques, I've included two detailed step-by-step procedures, one for repairs and the other for handcoloring transfers. As with every step in making a transfer, handcoloring is easy, and there is no one correct way to do it. In time, you'll develop your own methods. Practice on your "throwaways," and, of course, let loose, and have fun.

Colored Pencils

Colored pencils are one of my favorite handcoloring media. I enjoy the feel of the pencil on the paper's texture and delight in the detail that I can achieve, especially on small transfers. I like soft, waxy pencils, such as Berol Prismacolor pencils, which facilitate blending colors more readily than hard pencils do. In addition, you can apply soft, waxy pencils more smoothly than hard pencils. Berol also makes a fine-point colored pencil called Verithin.

Because the membrane of an emulsion transfer is fragile, sharp pencils can easily scratch and chip the surface. So using a dull point and applying light pressure work best. Colored pencils are also useful for "repairing" areas of liftoff, white spots, and other blemishes. For example, you have an area of liftoff that you wish hadn't happened, and you think that the transfer is ruined. By selecting a range of colored pencils that match the colors of the surrounding area, you can fill in the liftoff area. Simply replicate the pattern around the area and blend the colors so that you can't tell any liftoff ever existed. Of course, practice makes perfect (see "Repairing and Handcoloring Transfers" on page 78). Students are amazed at what they can do to cover so-called mistakes.

Pastels and Pastel Pencils

There are two types of pastel: soft chalk and oil (see page 76 for information on oil pastels). Soft pastels and pastel pencils work well on transfers, especially on surfaces that aren't very slick. By using pastel pencils, you can get more control in small, detailed areas than you can with pastel sticks.

"Ti Leaves, Onomea Botanical Gardens, Hawaii." 4 x 5 image transfer, handcolored.

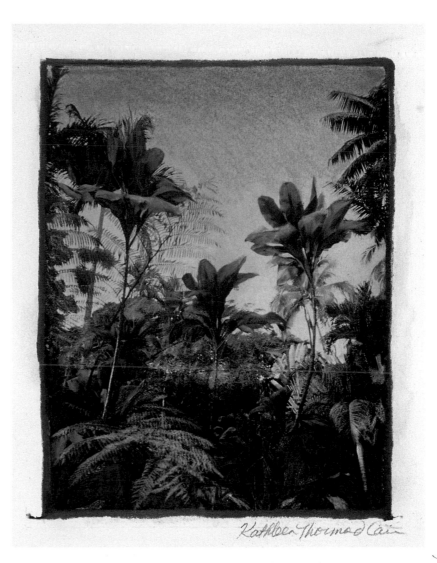

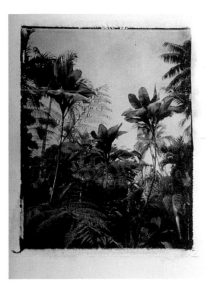

"Ti Leaves, Onomea Botanical Gardens, Hawaii." Original 4 x 5 image transfer.

Soft-chalk pastels blend best—the softer, the better. Extra-soft Sennelier pastel pencils, Rembrandt pastel pencils, and Schwan-Stabilo Carb-Othello pastel pencils are my favorites because they blend easily.

For large transfers, rather than use colored pencils, I ordinarily work with pastels or pastel pencils and blend the colors by rubbing with a cotton ball or cotton swab. The more I rub, the more color I remove. I can achieve a blended, subtly colored effect or a bright, chalky look depending on whether or not I rub some color off, and if so, how much. You can also use blending tools, called "tortillons." These are tight twists of paper that come in various sizes. When the end of the tortillon becomes dirty, simply peel that layer of paper away to get a fresh, clean end.

I can add layers of pastel if I want more color, or use a kneaded eraser to remove color. With a kneaded eraser, you can completely erase colored pencils and pastels if you don't like what you've done. By your folding in, or "kneading," the part of the eraser that picked up the color, the eraser

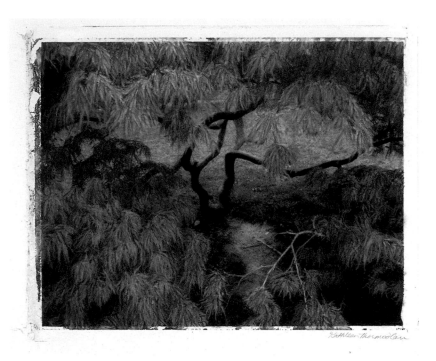

"Tree." 8 x 10 image transfer, hand-colored with pastel pencils to give original spring image an autumn look, as well as more contrast.

will last for years. When you color emulsion transfers, keep in mind that pastels tend to rub off of shiny surfaces more easily than matte surfaces, so you might want to use a matte fixative spray, such as Blair's workable matte fixative, before or after coloring with pastels.

Pastels and charcoal can smear when a transfer is unprotected, so I mat pastel work immediately. You can also cover the transfer with tracing paper or vellum, and then tape it in place for protection during storage. Occasionally I spray the pastel with Blair's workable matte fixative, especially on emulsion transfers, but sprays change the look of pastels, some more dramatically than others. If I like the coloring exactly the way it is, I tend not to spray pastels, and neither do some excellent pastel artists I know. Lascaux has been recommended as a good spray fixative that has minimal impact. Surprisingly, some charcoal and pastel artists use Aquanet hair spray because it, too, changes pastel colors less than other fixatives. Be aware, though, that its archival properties haven't been tested. I find that McDonald's Pro-tecta-cote ruins the blending of my pastel work, so I don't use it after applying pastels. (For more information about the presentation of pastel work, see Chapter 7, "Fine Art and Commercial Applications," on page 101).

Watercolors

Watercolors come in many forms, from traditional paint in tubes and pigment cakes for use with brushes, to watercolor pencils, crayons, sticks, markers, and inks. Gouache is opaque watercolor. The more pigment in watercolor, the longer lasting it tends to be. Watercolorists have told me

that Winsor & Newton professional-grade watercolor in tubes is generally considered the finest brand readily available in the United States. These artists also recommend Pelikan professional-grade watercolor, which comes in cakes.

For handcoloring with paint that comes in tubes, bottles, and pigment cakes, you have many styles and sizes of watercolor brushes to choose from. Use big brushes to apply diluted washes of color to skies and large areas. Another option is to wet the transfer first—the wetter the transfer, the more the edges of color will blur and run, and the less dense the color will be. When you handcolor a transfer that has dried, you can be more precise. For stronger color, don't dilute the paint with much water. Mixing colors on a palette offers a wide range of colors, even with a small set, although you can also mix color directly on the transfer.

With watercolor crayons and pencils, try starting with a dry pencil. Follow this step with a wet brush to blend the colors. Then rework the handcoloring with the crayon or pencil, if desired. Dry watercolor pencils provide more precise control for small details. Alternately, you can wet the tip of the pencil or crayon first and then color.

To remove color, use an absorbent material, such as a cotton swab, a cotton ball, or a paper towel to wipe up the wet watercolor immediately. After the transfer is dry, you can remove some of the color by carefully rewetting an area. This is possible because the surfaces of both image and emulsion transfers aren't as porous as watercolor paper, so the colors haven't been thoroughly absorbed.

Acrylic Paints

Plastic-based acrylics clean up with water while wet. More opaque than watercolors, acrylic paints will cover over a transferred image unless you use thin washes. You can dilute these paints with water, but this flattens the colors. A better choice is to dilute the paints with acrylic matte or gloss varnish. This is a thinned-down acrylic medium that enhances colors. Liquitex makes a medium-viscosity, concentrated acrylic color that you don't have to dilute. Golden's thin-viscosity fluid acrylics are even thinner, thereby making them a good choice to try with transfers. Both of these thin acrylics come in squirt bottles. Painters have also recommended Winsor & Newton and Grumbacher brand acrylics. To apply acrylic colors to transfers, try painting with a soft camel-hair or sable watercolor brush. Keep in mind that once acrylics dry, you can't rework them.

Oil Paints, Oil Pastels, and Oil Pencils

Like acrylics, oil paints are opaque. I prefer using Marshall's oils, which are made specifically for handcoloring photographs. Because these oil paints contain more pigment than oil paints made for canvas, you can use thinner washes to achieve greater transparency. You can rub off excess

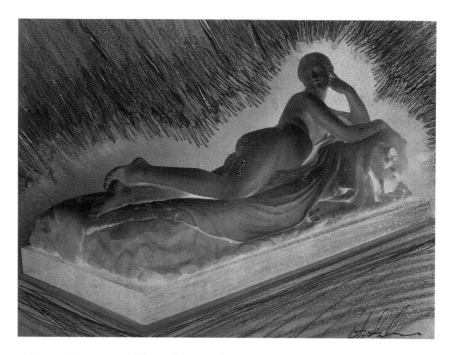

"Radiant Nude." 8 x 10 negative image transfer, handcolored with oil pastels and metallic inks. By Steve Sonshine.

color with cotton balls and/or swabs. And remember, a kneaded eraser provides another means for removing unwanted color.

A disadvantage to using oils is that even a thin coat of paint takes days to dry. Try to store a painted transfer in a dust-free environment, or stand it up vertically while it dries so that it doesn't collect dust. Before painting with oils or using oil pencils, Marshall's recommends that you coat the transfer with its Pre-Color Spray, designed to protect the paper fibers. Be aware, though, that traditional oil paints can rot the fibers of most papers and fabrics without some priming or precoating.

Oil pastels use oil rather than gum as a binder, which provides a rich, deep tone and a degree of transparency not found in soft chalk pastels. Heat softens oil pastels, so keep them in their original papers. Otherwise, they'll stick to your fingers. It is harder to blend oil pastels than soft pastels, although certain layering and scraping techniques produce interesting results. You can use oil paper, a textured paper coated with an oil-resistant primer, for emulsion transfers. Also, you can apply a clear-acrylic medium to either an image or emulsion transfer before coloring it with oil pastels.

Pen and Ink

Inks can be water-based, acrylic, or shellac-based. They are waterproof (usually acrylic-based), water resistant (meaning that a drop of water won't change the dried ink—unless the drop moves, and then the ink will smear), or will smear on initial contact with water. India ink, a heavily pigmented ink that comes in black and white only, is quite permanent once dry. Some water-based inks, such as Dr. Ph. Martin's Radiant

Concentrated Colors, have beautifully intense and brilliant colors. These are ideal for commercial work that will be printed immediately and when color is the most important factor. But these dyes are considered "fugitive"—they fade when displayed in UV light because they don't contain pigment. Dr. Ph. Martin's Hydrus line is pigmented, lightfast, and thin enough for use in technical pens.

You can apply inks in several ways. Technical pens with self-loading or prefilled cartridges are usually recommended. The Koh-I-Noor Rapidograph is a favorite technical pen of drafters. Heavily pigmented India inks might not flow well with technical pens' fine nib sizes, although they seem to work fine with crow-quill pens. Mastering these pens can be tricky, however, because they tend to drip and splatter and can't be stroked in all directions. Another option is to dilute inks and apply them with a brush.

A wide variety of colors is available for both permanent and water-based inks. Depending on what your needs are, other quality brands are Dahler-Rowney (acrylic-based, lightfast, and waterproof), Koh-I-Noor (water resistant), and Winsor & Newton (feathers on contact with water).

Felt-Tip Markers

These water-based or permanent markers have brush or bullet tips in various degrees of fineness for different effects. You can combine these markers with any other media. Be aware that colors might vary from brand to brand, so if you want a specific color, test first and then buy whichever brand has the shade you prefer. Dye-based, felt-tip marker colors are also regarded as fugitive. Eberhard and Berol make quality markers.

Fabric Paints

These paints are used primarily for image transfers on various fabrics. The paints, which are either water-based or acrylic, are opaque and generally stay on top of the material; this depends on the fabric used. It is important to wash the fabric first in order to remove any sizing. Deka water-based paint is a favorite among transfer artists because it is nontoxic, lightfast, and blendable, and can be washed and dry-cleaned. You can apply fabric paints with a brush, airbrush, stamp, or stencil.

Deka also makes a flowable "silk-technique" paint. Like dye, this type of paint is absorbed into the fabric and spreads. To control the spreading, use Deka's silk resist or hot wax for outlining shapes before you apply the paint. Deka paints need to be heat-set with an iron on the unpainted side of the fabric for 1 to 4 minutes. DecoArt acrylic fabric paints also come in a wide range of colors and styles, including iridescents, glitter, and metallic paints, none of which require heat-setting. Liquitex also makes good acrylic fabric paints.

Repairing and Handcoloring Transfers, Step-by-Step

I like to fix any blemishes, liftoff, or white spots that I find objectionable before handcoloring the transfer. I use colored pencils because they give me a great deal of control over details, and enable me to correct any mistakes with a kneaded eraser and start again. You can use any medium you feel comfortable with, including pastel pencils, watercolors, and spotting or retouching dyes. Keep in mind, though, that watercolors and dyes are less forgiving when you want to rework a repair.

Gather supplies needed

- Colored pencils
- Pastel pencils (or other preferred materials for handcoloring)
- Kneaded eraser
- Cotton balls
- Cotton swabs
- Pencil sharpener
- Magnifying glass or magnifying light
- Workable matte fixative (optional)

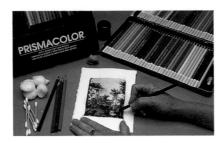

Repairing the Transfer

Adhere to the following step-by-step procedure for making repairs:

1. Choose a range of sharpened colored pencils that approximate the colors in the area to be repaired.

2. Starting with a pencil that is the closest match, lightly color in all or part of the area, imitating the pattern of shapes and colors of the surrounding subject(s). If you color with too much pressure, the pigment will get waxy and hard, and you won't be able to blend it with other colors. The technique for repairs is similar in approach to spot-toning photographic prints. You want to build up light layers of color until you get the effect you want.

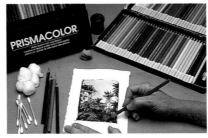

3. Alternate with the other colors, building layers of color. Replicate the existing pattern of colors as closely as possible. Once you get started, you'll be able to tell if you need to blend in more green, brown, or another color. If the color is the right shade but is too light, simply add gray or black to darken it.

4. View the result from different dis-

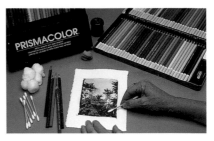

tances, including close up with a magnifying glass, and then add final touches. Rub the transfer with a cotton swab to blend if you notice pencil marks that you don't like. Penciled areas might be shinier than the rest of the transfer. You can spray the transfer with a workable matte fixative, such as McDonald's Pro-tecta-cote 951 Retouch or Blair's workable matte fixative, to dull the repair. If you're going to do further coloring, spray after you've finished. Follow the directions on the spray can. Spray outdoors or in a well-ventilated area. Also, don't spray if the humidity is more than 50 percent in order to prevent the lacquer solvents from penetrating the emulsion of the transfer.

Handcoloring the Transfer, Step-by-Step

Now that your transfer is repaired, you might want to be creative and see what effects color can have on the aesthetic quality of your transfer. Learning by doing is always a good idea, but you might be able to avoid some classic pitfalls via the following step-by-step procedures:

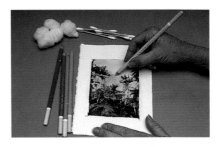

1. Start on large areas that contain very

little detail, such as skies. Use soft pastels or pastel pencils with light pressure to color in an area of the transfer, using either one color or blending two or more colors. The result will look like a preschooler's coloring job, but that is fine for now.

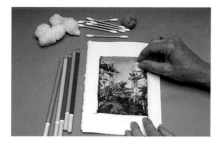

2. Rub the pastel with a cotton ball, moving away from the edges of the form being colored and being careful not to rub pastel into adjacent uncolored areas. The more you rub, the more the colors will blend, although less color will remain on the surface. Use a cotton swab or handmade, tiny toothpick swab for more controlled removal of color in a small area, and to retain more detail. Rework or add more color(s) as desired.

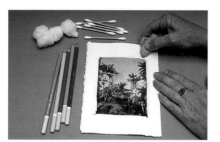

3. With a kneaded eraser, remove any unwanted color that spread into other areas or off the edges of the print. If you don't want to remove all the color, use a cotton swab instead.

4. Using either colored pencils or pastel pencils, begin coloring the rest of the transfer. On a flower, for example, the petals will look more interesting if you use several colors rather than a solid orange. Blend, adding layers of

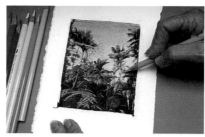

color and erasing with a kneaded eraser in areas you want to rework.

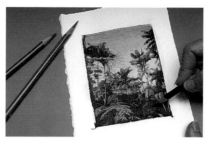

5. For shadows, use a color that is complementary rather than gray or black to give the colors life. Remember, complementary pigment colors are opposite each other on a pigment color wheel, such as yellow and purple, and blue and orange.

6. At this point, you can add a border with a metallic pencil, another colored pencil, or any other medium. If desired, rub the colors with cotton swabs for a more natural and blended look. Use a different cotton swab for each color so that you don't get muddy results.

7. View the transfer from different distances, and make any desired changes. You also have the option of spraying the transfer with a UV pro-

tective coating. Caution: If you think that you might want to use additional coloring at some point in the future, choose a workable matte fixative, such as Blair's. However, if you've handcolored with pastels or pastel pencils, be aware that any spray will change the look of the pastel, and to some extent will change even pencils (the look of watercolors, acrylics, inks, and crayons won't be affected). This is particularly true if you haven't rubbed off most of the pastel color.

Also, if you want primarily UV protection, choose a UV-inhibiting lacquer, such as Krylon UV Clear, which produces a glossy finish, or one of McDonald's Pro-tecta-cote finishes. (I don't recommend Pro-tecta-cote on pastel work; it has ruined the blending on a few of my image transfers.) You should experiment first on a throwaway transfer before risking your masterpiece.

Handcoloring several versions of the same image is a good way to explore a number of effects. When you compare your results, you might find that some types of images are best enhanced with pastels; these include portraits and landscapes. And other subjects, such as abstracts, become more interesting when you apply inks. You'll be surprised at how many different "personalities" or styles a single photograph can possess. The media used; the style of coloring you choose, whether realistic, impressionistic, primitive, or abstract; and your imagination all lend different moods to an image. In addition to the controlled effects and fortuitous accidents that transferring techniques lead to, many artists feel that handcoloring is a way of individualizing a transfer even further.

Further Explorations

Advanced Techniques: Equipment and Procedures

Once you master the techniques for making image and emulsion transfers with the Vivitar or Daylab Jr. slide printers, you might want to try equipment that provides more options. These include making large-size transfers and having the ability to crop your images. Perhaps you've decided not to invest in a slide printer at this time, and you would like to learn to make transfers with your equipment.

"Blue Mosque, Istanbul." 8 x 10 emulsion transfer; original image and sunset image sandwiched.

Whatever equipment you work with and whatever size images you create, the transfer processes are almost identical. What you now have to learn is how to apply the transfer techniques to the specific operating procedures for other equipment.

If you are a beginning transfer artist learning on an enlarger or slide printer other than the Vivitar or Daylab Jr. and haven't yet mastered transfer techniques, you should start by reading the step-by-step instructions for your equipment found in this chapter and in your owner's manual. Then review the basic step-by-step procedures for image and emulsion transfers in Chapters 2 and 3. (I'm assuming that if you have an enlarger, you already know how to use it and have a darkroom, and that you know how to operate your camera.) Whether you're using a camera, an enlarger, or a slide printer, I advise beginning with 3¼ x 4¼-inch Polaroid film if possible. It is more economical and simpler to use than other Polaroid films. So I often create a small version of a new image first to see if it has potential as a transfer before I work in the 4 x 5-inch or 8 x 10-inch size.

The Three Transfer Methods

This section discusses the three techniques for making transfers, including descriptions of slide printers other than those already covered. I describe features found on the slide printers, Polaroid cameras, and types of enlargers, as well as the advantages and disadvantages of each method to help you choose the most appropriate equipment for your needs.

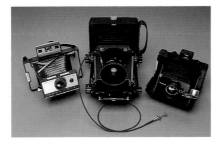

You can make in-camera transfers with either an old Polaroid model, a 4 x 5 press camera, or the current Polaroid Propack.

The In-Camera Method

This involves an in-camera exposure using a camera that contains a Polaroid film holder for peel-apart films, or a Polaroid back on another camera, such as a 4 x 5-inch or 8 x 10-inch large-format view camera. The advantage of the in-camera method is that you don't need any other equipment, such as a slide printer, or an enlarger and a darkroom. All you need is a Polaroid film holder as part of the Polaroid camera, or one that fits on the back of another camera. If you're making image transfers in the field, you'll need a 545 or 545i 4 x 5-inch sheet-film holder so that you can bring the film home and process it later. With a pack-film holder, you would have to carry all the necessary supplies with you.

On the other hand, you can make emulsion transfers at any point in time after you expose and process the positive print. In fact, you can create emulsion transfers years after you've taken the original shot. So field work for emulsion transfers is simply a matter of exposing the film and drying the positive prints before stacking and transporting them home. A drawback to using a camera is that the Polaroid negative is destroyed during the developing process for both image and emulsion transfers. As a result, you end up with only a single exposed image—unless you originally shoot numerous exposures of the subject.

Polaroid makes the Propack system for amateur photographers and the 600 SE for professionals. The Propack has a three-element fixed lens, automatic-exposure control, distance focusing, built-in flash-cube capacity, and an off-camera dedicated electronic flash unit. The 600 SE, a handheld instant camera, has two interchangeable lens options, 75mm and 127mm, as well as variable aperture and shutter settings, a tripod socket, a hand grip for electronic flash, and an accessory shoe mount. Both cameras use the 3¼ x 4¼-inch pack film, although the 600 SE can be modified to fit a Polaroid 545 or 545i back, which takes 4 x 5-inch sheet film.

Polaroid cameras that take the 3¼ x 4¼-inch peel-apart films have been made since the 1960s. The older, basic models have plastic bodies, although the metal-body cameras are the better ones in the 100 to 450 series. Model 360 is also a good choice. (The Propack is the current version of these cameras.) Older Polaroid professional camera models, which include the 180/195, are harder to find; however, conversions are being made from models 110A and 110B. These two cameras originally used a roll film that is no longer available. You can find these old Polaroid cameras at thrift stores, garage sales, and flea markets, and on online photography buy-and-sell message boards. The cameras require a slight modification in order to use a current model 523 battery, or you can order the standard battery from Polaroid. Fortunately, several companies specialize in reconditioning, conversions, and accessories for these old models (see "Resources" on page 154).

buy at Goodwins
619-291-5196

"Church, Crete." 4 x 5 image transfer, handcolored with gold Prismacolor pencil.

Polaroid film holders fit on the back of 4 x 5 and 8 x 10 view cameras, as well as on Hasselblads, Mamiyas, and Nikons, to name a few. But using one of these cameras limits you to that model's smaller image size. So if you have a 2¼ camera, the size of your transfers will be 2¼ x 2¼ inches. Polaroid makes a 20 x 24 camera, but it is only available for rent at Polaroid's New York studio, where you can make 20 x 24-inch image and emulsion transfers with the help of a studio technician (see "Resources" on page 154).

The Projection-Printing Method

This approach requires the use of an enlarger, a darkroom, and a 4 x 5-inch or 8 x 10-inch Polaroid film and film holder. One advantage of working with an enlarger is that you aren't limited to using 35mm slides or negatives, as you are with a slide printer. You can make transfers from whatever size film the enlarger holds. You can also selectively dodge and burn areas of the print to increase shadow and highlight detail, and you have increased ability to crop your image.

If you already have a darkroom with an enlarger, the only additional equipment you need is a Polaroid film holder for the size and type of film you wish to use, and a processor if you're working in an 8 x 10-inch format. Either a dichroic-color-head enlarger or a black-and-white, condenser-head enlarger will work for projection printing with transfers. (The color enlarger has a diffusion-head light source with dial-in color filtration, and the black-and-white enlarger uses a condenser to focus the light through the lens, thereby making an image with more contrast and grain than a diffusion head.) A cold-light enlarger is a black-and-white, diffusion-head enlarger. It isn't recommended for making transfers. This

unit emits a green, flickering light appropriate only for black-and-white printing. Transfer-suitable film must be exposed in complete darkness.

The Slide-Printer Method

This technique calls for using a slide printer, which exposes 35mm slides and negatives onto Polaroid film. The most popular models are the Vivitar slide printer, the Daylab Jr. slide printer, and the Daylab II modular slide-printer system. The other two slide printers that you might come across are the O & ER Proprinter and the Polaroid Polaprinter.

The O & ER Proprinter enables you to use all Polaroid 3¼ x 4¼-inch and 4 x 5-inch self-processing camera backs, as well as Graphlok 4 x 5-inch Polaroid film holders for sheet or pack film to make transfers. The printer offers either a cropped or a full-frame mode, flash exposure, and autoexposure with manual override. It operates on household current and has a filter drawer for gels.

The 8 x 10 Polaroid Polaprinter was the only slide printer available for making 8 x 10s, until Polaroid bases for the Daylab modular system were developed. The Polaprinter is similar to a Vivitar slide printer in that it offers flash exposure, manual-exposure adjustment, and a filter holder for using colored gels. The Polaprinter offers two cropping modes. The full frame creates black borders on the two longer sides of the transfer, and the 8 x 10-inch size crops off each end of the 35mm slide image. Remember, 35mm film has different proportions than 8 x 10-inch film. Unfortunately, Polaroid has discontinued the Polaprinter. You can, however, find secondhand models for reasonably low prices. (See "Resources" on page 154 for more information about Daylab, Polaroid, and O & ER slide printers, including where to order the equipment.)

"Nudes & Statue II." Two 4 x 5 emulsion transfers; double exposure gives figure-ground shift. Collaboration with Bill Graham.

Filtration and An Overview of Color Theory with White Light

Red, green, and blue, the colors found in light, differ from pigment colors. They also behave differently. The red, green, and blue wavelengths that make up white light are referred to as the additive primary colors. When you mix equal proportions of two additive primary colors together, you get one of three colors: cyan, magenta, and yellow (see chart).

These resulting colors are called the subtractive primary colors. They're used in color printing and color correction. The subtractive primary colors are the complements, or opposites on the color wheel, of the additive primary colors (see the color wheel).

You can make all colors by combining subtractive colors in different combinations and proportions. When you work with color filters, think of all the filters in terms of subtractive colors. In other words, you should consider the additive primary colors in terms of their component subtractive colors.

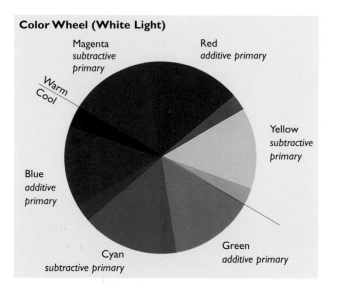

Color Wheel (White Light)

Magenta
subtractive primary

Red
additive primary

Warm
Cool

Yellow
subtractive primary

Blue
additive primary

Cyan
subtractive primary

Green
additive primary

Mixing Equal Amounts of Primary Colors

Additive Primary Color	Additive Primary Color		Subtractive Primary Color
Blue	+ Green	=	Cyan
Blue	+ Red	=	Magenta
Green	+ Red	=	Yellow

Complementary Colors

Subtractive Primary Color	Complementary Color
Cyan	Red
Yellow	Blue
Magenta	Green

When you want to adjust the color of your slide or transfer and see what effect the filter will have, look at the image through a set of color-correcting (CC) viewing filters. By looking through one filter at a time, you'll be able to see approximately how the colors will shift and to select the appropriate filter. To achieve a slight color change, use 10CC units. For example, you can use 10Y, 10M, or 10R to add warmth. To produce a moderate color change, use 20CC filters, and to get a strong color shift, opt for 40CC filters.

Color Correcting Filters

Warm colors

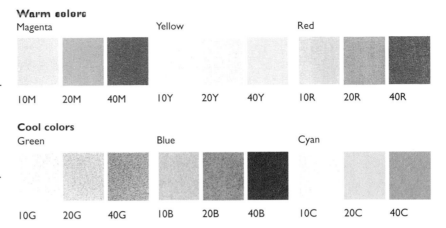

Magenta Yellow Red

10M 20M 40M 10Y 20Y 40Y 10R 20R 40R

Cool colors

Green Blue Cyan

10G 20G 40G 10B 20B 40B 10C 20C 40C

Color-Correction Filtration

Additive Primary Color	Subtractive Primary Color	Subtractive Primary Color
30 Blue	= 30 M	+ 30 C
20 Green	= 20 Y	+ 20 C
10 Red	= 10 Y	+ 10 M

Color-Balance Correction

If you want:	add:	or subtract:
- yellow	C + M	Y
+ yellow	Y	C + M
- red	C	Y + M
+ red	Y + M	C
- magenta	C + Y	M
+ magenta	M	C + Y
- blue	Y	C + M
+ blue	C + M	Y
- cyan	M + Y	C
+ cyan	C	M + Y
- green	M	C + Y
+ green	C + Y	M

Each of the three subtractive filters blocks out its complementary additive color. If you simultaneously used all three subtractive filters in equal proportions, any color would be canceled out and gray would be created. This is called "neutral density." Using only two filters at a time is recommended, unless you deliberately want to produce neutral density. Adding neutral density is necessary when you have to tone down an exposure that is too bright. This can happen, for example, when you projection-print with an enlarger to make transfers. Because Polacolor ER film is so much more sensitive than printing papers, you might require neutral density, in addition to a small aperture setting, to prevent overexposed transfers.

The Kodak Color Print Viewing Kit is an excellent way to understand this information visually (see Chapter 4, "Creative Techniques," on page 47). You can combine different effects and see how the colors interact. By looking at your transfer through the filters, you can see what effect the filtration will have on changing the color of the transfer.

Be aware that if you add a lot of color through the use of heavy filtration, you'll need to increase the exposure because of the additional density of the filters. When you work with a slide printer, increase toward the maximum exposure according to the amount of filtration you're adding. When you make the original image with a camera, you can opt for any of the screw-on lens filters available for the camera you're using. If you don't have through-the-lens (TTL) metering, use the filter factor for increasing the amount of exposure. (You can find information about filter factors in the literature that came with your filter in filter-factor charts in booklets or books about filters or photography.) By using filters for special effects, such as a starburst, soft focus, or a tone gradation, as well as colors, you increase your possibilities for unique results.

Some of the preceding information is found in Robert Hirsch's *Understanding Color Photography*, 2nd edition (Brown & Benchmark, 1993, pages 99-100).

Polaroid Polacolor ER 669, 559, 59, and 809 films are recommended for making transfers.

Large-Format Films

Polacolor ER and Polapan Pro 100 films are also available in 4 x 5-inch and 8 x 10-inch sizes for creating large-size transfers.

The color Polaroid films that work most consistently for both the image- and the emulsion-transfer processes are the family of peel-apart Polacolor ER films with Type numbers that end in "9." Balanced for daylight and electronic flash, the films have an ISO of 80 and produce a properly developed print in 60 seconds at 75°F.

Polaroid 559 Film This 4 x 5-inch pack film has 8 exposures per box for use with the Polaroid 550 4 x 5-inch pack-film holder.

Polaroid 59 Film This 4 x 5-inch sheet film has 20 individual sheets of film per box for the Polaroid 545 and 545i sheet-film holders.

Polaroid 809 Film This 8 x 10-inch sheet film comes in boxes of 5 and 15 sheets. The 809 negative film is packaged separately from the positive. An additional processing unit is needed for development (see "Special Procedures for Making 8 x 10 Transfers" on page 95).

Polacolor 64 Tungsten Film This film works for both transfer processes when you expose directly with a camera in tungsten lighting. It is available in the 3¼ x 4¼-inch pack-film and 4 x 5-inch sheet-film sizes only.

Polapan Pro 100 is a family of black-and-white, peel-apart films whose Type numbers all end in "4." Balanced for daylight and electronic flash, the films have an ISO of 100 and produce a properly developed print in 60 seconds at 75°F. You can use these films, as well as the sepia film (ISO 200), for black-and-white emulsion transfers.

Polaroid Polapan Type 54 black-and-white films come in a range of sizes, as well as the Type 56 Sepia 4 x 5 sheet film.

Type 554 Film This 4 x 5-inch pack film comes in boxes of 8 exposures and is used with the Polaroid 550 pack-film holder.

Type 54 Film This 4 x 5-inch sheet film comes in boxes of 20 sheets and is used with the Polaroid 545 or 545i film holder.

Type 804 Film This 8 x 10-inch sheet film comes in boxes of 15 sheets.

Type 56 Sepia Film This 4 x 5-inch sheet film comes in boxes of 20 sheets and is used with the Polaroid 545 or 545i film holder.

If you already have Polapan Pro or Sepia positive prints from previous shoots, you can use them for transfers or if you want to transform a color slide or negative into a black-and-white emulsion transfer, without first photographing it with black-and-white film. But transfers using Polapan films require a few modifications of the emulsion-transfer process (review Chapter 3).

Using the Daylab II Multiformat Slide-Printer System, Step-by-Step

Here, you'll learn the step-by-step procedure for creating 4 x 5-inch transfers with the Polaroid 550 pack-film holder and Polacolor 559 film. The Daylab II offers the most versatile way of turning 35mm originals into transfer images in all three sizes, 3¼ x 4¼, 4 x 5, and 8 x 10 inch. The Daylab II has many features that invite more innovative transfer work. These include:

• A modular system with a separate base for each transfer-image size

• The ability to use negatives, unmounted slides, and film strips without your having to cut them

• The ability to selectively crop or use a full-frame image (no full frame available in the 8 x 10-inch size)

• Dial-in filtration using the dichroic color head with up to 80 color-correcting (CC) units each of cyan, magenta, and yellow

• Automatic-exposure control with a broad range of manual-exposure adjustments

• The only slide printer option available for the 8 x 10-inch size

• The ability to make color-print enlargements from slides on Polaroid peel-apart films

The price depends on the modules you purchase. You can start with the 3¼ x 4¼-inch (size 3 x 4) system, and later get additional bases and film holders as you need them for different sizes.

The Daylab and Daylab II enlarging heads are identical, but the Daylab II is the system that uses Polaroid bases. Daylab also makes a selection of bases and chemistry for printing and processing conventional black-and-white and color prints from negatives and slides without the need of a darkroom. If you decide at some point that you want to make color or black-and-white prints without an enlarger and darkroom, you already have the most expensive part of the system, which is the enlarging head. The Daylab II slide printer comes with an instruction manual that supplements the step-by-step procedures discussed below.

Using the Daylab II, 4 x 5 base, Polaroid 550 film holder, and Polaroid 559 pack film
To make sure you understand the individual steps and the process as a whole, read completely through the following instructions before beginning.

Gather the equipment and supplies needed

• Daylab II slide printer with 4 x 5-inch base

• Polaroid 550 film holder

• Polacolor 559 film

• 35mm slide, negative, or film strip

• Appropriate transfer supplies for whichever process you're doing

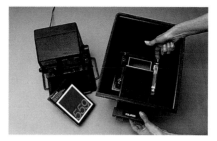

Attach the 550 film holder to the 4 x 5-inch base
1. Remove the enlarger head, and turn the base upside down.

2. Slide the two metal bars as far as they'll go in the "unlock" direction.

3. Place the film holder, with the white side of the dark slide facing down, in the opening.

4. Slide the bars to the "lock" position. The film holder will be held securely to the base. (Note: If you purchased the 550 film holder separately, spray-paint one side of the dark slide matte white, or call Polaroid for a replacement dark slide with a white viewing surface. This will enable you to position and focus your image.)

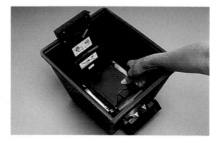

Load the 559 pack film
1. Open the Polaroid film holder.

2. Put the film pack in with the film facing down, handling the film carefully by the metal pack only.

3. Make sure all the white tabs are sticking out under the black safety paper.

4. Check to make sure that the rollers are clean. If they aren't, remove, clean, and replace them.

5. Close the film holder.

6. Pull out the safety paper.

7. Turn the base right side up with the film holder opening on the right, placing the enlarger head on the base so the orientation tabs snap into the locks on each side of the base.

Preset the timer

1. Plug in the power supply from the back of the enlarger head.

2. Press and hold the set button on the timer until the correct processing time is displayed. For image transfers, I usually start the timer when I fiinish rolling and place the negative and receptor surface on the heated water or tray for 1 to 2 minutes. I set the timer for 1 minute for color emulsion transfers.

3. To reset the timer to 0:00, press the "Start" and "Set" buttons simultaneously.

Put a 35mm slide in the slide carrier

1. Place the slide in upside down, with the emulsion (dull) side up and the shiny side facing down toward the Polaroid film. The image will appear backward when viewed on the white surface of the dark slide.

2. Make sure the slide is positioned horizontally, even if it is a vertical slide, or you'll get a square image.

To work with a negative or film strip

1. Insert the negative or film strip by turning the slide carrier over and centering the frame you want to print. Handle the film by the edges only. It is easiest to have the shiny side up because of the natural curl of the film.

2. Put the film sprockets under the two large tabs on the top horizontal side of the film carrier.

3. Using your thumbs on the bottom side of the film strip, push the film up until it buckles slightly. Be careful to avoid creasing the film by pushing up too far.

4. Make sure the sprockets on the bottom side of the film slide under the two short tabs. Let the film flatten.

5. You can also feed the end of the film strip into the tabs if your selected image is one of the last frames on the film strip. Practice with an unimportant strip of film first.

6. Insert the film carrier into the Daylab with the negative on top.

Set the "View-Off-Print" switch to "View"

1. Caution: First, make sure that the dark slide in the Polaroid film holder is pushed all the way in to prevent the film from being exposed. The viewing light will come on.

2. Open the previewing door on the front of the Daylab to see your image projected on the white surface of the dark slide.

3. Tip: It is easier to see the image if

no room lights are shining on it. Turn off the light or use a view-camera dark cloth to cover your head and the preview door. Also, if you have difficulty focusing, you might find using a magnifying glass helpful.

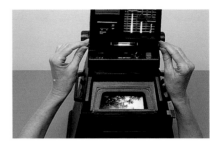

Align the slide or negative in the viewing area

1. To do this, move the carrier in the opposite direction you want since it is a mirror image.

2. Crop the image by turning the knobs located on each side of the enlarger head. Raise the enlarger head to increase the size for tighter cropping, and lower it to reduce the size of the image.

Focus the image

1. Turn the same knobs slowly in the reverse direction.

2. Once the image is enlarged, you can select any area to print by moving the carrier. What you see will be slightly larger than the resulting print. [Most viewfinders in single-lens-reflex (SLR) cameras give a preview of your exposed image that is 92 to 99 percent accurate.]

Set the "View-Off-Print" switch to "Print"

1. Choose color filtration if desired.

2. Use the three built-in color filtration controls, cyan, magenta, and yellow. They range in strength from 0cc to 80cc and increase in increments of 5. Combinations of any two colors

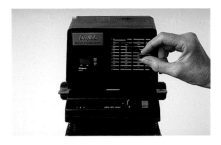

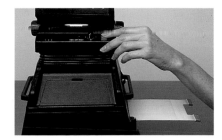

produce a wide variety of colors. The more filtration you use, the longer the exposure will be. You won't be able to see the color filtration in the viewer because the viewing lamp is different from the printing lamp.

3. Set the "Automatic Exposure" switch (ISO setting) to "1" for Polaroid 3¼ x 4¼-inch and 4 x 5-inch peel-apart films. Number "2" is used for extending the exposure times as needed (see below), and for working with Polaroid 8 x 10-inch peel-apart films. Number "3" is used when the additional color filtration calls for a longer exposure time with 8 x 10-inch film.

4. Caution: Don't leave your slide under the viewing lamp longer than necessary because heat from it can damage your slide.

Set the manual-exposure adjustment dial

1. For image transfers, turn the dial one increment above "0" in the plus (+) direction. For emulsion transfers, turn the dial one increment below "0" in the minus (-) direction. The exposure meter is similar to an averaging meter in a camera.

2. If you want your result to be lighter than average because your slide is dark or you don't want the meter to render your white snow a dirty gray, increase the exposure by moving the dial toward the plus (+) mark.

3. If you want the scene to be darker, move the dial toward the minus (-)

mark. Each line on the dial is equivalent to half an *f*-stop. You can add or subtract up to 2½ *f*-stops.

4. If you need more exposure than the maximum plus (+) setting will allow—because, for example, you've added a great deal of filtration or you're making a slide sandwich—try moving the ISO setting to "2," and set the exposure dial on the minimum minus (-) setting for starters. (If you want to measure exposure times to more accurately control the exposure, be sure the dark slide is inserted all the way into the film holder and the previewing door is closed. Press the "Start" button, and then time the exposure.)

5. Close the previewing door. Caution: Leaving the door open while exposing the film will fog and ruin the print.

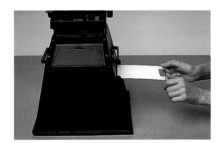

Pull out the dark slide

1. Pull it out until you can see the blue line painted on its underside. (You have to look under the dark slide.)

2. Tip: The first time you do this, mark two dots on the white side to make it easier to tell how far to pull out the slide in the future.

Press the "Start" button with a feather-light touch

1. If you press the button too hard, you could move the bellows and blur your exposure (there is no lock on the bellows setting). This turns on the

print lamp at an aperture of *f*/5.6 (the view light is at *f*/3.5 for brighter viewing). The automatic-exposure sensor times the exposure and turns off the light when the exposure is finished.

2. Make sure that the Daylab is stationary while the exposure is being made so that your image won't be blurred.

3. Push the dark slide all the way into the printer again after the printing light goes off.

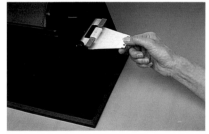

Proceed with making the transfer

1. If you're making an image transfer, follow the directions in Chapter 2; if you're making an emulsion transfer, follow those in Chapter 3.

2. Note: Because the film holder is on the bottom with the film facing up, the arrows tab will be underneath the white tab rather than above it (as it was on the Vivitar).

Projection Printing with an Enlarger

If you already have a darkroom with a diffusion- or condenser-head enlarger, you'll need a Polaroid film holder for the size film to be transferred. If you know how to make black-and-white prints, projection printing onto Polaroid film is easy. To crop and focus an image on a white surface when using the Polaroid 545 or 545i film holder, cut a white card to the size of the Polaroid 59 sheet film, or request a piece of white Plexiglas from Polaroid that fits into the film holder. (A piece of Plexiglas comes with the Daylab 4 x 5-inch base and film holder.)

If you're using the Polaroid 550 4 x 5-inch pack-film holder or the Polaroid 81-06 8 x 10-inch film holder for projection printing, you have to remove the dark slide from the film holder and spray-paint one side matte white first. Then you'll be able to crop and focus the image on a white surface.

You can't use safelights for two reasons. The Polaroid film is panchromatic and quite sensitive to light. So you must make the exposure in complete darkness. The best and easiest way to filter is with a dichroic color head, found on color enlargers. These offer up to 160CC units. You can use the colors singly or in pairs. Mixing three colors produces a neutral-gray density. As you increase the filtration, you must increase the exposure. For enlargers, do a test strip at various exposure times.

If you're using a condenser-head enlarger and you want to add filtration, you need to use gel filters. The 3 x 3-inch color-printing (CP) filters are a good choice for accurate color modification and fit in a filter drawer above the lens. The Rosco lighting gel 3 x 3-inch Cinelux sampler pack is also great for adding color (see "Resources" on page 154).

A suggested starting point for exposure is to make a test strip in 3-second increments, beginning with the settings that you normally use for black-and-white printing. Stop down a couple of stops so that you are in the $f/16$ to $f/32$ range ($f/16$ for 35mm, $f/22$ for $2^{1}/4$, and $f/32$ for 4 x 5-inch transparencies). For filtration, with a color-head enlarger start with 80 cyan, 85 magenta, and 50 yellow; for a condenser head, try 30 blue CC or CP filtration. Keep the exposure times the same to avoid variations in the reciprocity factor of the film. If the length of the exposure time changes, the color balance will shift. If the times and filtration remain the same, changing the f-stop will increase or decrease the amount of light needed because of the different size of the original slide or negative. The exposure will vary depending on the enlarger height; variation in bulbs, voltage, and lenses; and the color balance of various transparency emulsions. Polaroid films are more sensitive than printing papers and require less light, so you might need to stop down the enlarger lens aperture all the way, and possibly add neutral density through filtration so that the transfer won't be overexposed. One f-stop of neutral density equals 30 cyan, 30 magenta, and 30 yellow, so you can also stop down by using filtration.

Projection Printing with an Enlarger, Step-by-Step

The following step-by-step procedure applies to projection printing with a Polaroid 545 or 545i film holder and Polaroid 59 4 x 5-inch sheet film. To make sure you understand each step and its relationship to the entire process, read through the instructions completely before beginning the process.

Gather the equipment and supplies needed

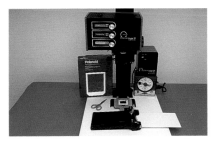

- Slide, negative, or transparency
- Diffusion- or condenser-head enlarger
- Polacolor 59 film
- Polaroid 545 or 545i film holder
- White Plexiglas or white card
- Enlarging timer
- Darkroom
- Appropriate transfer supplies for the process you're doing

Use the Polaroid 545 and 545i film holders in the same way

1. These holders work identically.

2. The 545 is shown in the pictures that follow.

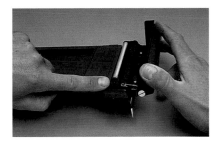

Clean the film holder

1. Before using the film holder, make sure the rollers are clean.

2. Open the roller cover by holding the sides and pulling upward to open the cover.

3. Disengage the hooks at the ends of the rollers. The top roller will lift up.

4. If the rollers are dirty, clean them with a soft, lint-free cloth or paper towel, dampened with water if necessary. Be careful not to scratch the rollers.

5. Clean the rubber light seal roller also.

6. Replace the top roller, engage the hooks, and close the cover.

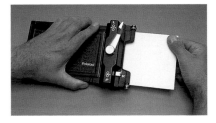

Slide a white card or the piece of white Plexiglas into the film holder

1. Put the control arm in the "L" (load) position.

2. Slide in the white card. Make sure that it is visible through the open side of the film holder.

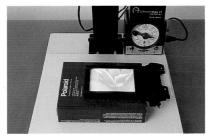

Crop and focus the image on the white area in the film holder

1. Brace the film holder in position under the enlarger so that it doesn't move. Tip: taping it to the enlarger base is a good method.

2. Remove the white card or piece of Plexiglas.

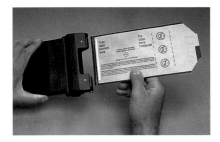

Insert the film into the holder

1. Hold the film sheet on the bottom middle edge.

2. Insert the film, cap end first, face up into the holder.

3. Make sure that the side marked "This Side Towards Lens" is visible through the open side of the film holder.

3. When the film is half way loaded, push it the rest of the way in from the end.

4. Make sure that the cap at the end of the film locks as the film snaps into place.

5. Check to verify that the tab ends show along the edge of the film holder.

6. Caution: While loading the film, don't push from the end of the film at the beginning because it might buckle. Don't press on the area marked "Do Not Press Here," where the developer pod is located.

Set the aperture, filtration, and timer for making a test strip
1. If you have a dichroic color head on the enlarger, dial in the filtration.

2. Otherwise, use CP filters or 3 x 3-inch Cinelux sampler lighting gels above the lens in the filter drawer.

3. You can also use CC filters between the lens and the film by screwing a filter holder onto the lens.

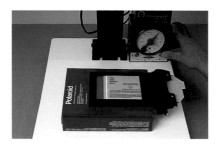

Expose the film
1. Turn out any lights so that the room is completely dark.

2. Pull out the paper envelope part way, with the control arm still in the "L" position.

3. Make sure that the film remains inside the holder.

4. Expose the film by first making a test strip with 5-second increments to determine correct exposure and filtration.

5. Slide the paper envelope back into the film holder.

6. Caution: To prevent a possible light leak, don't remove the envelope for longer than necessary.

7. Check that the "Do Not Press Here" area is flat. If you can feel the pod, the negative mistakenly came out with the envelope. Push the envelope in again, withdraw it, and check again.

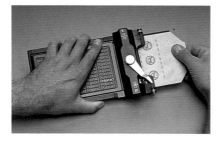

Remove the film
1. Switch the control arm to "P" (for "Process") position.

2. Pull the film straight out, at medium speed, with no hesitation.

3. When the metal cap reaches the rollers, you'll feel a slight resistance. Continue pulling. The film will be drawn through the rollers and will dispense the chemicals in the pods, thereby beginning development.

Processing the film
1. To process the film later, leave the control arm in the "L" position.

2. Depress and hold down the "R" (for "Release") lever while pulling out

the film. This will prevent the dispensing of the chemicals while you pull out the film.

3. When you are ready to process the film, reload the film with the control arm in the "L" position.

4. Switch the control arm to "P," and pull the film straight out.

5. Cut off the metal-cap end with a pair of scissors.

Processing the transfer
1. After the recommended processing time, peel apart the negative and positive.

2. Process the transfer normally.

Special Procedures for Making 8 x 10 Transfers, Step-by-Step

Peeling apart an 8 x 10-inch transfer is definitely thrilling, especially after you've worked in a smaller format. The adrenaline rush of knowing this piece of film is relatively expensive and you don't want to blow it contributes to the exhilaration that comes with a successful transfer. For image transfers, liftoff can be more prevalent with 8 x 10-inch image transfers, so master your technique before attempting this size. Evenly applied pressure is important, so you might want to get a larger roller or try a marble rolling pin. I use an ancient Kodak 10-inch, hard-rubber roller. I often peel 8 x 10-inch image transfers under water in the vinegar bath, thereby saving a step later. I start at one corner and peel back at a sharp angle to make sure that I get the least possible liftoff. But if your receptor surface might dissolve or is flimsy, as silk and handmade papers are, don't peel under water, and skip the vinegar bath.

I find that 8 x 10-inch emulsion transfers can actually be easier to manipulate. With smaller emulsion transfers, I can feel like I am all thumbs when trying to wrinkle and squiggle. Before making an 8 x 10-inch transfer, I usually make a smaller transfer first. This enables me to see if the slide or negative is suitable transfer material. Large-size transfers can be quite striking, but the size isn't suitable for all images.

Because the negative and positive parts of Polaroid 8 x 10-inch film are packaged separately, you need a special processing unit to bring them together. You feed the film through rollers that disperse the developing reagent chemicals evenly. Combine negative and positive sheets from the same box, or make sure the codes match. (The codes are printed on the tabs of the positive and negative.)

Two processors are available: the Polaroid automatic processor and the Calumet manual processor. In my experience, the Polaroid automatic processor, the more expensive of the two units, is more reliable. Sometimes my Calumet feeds only the negative through the rollers, thereby wasting a piece of film. The advantages of the Calumet are that it is compact and portable, and has a hand crank rather than using electricity.

The 8 x 10-inch Daylab II system includes an enlarging head, an 8 x 10-inch base, a 3 x 4-inch base, an 8 x 10-inch film holder (model 81-06), and a Calumet processing unit. If you already own a Daylab enlarging head, you can buy the 8 x 10-inch base and film holder separately. (Fortunately, you can buy secondhand film holders and processors, which, of course, are less costly.)

Using the Daylab II and the Polaroid Automatic Processor for 8 x 10 Transfers, Step-by-Step

To make sure you understand each step and its relationship to the entire process, read through the instructions completely before beginning the process. The Polaroid Automatic Processor, which runs on electricity, is a workhorse.

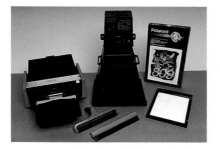

Gather the equipment and supplies needed

• Slide or negative

• Daylab II with 8 x 10-inch base

• 8 x 10-inch film holder (81-06)

• Polacolor 809 film (box of 5 or 15 exposures)

• Polaroid automatic processor

• Loading tray for processor

• Brayer roller

• Squeegee

• Appropriate transfer supplies for the process you're doing

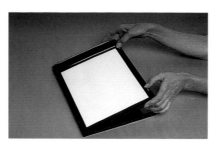

Loading the film

1. Place the negative film holder on a flat surface.

2. Make sure that the white surface of the dark slide is facing up.

3. Push the two blue buttons on the right side of the holder, and open it like a book. The orange tongue will be on the top right side.

4. Make sure that the felt strips are clean. Rub a finger back and forth along the strips to remove dust, or wipe them with the sticky side of masking tape.

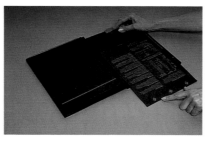

Place the negative film sheet on the right side of the open holder

1. Check that the film sheet is in its paper envelope and is between the blue lines.

2. Make sure that the three arrows on the envelope at the bottom are facing up, but pointing downward.

3. Slide the film and paper envelope down from the top so that the orange tongue catches on the underside fold of the envelope and you can't push down any farther from the top.

4. Caution: Don't pull the paper envelope out from the bottom or you'll expose the negative. The arrows on the bottom of the envelope should be showing, and the envelope edge should be sticking out about 7/8 inch below the holder.

5. Tip: Protect the film and film holder from strong light.

Close the film holder

1. Press the cover down firmly.

2. Make sure that both blue buttons are latched.

3. Place the holder on its side.

4. From the bottom end with the arrows, pull out the paper envelope slowly and carefully, leaving the film in the holder. The film should stick out about ⅛ inch on the bottom.

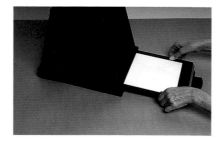

Slide the film holder into the base

1. Make sure that the white surface of the dark slide is facing up and that the negative tab is sticking out.

2. Slide the film holder all the way into the slot at the bottom of the Daylab II 8 x 10-inch base.

Set all the controls on the Daylab II enlarging head

1. The automatic-exposure switch should be on "2" because an 8 x 10-inch needs more exposure. If you're using heavy filtration, set the switch to "3."

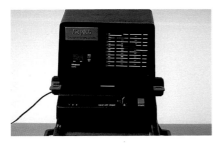

2. Select any filtration desired.

3. Turn the exposure dial to one increment above the "0" in the plus (+) direction for image transfers, or one increment below the "0" in the minus (-) direction for emulsion transfers.

4. Align the image in the viewing area by moving the carrier.

5. Crop the image by turning the knobs on each side of the enlarger head. Raise the enlarger head to increase the size of the image for tighter cropping, and lower it to reduce image size.

6. Focus the image by turning the knobs in the opposite direction than that used for cropping.

7. Turn the "View-Off-Print" switch to "Print."

8. Close the previewing door. (Caution: Leaving the door open while exposing the film will fog and ruin the print.)

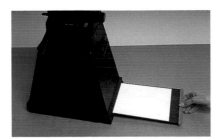

Pull out the dark slide
1. Make sure that you can see the

blue line on both edges of the dark slide.

2. Tip: To make it easier for you to see where to stop pulling the dark slide, make dots on the white area adjacent to the blue lines.

3. Make the exposure by pushing the "Start" button with a feather-light touch.

4. When pushing the dark slide back in after the exposure, make sure that the blue handle doesn't catch on the negative tab underneath and bend it. To prevent this, hold the tab down a little bit while pushing in the dark slide.

Remove the negative film holder
1. Pull back and hold the release lever at the bottom right front of the base with your left hand.

2. Put the fingers of your right hand, palm up, under the negative tab.

3. Grasp the entire negative film holder, and pull it out of the base.

4. Caution: Be careful not to pull just the dark slide.

Set up the Polaroid processor
1. Working in subdued light, fold open the top.

2. Make sure that the white button is visible at the right front.

3. Tip: Check that the rollers are clean (refer to the owner's manual for the cleaning procedure).

Insert the loading tray into the processor
1. Push it in as far as it will go.

2. Make sure that the flat narrow end is toward you. It will click into place.

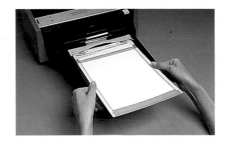

Load the positive film sheet into the processor tray
1. Slide the positive film sheet, pod end first and pod side face up, into the processor tray under the silver plate.

2. Continue sliding until you feel resistance.

3. Caution: Don't touch the surface of the sheet or press on the pod area. The edges will lie within the recessed area of the tray.

4. If you're making a wet or dry image transfer, prepare the receptor sheet.

5. Caution: Load the positive just before you are ready to process the film. A positive sheet lying face up for an extended period can collect dust.

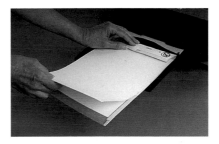

Working with image transfers only
1. If you choose, before completing the preceding step, you can first put the receptor surface under the pod area and on top of the positive sheet. This will produce an image transfer directly onto the receptor sheet. Then load the sheets together into the processor tray.

2. I find that 140 lb. watercolor paper works best; you can't use paper that is too thick.

3. Tip: The advantages to this method are that you don't have to separate the film (and lose some of the migrating dyes), and that you don't have to manually place the negative on the receptor surface and roll it with a brayer roller. The disadvantage is that you have to cut the receptor surface the same size as the positive (and negative), which might limit matting options later.

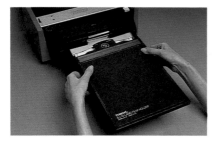

Place the negative film holder on top of the positive
1. Make sure that the white surface of the dark slide is facing down toward the positive sheet.

2. Check that the tab end is toward the processor; the yellow arrow should be facing up.

3. Make sure that the negative tab is straight, not bent or folded.

4. Insert the holder into the processor loading tray by pressing down while pushing the holder in, over the silver plate.

5. Push as far as it will go.

Multiple-step film processing
1. Push the white button on the processor.

2. Hold the button down for 1 second; when you hear a "clunk," the film has had enough time to go through.

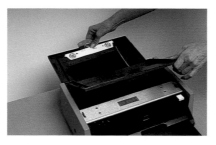

3. Lift the processing-compartment lid from the back. Take out the film by the tab end, holding the paper and not touching the film itself.

Working with image transfers only
1. After 10 seconds, peel apart the film quickly in one continuous motion.

2. Tip: Pulling diagonally from the non-tab end is the easiest method.

3. Caution: Be careful to avoid touching the excess chemicals. You can also cut off the tab end and peel. Also, don't bend the positive/negative sandwich: this can create an air pocket that will ruin your image transfer (see "Troubleshooting" on page 100).

4. Optional: After separating the film, cut off the non-tab end of the negative directly into the trash to dispose of the excess chemicals.

5. If you used the alternate method for image transfers (see "Working with image transfers only," step 1, on page 97), you don't need to separate the film. This is because the paper is already in contact with the negative.

6. Proceed as with small transfers.

7. Tip: If you're having trouble with liftoff, peel the negative off the receptor surface very slowly. I recommend peeling the negative under water in a tray of warm or room-temperature water, even with dry transfers.

8. Alternately, you can peel the negative off submerged in the vinegar bath, and then rinse the transfer for 3 to 5 minutes in running water.

Working with emulsion transfers only
1. Let the film process for 60 to 90 seconds before separating the film, depending on the room temperature, as directed on the black negative envelope (75°F-90°F at 60 seconds; 65°F at 75 seconds; 55°F at 90 seconds). You'll achieve the best results with a temperature of 70°F-80°F.

2. Tip: Pulling the film apart diagonally from a corner of the positive near the tab end is easiest.

3. Let the positive print dry before handling.

4. Continue as with the procedure for small emulsion transfers.

Remove the empty film holder from the loading tray
1. Push down on the ridged areas on each side of the holder.

2. Pull out the holder.

3. Caution: Don't try to lift up the film holder or remove the loading tray with the film holder in it.

Removing the loading tray
1. Do this once the printing session is finished.

2. Depress the tray at the raised oval in the center, near the processor end.

3. Pull the tray straight out.

Using the Calumet Processor
If you have a Calumet processor Model 150P, substitute the following instructions for the Polaroid automatic processor. This process is similar to the Polaroid process. The main difference is that you bring the film through the rollers by turning a hand crank rather than pushing a button. Be aware, however, that you can't include the receptor sheet with the positive.

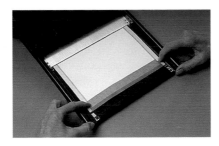

Open the processor to the extended position
1. Do this on a work surface that is at least 36 inches long.

2. Check that the rollers are clean before making each image (see the owner's manual for the cleaning procedure).

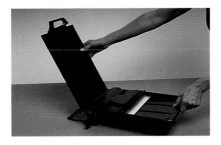

Insert the positive film sheet into the tray
1. Make sure that the pod end is first and the pod side is facing up.

2. Tip: Loosening the white flap covering the chemical pods on the positive sheet is helpful: the processor will be able to grasp the positive more easily when processing.

3. Slide the sheet in the processor tray under the silver plate.

4. Stop in front of the two small clips at the end of the processor.

5. Caution: Don't touch the surface of the sheet or press the pod area.

6. Pull the film back under the clips to the end of the processor. The positive will bow slightly.

7. Keep the film straight.

8. Tip: Once again, load the positive just before you are ready to process the film. A positive sheet lying face up for an extended period can collect dust.

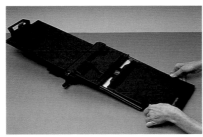

Place the negative film holder on top of the positive
1. Make sure that the white surface of the dark slide is facing down, and the tab end is toward the processor rollers. The yellow arrow should be facing up.

2. Make sure that the negative tab is straight, not bent or folded.

3. Insert the holder into the processor tray as far as it will go by pressing down while pushing the holder in.

4. If you're making a wet or dry image transfer, prepare the receptor surface.

Process the film
1. Place one hand firmly on the processor where it covers the rollers.

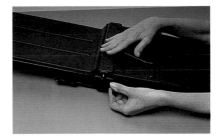

2. With your other hand, turn the crank briskly in the direction of the arrow (clockwise) for about four revolutions until you hear a "clunk." This indicates that the film is ready. The film will drop into the tray.

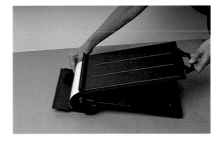

Remove the film
1. Fold the top end of the processor over.

2. Pull the film out.

Working with image transfers
1. After 10 seconds, peel the film apart diagonally.

2. Proceed with making the transfer.

Working with emulsion transfers
1. Process for 60 to 90 seconds as directed on the negative envelope.

2. Proceed with making the transfer.

Troubleshooting

I've found that 8 x 10-inch transfers, especially image transfers, can be far more difficult to do than smaller transfers. Besides liftoff being much more common, you need to fine-tune exposures more to each individual slide or negative. With practice, however, you'll discover that correcting potential problems becomes easier.

"Quan Yin." 8 x 10 image transfer, handcolored with pastel pencils.

Random white specks on the positive and negative

Dust on the positive sheet causes these specks. Also, the felt strips on the film holder or the loading tray might have collected dust. As mentioned earlier, you can remedy this problem by rubbing a finger back and forth along the strips, or by wiping them with the sticky side of masking tape.

A black line along one of the narrow edges of the image

The back flap of the negative envelope might not have been engaged on the orange tongue of the film holder. Another possibility is that you didn't pull the dark slide out far enough, so the film edge wasn't exposed.

The film assembly doesn't pass into the processor

If the negative tab is bent, sometimes the processor can't grasp it and pull it through. Another potential reason for this problem is that you might not have loaded the negative between the blue guidelines in the film holder. If you can realign the film in the dark, do so. Otherwise, the next time, make sure that you put the film in straight.

Only the negative passes through the processor

The positive isn't being grasped. Try loosening the white paper that covers the processing pods by lifting it up a little before loading the positive. If you're using a Calumet processor, try leaving about a ⅟₁₆-inch space between the end of the positive and the back of the recessed area.

Red color randomly appears on the positive and negative

Heat or oxidation of the film before exposure causes this. To avoid the first condition, store the film in a cool location. When storing an opened box of film, seal it in a plastic bag to help prevent excessive humidity or dryness. Touching the film during processing can also result in unwanted red color.

The slide or image is exposed onto the Polaroid film but the film is white

In addition to the reasons mentioned on page 35, you might have loaded the 8 x 10-inch negative backwards.

Long, "U"-shaped white area on the positive and on the image transfer

If you slightly bend the positive-negative film sandwich when cutting the top tab end to separate the positive and negative, you might create an air pocket that stops development in that area of the film. Peel from the non-tab end without bending the film to eliminate this problem.

Fine Art and Commercial Applications

Now that you've learned to create perfect image and emulsion transfers, you might want to go one step further: exhibiting your fine art or applying what you've learned to commercial work. This chapter explores what you can do with your transfers once they're finished.

"Turner Brioche." 4 x 5 emulsion transfer. By Christophe Madamour.

Photographers, artists, and art directors have found a growing number of applications for Polaroid transfers. Image and emulsion transfers offer an exciting, distinctive look for both commercial and fine-art uses, especially when combined with digital input and output possibilities. In terms of commercial applications, transfer images have appeared in fashion and product advertising, annual reports, books, magazine and CD covers, editorial illustrations, promotional materials, greeting cards, and posters. Today, photographic stock agencies represent transfer work, as well as conventional color and black-and-white photographs.

In the fine-art arena, Polaroid transfers are considered crossover art. They're recognized as both photography and mixed media, especially when the transfer has been manipulated, handcolored, or used as part of a larger piece with other media. Well-known galleries, museums, and private collections around the world collect and exhibit Polaroid transfer work.

The ability to digitally scan and input Polaroid transfers into a computer using Adobe Photoshop, Fractal Painter, or other software programs for additional manipulation and enhancement facilitates even more commercial and fine-art possibilities. Color separations can be made in a computer directly from scanned transfers for commercial offset printing as well. Digital output, such as Iris prints, EverColor pigment and dye prints, and UltraStable prints, enable photographers and artists to create fine-quality, limited-edition prints at sizes larger than the original transfer. In addition, creating a Web page and displaying your transfers online on the Worldwide Web opens up another vast area of opportunities.

Fine Art and Decorative Art

Polaroid transfers are an excellent medium for fine-art exhibits, as well as decorative art for the home or corporate environment. Because I've been focusing for the last 6 or so years on my fine-art work, I've noticed the increasing popularity of Polaroid transfers and other transfer media in the fine-art arena.

An economical and creative way to present transfers is to mat and frame them yourself.

Matting and Framing

Once you have your finished image or emulsion transfers, matting and framing is the most common method of display. Cotton rag or good, purified-wood-pulp mat boards offer the best quality and won't yellow or stain the artwork. These boards have an alkaline pH, which is necessary because the environment is slightly acidic and increased alkalinity defends against environmental acids. Strathmore, Crescent, and the boards available from Light Impressions and University Products, are well-known, museum-quality boards (see "Resources" on page 154).

Several relatively inexpensive mat cutters are simple to use and do an excellent job. These include the Alto E-Z Mat-Cutting System, Model 4501, which can cut any size mat, and the popular Logan 700 SGM, which is suited for cutting a high number of mats. You have two other alternatives as well. You can find and hire a person who cuts mats in quantity for a reasonable price. Ask other photographers and artists for recommendations. Another possibility is ordering pre-cut or custom mats from a mail-order catalog.

In order to mount the image or emulsion transfer on a backing mat board, I like to use clear archival corners, which are also available from Light Impressions and University Products (see "Resources" on page 154). I can then remove the transfer at any time without having to deal with adhesives, which can damage the artwork during removal. When the transfer is on handmade paper and I want to show the paper's borders, I have the window of the mat cut larger than the paper and mount the transfer with a neutral-pH, removable tape, such as Filmoplast P-90, two-sided tape, or thin artist's tape.

To create "Leaves," a 4 x 5 emulsion transfer, I printed a black-and-white negative on handmade paper and then mounted it on another sheet of handmade paper.

Pre-made wooden frames and metal or lacquered sectional frames are also available from numerous mail-order frame companies (see "Resources" on page 154). Be aware that quality and selection vary from catalog to catalog. Choosing glass or Plexiglas for your frame depends on several factors. Glass is heavier than Plexiglas and can break; however, Plexiglas scratches quite easily, collects a great deal of dust through static electricity, and costs almost twice as much as glass. Don't use Plexiglas if you've handcolored your transfer with pastels but you haven't rubbed off most of the color. This is because the static charge from the Plexiglas will lift up the pastel particles, and they'll cling to it. When I need to ship work, I frame in Plexiglas. When I deliver work in person, I use glass.

Protection

When you display your work, it is wise to protect the finished transfers to help prevent fading over time from both UV rays and damage from atmospheric pollution. If possible, frame your work with "Conservation Clear" or another UV-filtering glass. Window glass does filter out some UV wavelengths (up to about 325 nanometers, otherwise carpets and furniture upholstery would fade at a much faster rate). UF-3 or OP-3 UV Plexiglas filters out the highest number of UV rays.

You can also use UV fluorescent-light filters to cover tube fixtures if the work will stay in a particular room. All of these products filter out 92 to 98 percent of the harmful UV rays. They are available, along with many of the products mentioned in this section, from Light Impressions and University Products (see "Resources" on page 154).

You can use UV and other coatings to protect your transfers from atmospheric pollution, dust, and dampness.

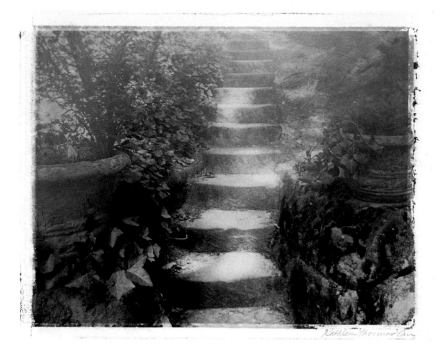

Spraying the transfer with a UV protective coating, such as McDonald's Pro-tecta-cote, Krylon UV Resistant Clear Acrylic Coating, or Golden Polymer Varnish with UVLS, not only minimizes the damaging effects of UV light, but also helps protect the transfer from moisture, scratching, marring, and smudging. Several coats of spray offer even more protection.

Suppose that you don't frame a transfer for some reason—because it is on a sculpture or ceramic piece, for example, or is part of a larger multimedia piece—or perhaps you want additional protection from dust, cigarette smoke, such environmental gases as paint fumes, moisture, wide fluctuations in humidity and temperature, or some other environmental pollution.

In both situations, consider using a varnish or another protective coating, such as art-grade acrylic or ceramic sealers made by Duncan and DecoArt, among others. With advances in technology, you have a wide variety of nontoxic, nonyellowing, clear varnishes to pick from. These varnishes are available in matte, satin, and gloss finishes. Some artists consider Krylon's Kamar Varnish to be the best, but Liquitex Gloss Medium and Varnish or Matte Varnish with a satin sheen are also excellent choices.

Longevity

Many people want to know how long Polaroid transfers will last—how archival they are. Most modern photographic color positive and negative films, print papers, and display transparencies are made with organic chromogenic dyes, which gradually fade when exposed to light, varying

temperatures, and humidity. These dyes also stain, fade, and exhibit color shifts in dark storage. Special processes that use more permanent azo dyes made from diazo compounds, such as Ilfochrome, have exceptional dark-storage stability and develop little or no stain, but will eventually fade in display light. Polacolor ER films are made with metallized dyes. While more permanent than organic dyes, they fade over time when subjected to UV light, but are as stable in dark storage as azo dyes and much more stable than chromogenic dyes.

When a color photograph is exposed to light, its rate of fading depends on the intensity of the light, the kind of light (daylight, tungsten, fluorescent, and the amount of UV present), the length of the exposure time, and the nature of the dyes in the photograph. Rich DeFerrari of Polaroid's Technical Assistance Department indicated to me that he has seen Polacolor ER prints last more than 20 years in normal lighting, which is almost comparable to C-prints. He also commented that strong-colored prints fade less rapidly than weaker-colored prints because "dye protects dye"—that is, the more dye there is, the less fading occurs.

This is an important factor in terms of Polaroid image transfers because their color palettes are more subtle than those of traditional prints. It would follow, then, that by your using saturated color slides for the transfers and by your ensuring that the maximum amount of dye transfers from your Polaroid negative, your image transfers will last longer. DeFerrari also noted that with emulsion transfers, since you use only the top image layer and throw out the layers in the paper base that contain all of the residue chemicals, he believes that the emulsion transfers would be more stable than regular Polacolor prints. Polaroid is conducting tests to determine whether this is true. Finally, DeFerrari commented that Polapan Pro 100 prints should last for many years in normal conditions (no direct sunlight, constant UV lighting, high temperature, or high humidity).

Polaroid's response to the question of how long transfers will last is that it is impossible to give a definite answer. A transfer's longevity depends on how archival the receptor surface is; how much dye is present on the transfer; how the transfer is protected, stored, and displayed; how intense the UV light is; and the amount of exposure. [For Polaroid's complete response, see its booklet, "Advanced Image Transferring" (1994, page 38)].

But most important is preventing the conditions that can damage transfers in the first place. Keeping them out of direct or indirect sunlight, using a UV-inhibiting spray, framing them with UV-filtering glass or Plexiglas, and rotating your artwork so that individual transfers spend some time in the dark are essential precautions that you can take. Since pigments are much more stable than dyes when displayed in light, hand-coloring with pigment materials would significantly increase the longevity of a Polaroid transfer wherever the pigment was applied.

"Bamboo II." 4 x 5 dry image transfer with deliberate liftoff, handcolored with Prismacolor pencils.

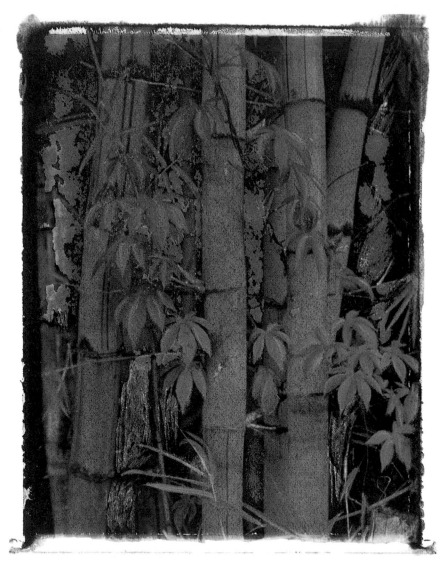

For maximum protection, you can also make two similar transfers from the same slide, and keep one in dark storage. Store matted or unmatted transfers in non-acid or acid-buffered boxes or containers in a dark, cool environment with constant temperature and humidity levels. Generally, I don't spray my transfers when storing them, only when I'm going to display or sell them. This is because I don't yet know about the long-term effects of nonyellowing lacquers on the transfer surfaces, and because they don't need UV or other protection when stored.

EverColor and UltraStable Pigment Transfer Prints, and Lightjet 5000 Digital Prints

If you need a truly permanent reproduction of a Polaroid transfer, you can try UltraStable and EverColor, which are two color processes involving pigments (instead of dyes) to make prints. This use of pigments results in a high-quality, light-stable print that you can safely display for

hundreds of years. To produce these prints, the original transfer is scanned into a digital system that creates electronic files from which four, full-size separation negatives are created. These high-resolution, 400 lpi+ (lines per inch plus) negatives are printed using cyan, magenta, yellow, and black (CMYK) pigment films, which are then laminated together to form the final color image.

EverColor Pigment Print

With an EverColor pigment print, your transfer is first scanned at a very high resolution and an Iris print is made as a proof. After you make corrections and approve the proof, four-color-separation negatives, CMYK, are output with a 400-line screen from a digital file. Each separation is exposed and handprinted onto its corresponding color pigment gel (cyan separation onto cyan pigment gel, etc.). Each gel is processed and laminated, also by hand, onto a polyester base and dried before the next pigment layer is exposed and applied. In addition, EverColor produces dye prints on Fuji Super FA5 paper, also made from color separations.

UltraStable Permanent Color Print

UltraStable prints are pigment transfer prints, based on the historic nineteenth-century carbon process that Charles Berger revived. These prints can be made by a professional lab on a variety of watercolor papers, which gives you the option of matching the receptor surface to that of the original transfer. You can produce your own UltraStable prints using the specially made, nontoxic pigment films (workshops, instruction, and a list of professional labs are available from the UltraStable Corporation; see "Resources" on page 154).

An additional benefit, as mentioned before, with having EverColor and UltraStable pigment prints made are that you can output to any size you choose, up to 40 x 50 inches. This is a great advantage for museum and gallery exhibits. You can also create limited editions of your transfers, each one identical, which is something you can't do with original Polaroid transfers.

Lightjet 5000 Digital Prints

Starting in January 1997, Cymbolic Sciences began shipping its new Lightjet 5000, a digital enlarger. The Lightjet lasers directly onto conventional photographic papers up to 50 x 50 inches from a digital file. Depending on which processor the lab owns, it can print on both type C papers, as well as Ilfochrome and Fuji Super FA5 paper. The advantage of using the Lightjet over conventional methods is in the control the printmaker has in matching. The printmaker has a host of electronic selective color tools when using a photo-retouching program, such as Adobe Photoshop. Ilfochrome and Fuji materials are the most light stable of the photographic papers available.

Aesthetically, prints from the Lightjet look precisely like conventional photographs, which would work well for reproducing Polaroid emulsion transfers. The Iris and UltraStable prints have a softer, more painterly feel since most are made on watercolor papers.

Iris Prints

The Iris printing process uses a high-resolution, digitally scanned file of your transfer and four-color, continuous-tone technology. You can choose from among a variety of surfaces, including watercolor papers, canvas, fabric, and vellums, for the receptor surface for an Iris print. Most printers stock up to 30 x 46-inch sheets and some stock rolls, allowing a longer length. The surface is attached to a rotating drum, and each color is sprayed onto the surface at a rate of 4 million droplets per second. After the finished print is removed from the drum, it can be coated with an archival coating.

The Iris printer was originally designed for color pre-press proofing and has been adapted for fine art prints. Three types of ink are available, each with its own advantages. The inks are dye-based, not pigment-based.

Although improved formulas for longer-lasting dyes and UV protective coatings continue to emerge, the Iris print can't yet compete with the pigment-process prints in terms of their archival capability. But a key advantage of the Iris print is its high resolution, which in essence approximates 1200 dpi (dots per inch). For the artist, this means that no other digital process—and many photographic processes such as C-prints—can compete with the clarity that an Iris print offers. Images to be printed in Iris must be scanned at no less than 300 dpi. It is better to have the print shop that is doing the Iris print do the scanning because the scanner, color tables, and printers are calibrated specifically for their system. Many service bureaus offer Iris prints but quality and cost vary, so do some research before choosing a service bureau (see "Resources" on page 154).

Color Laser Copies

With the improved quality of color laser copy machines, you can get a fairly close match of an original transfer in terms of density and color. Paper selection isn't great and much of it tends to be flimsy, but some copy stores print on 90 lb. matte or glossy paper stock. You can enlarge and make limited editions of your transfers inexpensively. The new Canon machines are superb, although the Xerox color laser copiers are also good. According to Henry Wilhelm, color laser copies can last up to 40 years, depending on display conditions (from *The Permanence and Care of Color Photographs*, with Carol Brower, Preservation Publishing Co., 1993, page 137). People in the fine-art field have mixed feelings about using color laser copies as fine art, as well as about how much an artist should charge for one.

Mondavi Advertisement, Bottle and Music. 8 x 10 image transfer. By Charles Shotwell.

Commercial Applications

Around much of the world, professional photographers have been using Polaroid image and emulsion transfers in commercial assignments. For commercial photographers, Polaroid transfers offer a unique and competitive option to conventional photography. They provide a new, innovative approach to what might otherwise be an everyday subject.

With the increased use of digital scanning, accurate color separations and printing can more closely match the color and density of the original transfer. The best results come from scanning the transfer as reflective art (which is any artwork that light can't pass through, as opposed to a transparency).

But this kind of scanning can't be done if the paper is too thick to wrap around a high-end scanning drum. Transfers on thin paper might buckle and need to be flattened to avoid distortions in the scan. A transparency copied from an original transfer generally contains more saturated dye hues and is preferable to a C-print made from copying the original transfer onto color negative film.

Product Advertising

Transfers used for product advertising in the United States range from those created for Carl Zeiss, Inc., a surgical microscope manufacturer, photographed by Scott Kriner, to Charles Shotwell's work for Starbucks Coffee, Neiman Marcus, and a Mondavi Wine advertising campaign. Working abroad, Christophe Madamour of Paris, Peter Dazeley of London, and Emilio Brizzi of Holland have created striking, distinctive product advertisements with emulsion transfers (see the Gallery section on page 112 for more examples of their work).

Fashion Advertising

Fashion photographer Patti Bose finds that images transferred on silk and other fabrics create effective advertisements. Photographer Jose Picayo used a series of image transfers for a Bloomingdale's campaign.

Other Media Applications

Book, magazine, album, and CD covers offer a broad range of possibilites for image and emulsion transfers. Tina Williams, hired to create a CD cover for a rock group, photographed the band members' facial features as seen from different perspectives using colored gels, and created a collage using emulsion transfers of the photographs (see page 111). Chicago-based photographer François Robert provided several HarperCollins textbook covers, and Lynette Zeeng has created image transfers for the covers and interior images of two best-selling cookbooks in Australia, as well as for advertisements for the Sydney Opera and posters, bags, and cards for a clothing line.

"Couture, 1992." 20 x 24 image transfer. By Patti Bose.

Stephanie's Seasons Cookbook Cover. 8 x 10 image transfer. By Lynette Zeeng.

Greeting Cards

Greeting cards featuring Polaroid image transfers have become quite popular. Amy Melious and others have created beautiful, compelling imagery for card lines, posters, and framed prints, some of which are sold through The Nature Company. Melious also uses image transfers for commercial portraits (see page 136).

Corporate Use

When a corporation wants to accentuate the personal aspects of its company and employees, using the distinctive qualities of image transfers for an annual report lends a feeling of warmth. Other annual reports utilizing image transfers suggest a fine-art look. Emulsion transfers, on the other hand, can accent dynamic and expansive qualities.

Whatever the use—fine art, digital, commercial—Polaroid image and emulsion transfers are making inroads in the way photography is viewed and appreciated. Polaroid transfers have opened up a whole new avenue for the presentation of photographic images. Many photographers who come to my workshops indicate that they felt stuck in their work, and that photography didn't seem inspiring anymore. After a one-day transfer workshop, these people became excited about the possibility of photographing new images, and of going through their old work to recreate images as transfers. Image and emulsion transfers are a great way to breathe new life into old images, or give a fresh perspective to seeing.

Sydney Opera Poster. 4 x 5 image transfer. By Lynette Zeeng.

"Fractured Face 1996." 4 x 5 emul-sion-transfer collage. By Tina Williams.

My hope is that you, too, will find new excitement about your photography and art, and about the myriad directions that Polaroid image and emulsion transferring can take you in. You'll find more to discover each time you set up to create transfers.

Use this book as a reference. When you begin, as with any new skill, the important task is to master the basic technique. After you have your technique down, look through the book for ideas and directions that spark your interest. The Gallery section, filled with outstanding transfer work representing some of the top transfer photographers and artists in the United States and Europe, is designed to stimulate even more ideas and serve as inspiration. Remember, there is no correct way to create transfers—there is only the way you do it, as you develop your individual vision and style. Explore, experiment, and you'll find it is impossible not to have fun!

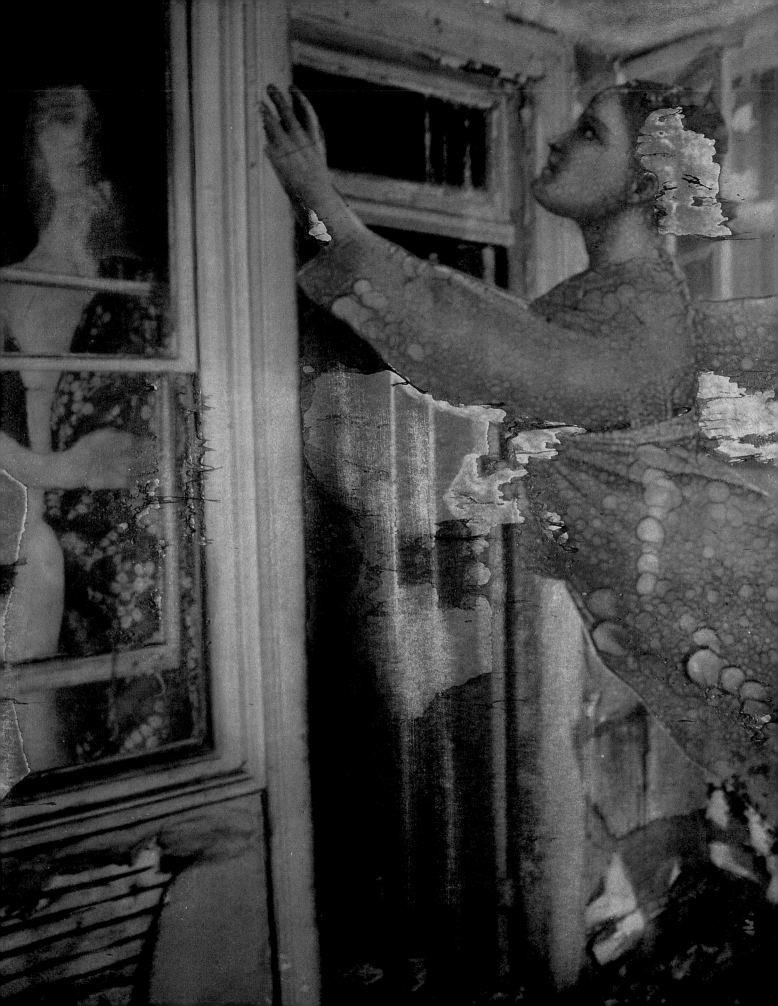

Gallery

The artists whose work appears in this book come from around the world, and their image- and emulsion-transfer work represents a wide variety of styles and subject matter. Some of them are well known and well published, some exhibit principally in the world of "fine art," and some have used transfers innovatively within the commercial arena. One of the photographers is a young art student with a creative flair for incorporating transfers into mixed-media pieces.

For each photographer, I selected work that I believe will encourage your explorations with image and emulsion transfers. Many of the photographers' efforts beautifully illustrate the techniques and concepts covered here. But the photographers' work also goes one step further, beyond technical manipulation and into the realm of pure inspiration. You might begin by trying some of the techniques each photographer describes in the statements that accompany the transfers, and then soar from there into a flight of fancy of your own design.

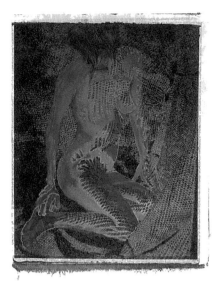

"Lady in a Web." 8 x 10 image transfer, made from 35mm copy slide of pulled, solarized, image-transfer Polaroid 809 negative.

Theresa Airey

Theresa Airey uses images with an "old-world" feel for her image transfers, with compositions that hint of something eternal, boundless, or ancient. When working with nudes in her image transfers, she looks for flow and rhythm, which the use of fabrics enhances: "I believe the negative is only a starting point for the fine-art photographer. The darkroom is the key to best express the power behind the image. I choose my paper, developer, and printing technique to suit the body of prints on which I'm working."

For Airey, the image-transfer process is a powerful medium of photographic expression because she feels it transcends the boundaries of printmaking, painting, and photography. "The photographer can impart his or her emotions to the print," she says, "enhancing the mood or altering

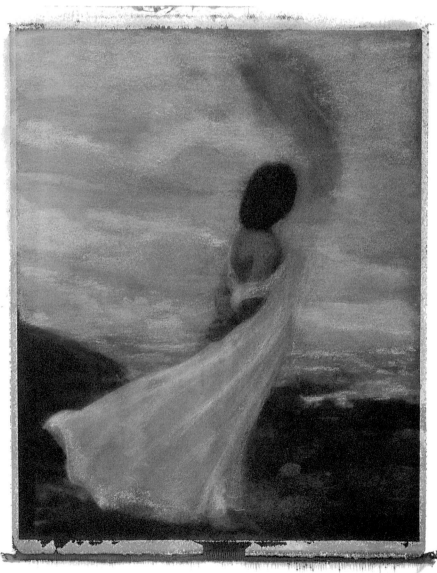

"Dawn." 8 x 10 image transfer, made from slide sandwich; handcolored with Conte pastel pencils.

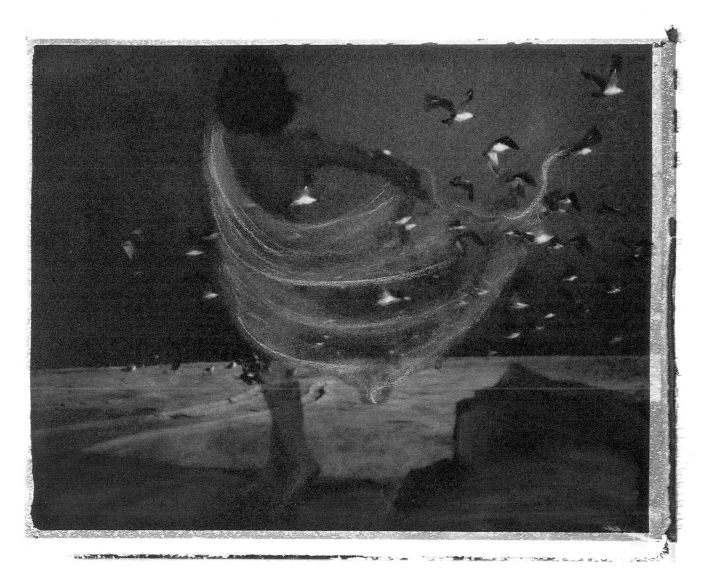

"Origins." 8 x 10 image transfer, made from slide sandwich; lightly enhanced with Conte pastel pencils.

it altogether through the use of color." The receptor material is, for her, as important as the image that becomes a part of it: "These factors give the finished transfer tremendous psychological impact."

If the scales of Airey's selected image transfers are suitable for enlargement, she has the transfers digitally scanned and has very large Iris prints made on 300 lb. to 600 lb. artist papers. The surface texture of the receptor paper is also enlarged; this becomes an important visual part of the image, especially if it was scanned from a small transfer. This new digital technology, coupled with the image-transfer process, enables her to work within both traditional and state-of-the-art printmaking processes.

Airey's work has been exhibited internationally and is represented in prestigious private and public collections worldwide. It continues to be featured in photography magazines, such as the new *Photo-Technics*, *Photo-Op*, and *Camera*. Her book, *Creative Photo Printmaking*, was published by Amphoto Books in January 1997.

"Portrait of Young Girl, 1994." 8 x 10 sepia-toned image transfer.

David Aschkenas

While at Penn State University in the 1960s, David Aschkenas realized that he wasn't destined to be a filmmaker. He lacked the patience required for the processes of scriptwriting, filming, editing, selecting and adding music, and so on. And after months of work he realized that without a movie projector (video cameras weren't available), he couldn't even show his finished product. Then in 1973, as Aschkenas watched a friend process and print a photograph in a home darkroom, he realized that it was possible to take a picture, develop the film, and make a print in one day. "I was hooked," he says. "Reading every photography book I could get my hands on, I studied technique and monographs on the great masters." Photography soon took up all of his free time. Aschkenas explains:

During my first year of taking pictures, I entered the Nikon International Photo Contest and, to my surprise, won second prize. I was awarded a Nikon camera and lenses along with my engraved silver medal. In 1975, I began teaching photography at Pittsburgh Filmmakers. A few years later, I began teaching college-accredited courses. In 1980, I was awarded a National Endowment for the Arts grant, and my work (done exclusively in the SX-70 format) was purchased and supported by the Polaroid Collection.

In 1982, I began a freelance career. To say that I had a slow start would be a gross understatement. I didn't know the difference between editorial and studio work, and my portfolio consisted of fine-art work. Art directors often inquired about purchasing prints for themselves, but were terrified to give me an assignment. Slowly I began getting commercial assignments, while still pursuing my personal work. Today, most of my photographs end up as Polaroid image transfers or emulsion transfers. My favorites are image transfers made from black-and-white prints, filtered to create sepia tones with either cool green or purple shadows.

Generally, I use the image-transfer process recommended by Polaroid. I use 809 film exclusively, and trim the Arches watercolor paper and feed it through the processor rather than peeling and rolling the negative onto the watercolor paper. I expose the Polaroid film with a Polaprinter using a 30 magenta filter. The print is cleared in a bath of hot water and white vinegar for about 2 minutes, then washed and hung to dry.

To create emulsion transfers, I use a coffeemaker to heat the water. After about 5 minutes in the hot water, the emulsion is ready to peel. I apply the emulsion to a dampened sheet of watercolor paper, which enables me to slide the emulsion around until it suits me.

"Woman in Museum, 1995." 8 x 10
blue-toned emulsion transfer.

"Ray in Car With Kitten, 1994."
8 x 10 sepia-toned image transfer.

"Man With Pigeons, France, 1994."
8 x 10 sepia-toned image transfer.

"Archer, 1992." 8 x 10 image transfer on silk, handcolored.

Patti Bose

Classic and surreal at once—these terms best describe Patti Bose's Polaroid image transfers. A fine-arts and fashion photographer based in her own studio in Orlando, Florida, since 1981, she transfers images onto fabrics, such as heavy silks, broadcloth, knits, and denim. Bose explains: "I start with a transparency, and projection-print with an enlarger. I expose the image onto Polaroid 809 film and run the film through an 8 x 10-inch processor. Then I place the separated negative on fabric, and burnish it to make a transfer." She discovered that 100 percent natural fibers (cleaned of all additives and conditioners) absorb the emulsion, while fabrics with polyester or acrylic fibers repel it.

Bose prefers to use light-colored silk, which offers the most clarity and visual appeal. She soaks the silk in water, then spreads it out on a hard, flat, smooth surface, such as wood or Formica, to make sure that the material stays flat. From this point on, the transfer process for silk is the same as that for paper.

After Bose's transfers dry, she sometimes uses Deka fabric dyes to add a sheen to their surface and to fill in areas of detail. To mass-produce an image, printers can wrap silk transfers around a printing drum and scan from originals. "Just make sure your printer stretches the silk so the image isn't distorted," she advises. The technique is well suited to her work for the fashion industry.

Bose, who has a Bachelor's degree from Florida State University, says her fine-arts background has helped her develop a steady stream of new ideas for the technique. Her photographic sensitivity also contributes to her success: "I like a model's personality to show through. I try not to tell them what to do." And about her own approach she says, "It's best when you can play."

Many of Bose's clients, which include Revlon, AT&T, and the Southern Ballet, grant her a great deal of artistic freedom. Her poster for Mothers Against Drunk Driving (M.A.D.D.) won a Clio award in 1989. The same year, she won the One Show Merit Award for a poster created for the Florida Film Bureau.

Bose has been thinking about creating image transfers on glass, balsa wood, and other surfaces. "If you're willing to try," she says, "it's endless what you can do."

"Tutu's, 1990." 8 x 10 image transfer on silk, handcolored.

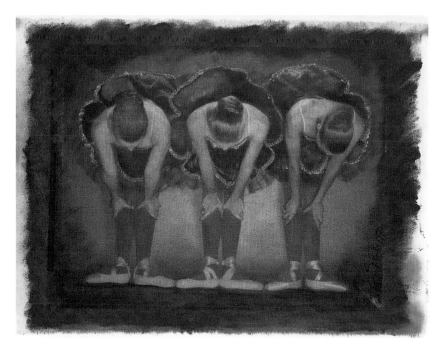

"Porcelain in Window, 1992." 8 x 10 image transfer on silk; manipulated emulsion.

"Black Woman, 1996." 8 x 10 image transfer with liftoff.

"Blue Hands, 1996." Emulsion transfer; original shot on 4 x 5 black-and-white negative film; negative reproduced on Polaroid 35mm Polablue (high-contrast, graphic) film; slide then exposed onto Polaroid 59 film to make emulsion transfer.

Emilio Brizzi

Born and raised in Italy, Emilio Brizzi moved to Holland in 1988 and has been working in his Amsterdam studio since 1991. He learned photography as a studio hand and later as an assistant to commercial and industrial photographers. Today, he combines commercial work for advertising agencies with personal and experimental work. Much of Brizzi's private work involves an unconventional selection of materials; he often uses Polaroid films. His interest in art history and painting influences his photographic style. As Brizzi explains:

> I don't have a message or something literal to say. My work is more about a personal idea of beauty. Beauty to me is the aesthetic revelation of ideas. Every photograph begins as an intuition, a purely visual thought. Then I work to make the picture, and things find their own direction along the way. By the time I'm finished, the photograph doesn't necessarily look like the original idea.

Because of their pictorial quality, transfer techniques have great appeal for Brizzi. He also likes the colors and softness typical of Polaroid films:

> A transfer tends to look interesting in itself, and, therefore, it is easy to abuse this technique. Its growing popularity is possibly the biggest threat to its validity. However, once we get used to the transfer "look," the images will have to be strong to stand out.
>
> The real challenge of this technique is not so much learning how to do it, but gaining understanding of its aesthetic potential. Learning and sharpening one's aesthetic feeling is a lifelong commitment. The power of photographs to reach visually sensitive people and convey emotions is great. I believe that the best photographs were as revealing for those who made them as for the rest of us who view them. An element of magic and surprise is always there.

"Portrait of Saskia, 1991." Image transfer on old, yellowed paper.

"Pomegranates, 1993." Emulsion transfer on watercolor paper; original shot on Polaroid 809 film.

"Three Apples, 1993." Emulsion transfer on watercolor paper; original shot on Polaroid 809 film.

"Laura Ashley Cosmetics, 1994." Soft-focus emulsion transfer.

Peter Dazeley

Peter Dazeley is a London-born international photographer, based in his own large studio complex off the New Kings Road in London, England. A self-taught photographer, he shoots in all formats and specializes in producing creative images for advertising agencies and design companies. His work includes still lifes, cars, fashion, and people, photographed both on location and in his studio. Always looking for new ideas to excite art directors, Dazeley began using the emulsion-lift transfer technique several years ago. He describes the method:

> The technique itself, although very simple, involves an extreme amount of patience and skill. Most of my subjects are shot with a 10 x 8-inch Sinar P2 camera on 809 Polaroid film. The emulsion layer is then removed from its backing paper. The key is removing the emulsion in one piece; once removed, the emulsion is extremely delicate and can be easily broken. When the emulsion is free, it can then be transferred onto any of a wide variety of materials.

Dazeley's emulsion-lift transfers have won awards in England and the United States and have been featured in such magazines as *View Camera*, *Communication Arts Photo Annual 1994*, *Popular Photography*, *British Journal of Photography*, and the Polaroid magazines, *Test* and *"P"*.

"Sweetcorn, 1993." 8 x 10 emulsion transfer; original shot on Polaroid 809 film.

"Dancer and Lights, 1994." 8 x 10 emulsion transfer; original shot on 2¹/4 black-and-white negative film; print copied onto Polaroid 809 film.

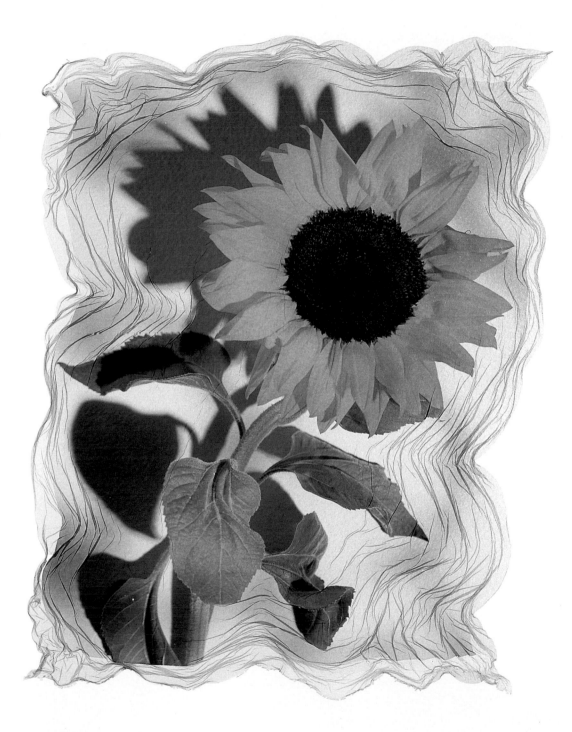

"Sunflower, 1996." 8 x 10 emulsion
transfer; photomontage.

"Portrait of Nadia, 1995." 50 x 70cm emulsion transfer.

Ennio Demarin

Ennio Demarin lives and works in Trieste, Italy. Many of his images have been published in European photography magazines, including *Zoom, Fotographia,* and *Progresso Fotografico,* as well as exhibited in galleries. His "I Pesci (The Fish)" series earned him the Prix de la Fondation Kodak-Pathe at the International Photographic Research competition in Royan, France. The Georges Pompidou Center in Paris has requested his portfolio, and the European Polaroid Collection recently acquired one of his works.

Demarin has devised two emulsion-detachment techniques. The first calls for a basin of boiling water, in which he dips a developed Polaroid positive until the emulsion layer detaches itself from the paper backing. This takes about 5 minutes. By this time, the water has cooled enough for him, wearing rubber gloves, to dip the receptor surface in the basin, being careful not to damage the delicate emulsion. With the emulsion in the water, he can stretch, smooth, and flatten it, or arrange it into the desired shape and then place it on the receptor surface.

The second method uses a basin of hot water at a temperature of 60°C (140°F). After dipping a Polaroid positive in the water for about 5 minutes, Demarin detaches the emulsion with a spatula, working from the edges toward the center, as if he were removing old wallpaper. Once again, the water has cooled enough so that, with rubber gloves on, he can reach into the basin. This technique requires more care than the first method. Demarin can recompose the emulsion on the receptor surface either in the water as described above or out of the water, being careful not to tear the emulsion. During both procedures, though, he mustn't cool the water until the emulsion is loose.

Demarin allows the emulsion transfers to air dry, and then mounts them on 5mm-thick cardboard with broad margins. The sizes of his finished works are generally between 70 x 100cm and 100 x 140cm. He combines three, five, or eight 20 x 25cm transfers in order to create larger images. He explains:

> One of the interesting aspects of this technique is that the creation of the image doesn't end with exposing the film. I'm fascinated by the uniqueness of each work, the possibility of reinterpreting it, and the manipulation of images without using tools. Part of the aesthetic pleasure comes from planning the final result when taking the original photograph.

Demarin is also excited by the expansion and tearing of the emulsion. "By accentuating the folds, I reach the depth, light, and shade necessary for creating the final image," he adds. For Demarin, detachment and recomposing are essential steps that go beyond technique and influence his sphere of creativity.

"Male, Female, 1994." 70 x 100cm emulsion transfer.

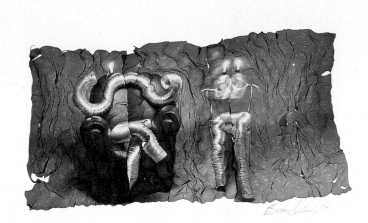

"Red Wood, 1994." 70 x 140cm emulsion transfer.

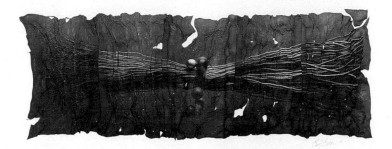

"Japanese Poppies, 1992." 70 x 100cm emulsion transfer.

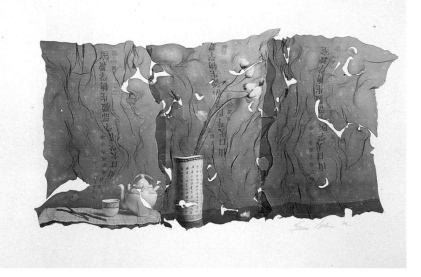

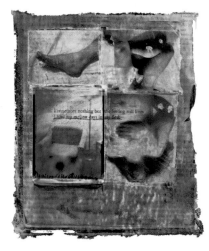

Canto Three/Circumstantial Evidence

Diane Fenster

Diane Fenster's juxtaposition of seemingly unrelated visual elements reflects her interest in the Dada and Surrealist movements. She digitally manipulates image transfers with her computer and groups together several of them in the tradition of photomontage. The result suggests an emotionally charged relationship between the disparate images. "This methodology enables me to present an almost 'cinematic' storyline based on the relationship of each of the vignettes within a particular piece," she says. Fenster experiments with different types of image processes for her original photographs as a way to find her own voice. She explains:

> There is an odd contradiction in my work in that I'm attempting to create personal images that relate both to the collective unconscious and the process of individuation while using advanced industrial technology. I'm hoping to move beyond some of the current hard-edged approaches to computer art, and to present both in image content and color a world in which the borders aren't so well defined. Here is where the technology excels in providing me with a way of crafting dream-like sequences that seemingly float into each other, overlap, and merge, reflecting the inner processes I'm attempting to portray. My desire is for the viewer to be unaware that the art was created on a computer.

Fenster is attracted to both the spontaneous, one-of-a-kind quality and the handmade look of Polaroid image transfers, which are the bases of her montages. She calls herself a "modern alchemist, using silicon chips as a tool to transform electrical patterns into art."

Residing in Pacifica, California, Fenster creates both fine art and illustration. Her fine art combines her own 35mm photography, video, still video, and scanned imagery. Her illustration style is an outgrowth of the explorations she has taken with her personal work, and her commissions range from editorial to advertising, to creating pages for the Internet's Worldwide Web.

Fenster has exhibited internationally, and her fine-art images appear on many CDs and in numerous publications, including the monograph, *Metamorphoses: Photography in the Electronic Age* (Aperture). Her work was exhibited at the Siggraph 95 Art & Design Show, and she is a guest lecturer at many seminars and conferences. Fenster has created and maintains two Web sites where she presents her work.

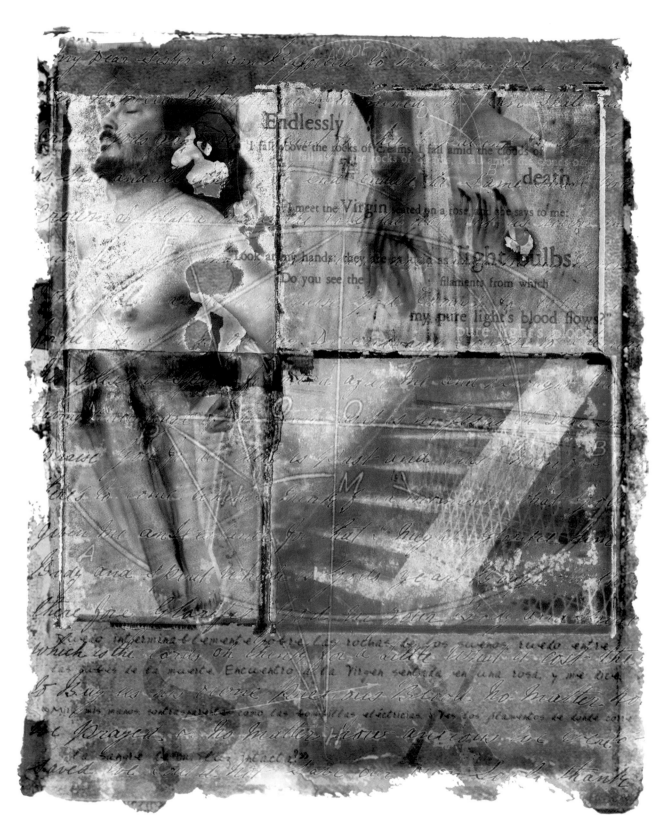

Canto Six/In the Shadow of the Cathedral

Dewitt Jones

Dewitt Jones has had a long career in the arts. As a motion-picture director, he had two films nominated for Academy Awards before the age of 30. Many years as a freelance photographer with *National Geographic* earned him a reputation as a world-class photojournalist. His photographic work is well known in the corporate world and in advertising campaigns for such clients as Dewar's Scotch, Nikon, and United Airlines. He has published seven books and writes a monthly column for *Outdoor Photographer* magazine. He holds a Bachelor's degree in drama from Dartmouth College and a Master's degree in filmmaking from UCLA. Over the past several years, Jones has been working extensively with image and emulsion transfers and SX-70 Time-Zero manipulation. He recalls:

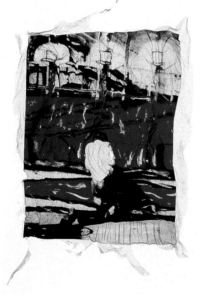

"Midway." 4 x 5 emulsion transfer of an SX-70 manipulation.

> It started slowly, watching my partner make one beautiful image transfer after another (see Lynette Sheppard's work on page 140). Her interest in transfers led me to try SX-70 manipulation. My fascination with that technique—which now borders on a sublime addiction—allowed me to turn my photographs into paintings. My personal work was already headed in this direction, and so it became an elegant next step. Using an SX-70 camera, I photograph images directly onto Time-Zero film. I also rephotograph my 35mm slides onto Time-Zero film.
>
> Much as I enjoyed SX-70 manipulation, I was frustrated with the hard edges surrounding each image. Then when Lynette and I began working with emulsion transfer, things began to really open up. I found I could manipulate the final shape of the image, moving it far beyond the rigid photographic shape. Layering emulsion images added yet another dimension to the process. Rephotographing my SX-70 images onto Polaroid 59 film and turning these into emulsion transfers gave me images that truly redefined the way I looked at photography.
>
> My son's involvement in image manipulation has made these techniques into a "family affair," producing the best kind of creative interaction (see Brian Kavanaugh-Jones's work on page 132). Our images and approaches are quite different, but each great image by one family member spurs the others on to even better work!

"Torn Sail." 4 x 5 multilayered emulsion transfer, made from 35mm slides.

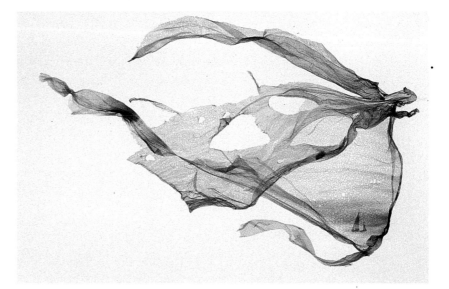

"Grand Canyon Reflection." 4 x 5 emulsion transfer of an SX-70 manipulation of 35mm slide.

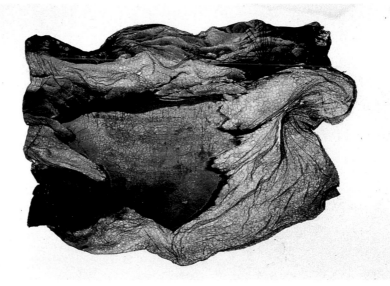

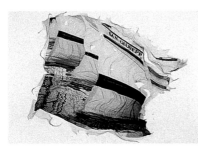

"San Giuseppe." 4 x 5 emulsion transfer, made from 35mm slide.

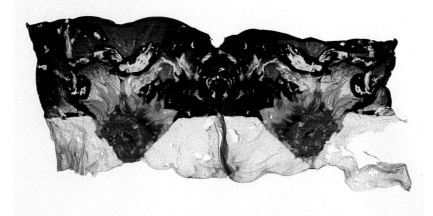

"Rising Suns." 4 x 5 double emulsion transfer of SX-70 manipulations.

"Alexandra at Four, 1992." Image transfer.

Rob Karosis

The passion and magic that Rob Karosis discovered when he began his life as a photographer in 1982 have never diminished. Based in Portsmouth, New Hampshire, he is largely a self-taught photographer, inspired by Edward Weston, Wynn Bullock, Walker Evans, and Ansel Adams. Since Karosis earns a living from his photography, his work has been produced largely for commercial applications. He began to experiment with Polaroid transfers in 1990, primarily with studio still life. As Karosis states in an interview in Polaroid's *Test* magazine (Spring/Summer 1996), lighting is an integral part of the success of his transfers:

> I normally use tungsten light, which provides a warmth and richness you don't get with a strobe. Also, I sometimes take an overall exposure with 250-watt tungsten model lights and then reopen the shutter and paint with light, using a flashlight fitted with a cardboard snout. The process gives me good saturation, with subtle falloff.

In the *Test* article, Karosis reveals that he keeps his studio at around 70°F or 72°F, and keeps his film at room temperature for at least an hour before transferring to ensure proper film handling. He ordinarily overexposes Polaroid 809 film by at least a stop, and creates dry transfers on Arches 140 lb. hot-pressed paper. He shoots the transfers that he does on location in-camera on Polaroid 59 film and removes them from the holder without processing. He later completes the transfer back at the studio or hotel to let the film rest at 72°F for at least an hour.

Karosis likes the look of a finished transfer without manipulating it, but occasionally he fills in light spots with Marshall oil-color pencils. Sometimes he "bleeds" selected areas of the transfer by pouring hot (about 125°F) water over them as he separates the negative and paper.

The photographer uses transfers in the commercial arena for print advertisements, annual-report photographs, posters, and editorial work. Transfers seem to represent the human aspect of his clients' businesses and to downplay the corporate side. In 1992, six of Karosis's transfers were selected for the Polaroid Collection. Two one-man shows at New Hampshire galleries soon followed. More recently, his work has been featured in *Test* (Spring/Summer 1995; Spring/Summer 1996), and on the Polaroid Corporation Web page. His newer work includes 8 x 10-inch floral still lifes and nudes, also done in-camera.

"The Henniker Bridge, Henniker, New Hampshire, 1992." Image transfer.

"Autumn Ferns, Livermore Falls, Maine, 1993." Image transfer.

"View from the Roof, The Balsams Resort, Dixville Notch, New Hampshire, 1993." Image transfer.

"Static Perspective." Manipulated image transfer.

Brian Kavanaugh-Jones

Brian Kavanaugh-Jones, currently a student at the University of California at Santa Cruz, is studying literature and art with an emphasis in photography. His transfer work ranges from classical to photojournalistic. He is the son of photographer Dewitt Jones, whose work also appears in this section (see page 128). Kavanaugh-Jones explains his approach:

What excites me about the transfer process is the new environment that it creates for photography to exist in. Mixing my transfers and watercolor painting lends a surreal effect. I like the way that the transfer sits on the page when it is surrounded by watercolor wash.

I went to Europe in the summer of 1995 with my dad. The first day in Paris we visited the Louvre, and at that point the trip metamorphosed from a vacation to an art tour. This is when I decided I would really get serious about art. When I saw Michelangelo's "David" in Italy, it knocked the wind out of me. Michelangelo was only in his twenties and already he'd found perfection. I sat in front of perfection for 3 hours. From that point forward, I knew that I wanted to be an artist.

I didn't like to take photographs when I was a kid because I felt as though I couldn't compete with my dad. I finally overcame that fear, and found out that my dad was my greatest supporter. I realized that we could push each other in art without competing.

I want to become a professional artist when I graduate. Whether that means that I'll work in a commercial venue or not, I'm not sure. If I could make a living doing something I love, I would be ecstatic. Maybe my naive 19-year-old brain is experiencing delusions of grandeur, but my ultimate goal in pursuing art is to change the way the world sees. I want to reach my full potential as a human being and as an artist, and in doing so I hope to come to a greater understanding of universal truths. The reason I love art is that it has the ability to transform both the artist and the viewer. When I'm making art, I lose all sense of time, and when I view good art, I lose time.

"Fade." Three emulsion transfers.

"Another Veil." Two emulsion transfers superimposed, with watercolor.

"Conversion." Two emulsion transfers and two wet image transfers.

"A Prayer." Ripped emulsion transfer.

**"Goldfish on plate." Emulsion
transfer.**

Christophe Madamour

A self-taught photographer since the age of 12, Christophe Madamour is a still-life photographer based in Paris. He works with advertising and design agencies shooting food, beverages, perfume, and cosmetics. Madamour started working with Polaroid transfers in 1992. He'd been looking for a way to give more energy and movement to his still-life photographs, as well as a different definition. As Madamour explains, "I wanted to break the rules of still life and photography. I wanted a way to remove my images from their normal context. After many experiments with various emulsions and products, Madamour was working in his kitchen one night when he became one of the first Europeans to discover the Polaroid emulsion-lift process using a common dish-cleaning product. He immerses exposed Polaroid ER film in a mixture of hot water and household window-cleaning fluid before gently moving the emulsion onto other papers, some of which he makes himself. "With emulsion transfer, I can take my subject beyond the frame of the print and give it a new life and freedom," he says. In 1993, Madamour won second place in Polaroid's European Final Art Award.

Madamour's goal is to create a unique artistic object, much like a painting or a sculpture. He prefers the natural Polaroid colors and isn't interested in handcoloring. He sometimes manipulates images with paintbrushes or allows the movement of water to dictate the form the emulsion image takes. He then cuts, scratches, pulls, and stretches the emulsion before letting it dry. He reveals his thoughts about Polaroid transfers:

> Photography here becomes more physical; all your senses are awake. There is no limit to creativity. I am happy to see this technique growing in popularity in the photographic world. As a pioneer, I hope to continue to create more work in this new artistic approach.

**"Gitanes and coin."
Emulsion transfer.**

"Lemon." Emulsion transfer.

"Red and yellow flower." Emulsion
transfer.

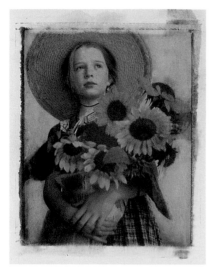

"Casey with sunflowers, 1994."
3¹/4 x 4¹/4 image transfer.

Amy Melious

As a full-time photographer since 1985, Amy Melious has done much of her work in black and white, and it often involves people—nudes, portraits, and documents of the lives around her. "I love the power of black and white to articulate a feeling and compose an artwork pleasing to the eye, with just strokes of light," she says. Melious is based in rural Willits, California. Always drawn to alternative processes and ready to explore color, she began handtinting select black-and-white images in 1990. After her first image-transfer workshop with Kathleen Carr in 1993, Melious found a new direction:

> Finally, a color process that I felt was in line with the overall mood of my work. It made me think of still life: flowers, fruit, the whimsical and elegant, the timeless and moody—the essence of a Polaroid image transfer. While I've always liked to use black and white for my personal work, finding images that originate from places deep within me, the handcolored photographs and transfers achieve a balance in that they tend to be more gentle and simple. Creating these images is very recreational, like playing. These are feelings that are very welcome in my chaotic life as a mother and businessperson.

Melious uses Polaroid 669 film most of the time, and transfers onto Arches hot-pressed watercolor paper. She sometimes uses colored filters, but not often. When her prints have dried, she dips them into an acid bath and then rinses them again. She does some textural work when the prints are still wet from this acid bath, using paper towels or bits of cloth to rub parts of the image.

After the second drying, during which the prints always lie flat between screens, Melious colors the transfers with a variety of materials. She usually starts with Marshall oil pencils and then continues with chalk or oil pastels. Occasionally, she accents with inks or watercolors. Recently, she has come full circle, creating transfers from slides of her black-and-white prints and adding touches of color. In 1993, using Polaroid image transfers, Melious initiated her "Grain of Sand" line of notecards and journals, which are available in the United States and Japan. You can find framed reproductions of her still-life image transfers at The Nature Company stores. She currently displays her work at a cooperative gallery in Hopland, California.

"Fiori, 1995." 3 1/4 x 4 1/4 image transfer.

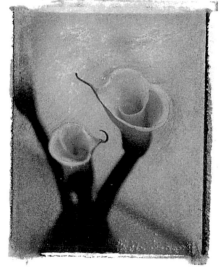

"Lily Series, 1994." 3 1/4 x 4 1/4 image transfers; triptych.

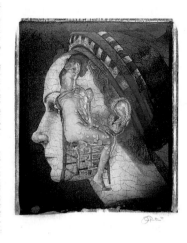

"Double Portrait, 1987." 20 x 24 image transfer, with dry pigment and pastel.

John Reuter

Internationally known artist John Reuter has had a consistent approach to photography since the early 1970s. He works with a variety of media to transform an existing reality into something else. Usually his subject matter either involves the human figure and its interaction with its surroundings, or emphasizes an emotional state. The final piece conveys a mythic reality, one that doesn't really exist beyond its depiction in the work. For example, in the 1980s Reuter began an Androgeny series, with the Androgen figure (acting as a surrogate for himself) entering into art-history scenarios and disrupting or reacting to the appropriated scenes.

Reuter's most recent images are digital collages constructed from nineteenth-century portraits that he found in thrift shops and combined with backgrounds from Ellis Island and the Lower East Side Tenement Museum, where he sought deteriorated and decaying rooms. "By adding the portrait figures," he says, "I hope to create a sense of the spirits of past lives that I felt so strongly when I was in these locations." Reuter has worked exclusively with Polaroid materials since 1975, and the digital collages are a natural extension of his earliest SX-70 collage work, which he made using scissors and glue. He explains the new method:

> The Polaroid CS 500 scanner takes a print up to 4 x 6 inches, making it ideal for the number of existing images I've produced with Polaroid films. The Sprintscan software allows me to bring an image immediately into Adobe Photoshop, duplicating the sense of immediacy I've always treasured working with Polaroid materials.

Once in Photoshop, Reuter generally combines a figure with a background. After completing the digital collages, he prints the images onto a 4 x 5-inch transparency film with a Polaroid CI 5000 Film Recorder using Image Print software. Reuter's next step is to "print" the 4 x 5-inch transparency onto 20 x 24-inch film using a Polaroid 20 x 24-inch camera, which is best known for the exquisitely sharp and saturated photographs it can produce in a studio. He transfers the image onto Fabriano Artistico paper using the 20 x 24-inch Polacolor negative. Although capable of producing fully resolved transfer images, Reuter prefers to make partially peeled transfers, thereby yielding unexpected results.

Reuter's final step is reworking a transfer, often with retouching dyes, dry pigment, pastel, and graphite, as well as sanding to obscure and blend areas. "Reworking," he says, "allows an additional transformative step, and is perhaps as important to me as the initial creation of the collages. Intuition can again take hold, and hopefully it brings the image to another level."

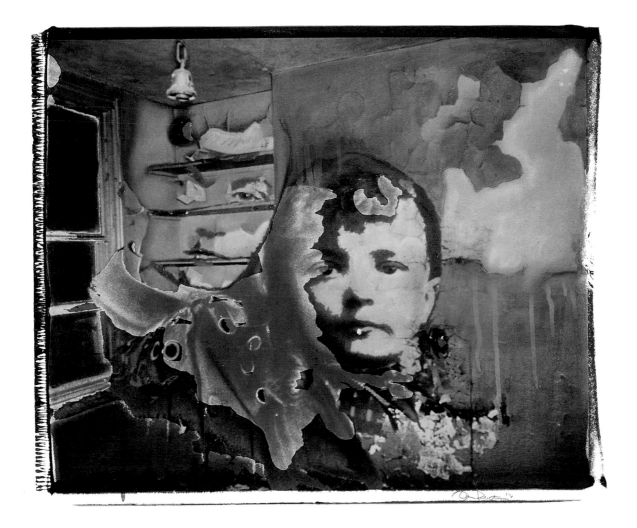

"Siblings, 1994." 20 x 24 image trans-
fer, with dry pigment and pastel.

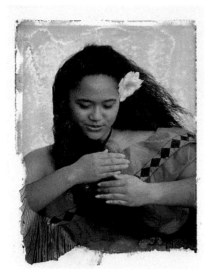

"Mo'olelo o'Moloka'i." Image transfer, lightly handcolored.

Lynette Sheppard

Having majored in photography at the San Francisco Art Institute, Lynette Sheppard has been photographing for more than 15 years, and has become captivated by or, in her own words, "obsessed with" the transfer process. She also teaches workshops on "Photography and Healing" with Dewitt Jones (see page 128). During these sessions, they use photography as a metaphor for healing, for becoming whole. Sheppard divides her time between Northern California and her spiritual home, Moloka'i, Hawaii. She explains the connection:

> Image transfers give me a sense of looking into the past. Colors appear muted when compared with the original transparency, giving it a faded, timeworn quality.
>
> For the past several years, I've been photographing the Hawaiian hula. The time-softened quality of image transfer allows me to express the feeling of "hula kahiko," the ancient hula, lending an "old" look to a photograph that I may have taken just last week.

Various techniques, such as zooming and selecting slow shutter speeds when making the original photograph, enable Sheppard to convey a hula dancer's motion. During the transfer process, she sometimes double-exposes dancers and parts of their environment—waterfalls, palm trees—to illustrate the interconnectedness of hula and the "aina," or land. Love for the aina informs Hawaiian culture: the land and the dancer are one. The pieces become a living cultural-history lesson for her.

Sheppard describes her approach: "Emulsion transfers have the bright color of the original slide. I use the wrinkles to show motion or accentuate a particular feature, such as a hula dancer's hair or her 'ti' leaf skirt." Sheppard finds that emulsion transfers are more effective than image transfers on textured bark- or papyrus-type papers:

> These organic papers give the feeling of Hawaiian tapa cloth, or "grass" skirt material, providing another link between the natural world and the dancer.
>
> I love the fact that each transfer is one-of-a-kind and can never be repeated. The process of image and emulsion transfers slows me down, so I spend time with the images, listening to what they're teaching me. If I paint or handcolor a piece, I get to know it very deeply. Straight photographic prints never demanded as much attention from me, nor did they intensify my creative experience in the way the transferred images do.
>
> I'm constantly surprised by the process; magic plays a very large part in the end result. And speaking of results, the many failures teach me over and over that the process itself truly is the art—the outcome (transfer) is just a lovely side benefit.

"Hula Skirts." Image transfer, hand-colored; zoomed lens while using slow shutter speed in original 35mm slide.

"Palms I, Kaunakakai." Image transfer on cold-pressed watercolor paper.

"Kualapuu Coffee." Emulsion transfer on papyrus.

"Violin." Image transfer.

Charles Shotwell

A commercial photographer based in Chicago since 1973, Charles Shotwell steeps his photography in the historical and fine-art traditions of the medium. He graduated with a Bachelor of Fine Arts degree from Southern Illinois University in 1971, and then studied under Garry Winogrand and Charles Harbutt. Shotwell has won many awards in the advertising and design fields. For the past few years, along with producing conventional 4 x 5-inch and 8 x 10-inch color work, Shotwell has been working with Polaroid film via the image-transfer process. Using dry rather than wet transfers helps him retain a "crisp, clear look" that he likes. He explains:

> My still-life photographs are inspired by traditional paintings in the same genre, reflecting the simple, balanced expression I refer to as "the humble truth." These photographs demonstrate a painting aesthetic working in conjunction with the camera's recording function. Many of these images should be viewed as photographic documents, records, or catalogs of artifacts in which the subject matter transcends itself.

Most of Shotwell's work consists of conventional color-transparency or black-and-white assignments for major advertising agencies. Occasionally, a client has a project that is suited to the soft look of a Polaroid image transfer; Shotwell took this approach for Starbucks Coffee, Neiman-Marcus, and the Mondavi Winery. He is represented in print by Friend & Johnson, a national firm that works with commercial photographers. He has also recently joined Backyard Productions as a commercial-film director with an emphasis on table-top photography.

"Cupboard and painting." Image transfer.

"Silverware balance." Image transfer.

"Sidewalk Billboards." 4 x 5 image transfer on spandex.

Steve Sonshine

An architect, Steve Sonshine brings his professional experience to his imagery. With his wife, Willette, he owns and operates Artworks Gallery in Danbury, Connecticut, where he shows his work and conducts seminars in image- and emulsion-transfer techniques. He explains how he got started:

My continued interest in Polaroid films is really about their ease of processing, and the success I've had experimenting with them. A new interest in photography— based on experimentation—took hold. I began to explore the image on watercolor paper and its new textures and colors.

Using an Omega 22 enlarger gives Sonshine creative control through burning and dodging. On image transfers, he often removes selected areas of the emulsion with a razor blade or an X-acto knife while the image is still wet. Then after the transfers dry, he handcolors them with both colored pencils and ink. Sonshine uses Polaroid 55 positive/negative film for shooting his black-and-white work. He projection-prints these images on Polaroid 59 or 809 film, and then transfers onto watercolor paper. In addition to using paper receptor surfaces, he also experiments with silk, linen, and spandex. Sometimes he creates positive and negative images of the same photograph.

"Buddhist Monks." Image transfer, with the emulsion scraped off. I knew that someday, the entire emulsion wouldn't come off in a single piece, and thought that if I removed some of the emulsion, I could deliberately set up the conditions for this kind of problem. By carefully removing the background of this image, using a light touch to scrape the surface with a razor blade, I found that I could make the subject "pop up."

"Gothic Hall and Monolith, New
Haven, 1994." 8 x 10 negative image
transfer.

"Parthenon on Papyrus." 4 x 5 emul-
sion transfer.

Kathryn Szoka

Kathryn Szoka, from Sag Harbor, New York, is currently working as a freelance commercial and fine-art photographer. Her commercial photography includes portraiture, product and architectural shots, and landscapes. Her work has appeared in many publications, including *Vanity Fair, Vogue, GQ, L.A. Style,* and the *New York Times,* and has been exhibited at galleries in the United States, Japan, and Germany. Recently, Szoka has pursued a number of projects ranging from regional American essays and rural documentation to video productions and commercial books on style.

Szoka worked in the computer-graphics field for 12 years. A self-taught photographer, she changed careers to explore her passion for photography, which she uses to chronicle a passing way of life. Szoka is developing several additional projects using the Polaroid image- and emulsion-transfer processes, as well as other alternative techniques. She frequently frames her images in old barn wood or with window frames, which complement the works' aesthetic character. Occasionally, she escapes to Maine to indulge her love of nature.

"Red, White and Blew." 8 x 10 emulsion transfer.

"Ball & Glove." Image transfer.

"Coke and Barber Chair." Image transfer.

"Dance of Life #2, 1993." Four image transfers.

Val Valandani

Since 1991, Val Valandani has been photographing the human body, producing a portfolio of work that shows the beauty, character, grace, and power in every body. "My primary interest," she says, "is photographing women and men over the age of 45, with a special series on breast-cancer survivors." Her breast-cancer series is included in the "Healing Legacies" exhibition, a joint project of the Vermont Women's Caucus for Art and the Breast Cancer Action Group of Vermont, which has been showcased in state capitals, museums, and galleries across America.

Valandani's photographs have been widely exhibited in the United States and Europe, and since 1993 all of her exhibited work has been Polaroid images. She combines fine-art photography with commercial assignments through her advertising agency, which she launched in 1985 in Campbell, California. Her transfers have been published in a number of photography magazines, including *Popular Photography*, *Communication Arts*, and *Photo District News*. She also teaches workshops on various Polaroid processes.

"I simply photograph what I see—with my eyes, my intellect, and my heart," she says. "The common thread running through my work is the power of the image I felt at a particular moment and in a particular light." She is currently working with Polaroid image transfers, emulsion transfers, and SX-70 manipulations because she feels that these processes best express her vision. She reworks each image as the spirit moves her, until a quiet intimacy emerges.

"Dance of Life #5, 1995." Four emulsion transfers.

"St. Petersburg Fantasy, 1995."
8 x 10 emulsion transfers of hand-
colored black-and-white original.

"Renaissance Woman I #1, 1994."
Image transfer.

"O with Hapu'u, 1994." Emulsion transfer; intentionally overheated for bubble effect; made on pre-1996 Polacolor Pro 100 film using a Vivitar slide printer.

Mary Walsh

Photographic artist Mary Walsh finds that the selection of the right image is integral to the creation of a successful transfer. Nudes, portraits, and landscapes with simple compositions, combined with strong contrasts and sharpness, are some of the qualities she looks for. She reveals her motivation:

> I like something I can "read" easily from several feet away. I think of transfers as little jewels, gracing a small niche or corner. Viewing them is a minute escape—a moment of personal reflection and intimacy. I like to create and live with gentle, sensual artwork that enhances my life and nourishes me spiritually.

Walsh divides her time between Volcano, Hawaii, and Santa Rosa, California. Having worked in photography and drawing since 1973, she finds that Polaroid transfers bring together her skills in an exciting way. What initially stirred her interest in alternative photographic processes was the way in which a photograph considered to be "realistic" can be changed via various techniques, such as sandwiching slides, multiple exposures, masking and filtration, handcoloring, and darkroom manipulation. She explains:

> The layering of separate realities lends mystery and interest to photographic images. I prefer to use manipulations with a more subtle hand than is generally present in what is known as "special effects." It might not be apparent that I've changed or added something to an image. It is exciting to work with transfers, which give a unique look to my photographs. Combining slides with other effects is simple to do with the Vivitar slide printer.

Walsh also creates multi-image slide programs using three projectors. The blend of images offers challenging ideas for transfers because she can approximate the transfer result with two or three projected images. But a multiple-exposure transfer isn't the completed piece for Walsh. She might handcolor the original or enlarge the image on a color laser copier, handcoloring the copy with pastels.

Walsh's work is sold in galleries as prints and greeting cards, and she has supplied artwork for a number of CD and cassette covers. She teaches a variety of photographic workshops; the topics include darkroom manipulations, special effects with slides, the use of infrared black-and-white film, and handcoloring. Her courses are offered through camera clubs and arts organizations. Walsh's plans include further exploration with Polaroid materials and the development of photographic workshops in alternative processes.

"Keaukaha, 1995." Image transfer, underexposed intentionally on a Vivitar slide printer for dramatic effect; dry transfer produced liftoff; handcolored with pastels; then more coloring was added to waves and clouds.

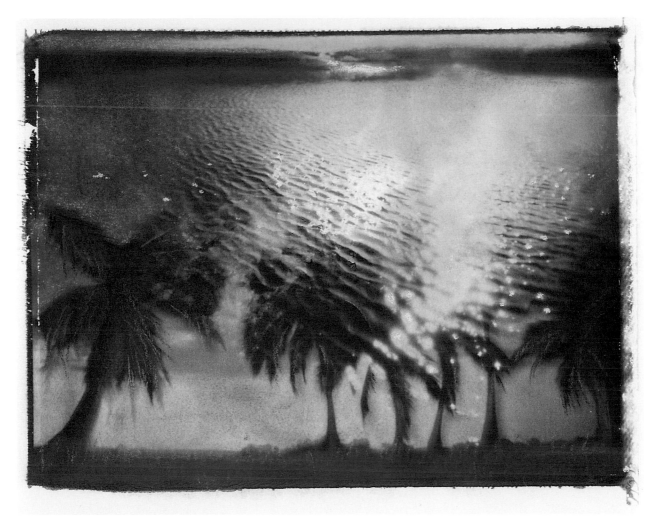

"Twilight at Honaunau, 1995." Image transfer; double exposure made in a Vivitar slide printer; pastels separate background tones from palms.

"Aargh." 4 x 5 black-and-white emulsion transfer.

Tina Williams

In 1991, Tina Williams began her career as a commercial photographer in the Washington, D.C., area. In recent years, she has worked with Polaroid as a guest photographer at trade shows and has taught seminars on the creative uses of Polaroid films. In her seminars, Williams encourages students not to rush. She has seen photographers ruin great image transfers because they thought the film would dry quickly. She explains:

> It takes several minutes for the Polaroid negative to dry. Take this time to wipe away any excess water and chemicals, and to make sure the placement is where you want it. This is also true of emulsion transfers. The emulsion is delicate, and pushing it off before it is ready can cause it to tear. But it isn't so delicate that sitting in hot water for a few extra minutes is going to ruin it.

Williams encourages her students to develop their own rules:

> You'll find that what works for others might not work for you in your environment. Your water might be different (hard or soft), the humidity might be different—so might the temperature and any number of variables—so grasp the basics and then run with them. Experiment! Don't be afraid of failure because that is how we discover success. If you can picture it in your mind, try it! You'll be surprised by the results.

Williams has consulted and tested new products for Polaroid. Her work is included in the company's permanent collection, and in various Polaroid publications. Williams worked with Eastman Kodak in a similar capacity, focusing on the uses of black-and-white films and papers, and in digital photography, testing equipment and cameras. She has also been a guest photographer for the Beseler Corporation.

Today, Williams is an award-winning commercial photographer whose work melds photography and illustration in a blend of contemporary and traditional styles. She continually strives to create visual excitement in her images. Articles in *Camera and Darkroom*, *Shutterbug*, *Test*, *View Camera*, and *Darkroom Photographer* magazines have featured her work.

"Hat Head." 4 x 5 black-and-white emulsion transfer.

"Knock, Knock." 4 x 5 emulsion transfer.

"The Red Door." 4 x 5 emulsion transfer.

Resources

Polaroid Information

In the United States, the single most important source of information about where to purchase film and equipment, to find answers to technical questions, and to get additional instruction in applications for Polaroid films is the Polaroid Customer Care Center.

Contact:
Polaroid Corporation
Customer Care Center
201 Burlington Road
Bedford, MA 01730
800-POLAROID (800-765-2764)
Product and technical information:
800-225-1618; 800-343-5000
Parts Department: 800-343-9896

Polaroid maintains numerous service centers throughout both the United States and the world. The Customer Care Center can tell you where to find the nearest center for local information, including your local dealer.

If you don't have a local dealer but want to order products at list prices, call: Polaroid Express: 800-552-0711. If you are online, you can visit Polaroid's Website. It has up-to-date information on a variety of topics, including products, processes, and *Test* magazine. Contact the Website, which also features a gallery of work by photographers who use Polaroid films, at: http://www.polaroid.com.

If you want to recycle anything from Polaroid films, from packaging to film cassettes, send it to the following address (you pay the shipping):

Polaroid Recycle Center
151 Third Avenue
Needham, MA 02194

If you're interested in working with Polaroid's 20 x 24-inch camera, which produces a full-color, 20 x 24-inch contact photograph in 70 seconds using Polacolor ER film, get in touch with:

Polaroid 20 x 24 Studio
888 Broadway, Suite 1010
New York, NY 10012
212-925-1403; Fax: 212-925-2239

Photographic Equipment and Supplies

You can find slide printers and Polaroid film at most large camera stores. If a store doesn't stock the Vivitar and Daylab slide printers, you can special-order them (Polaroid distributes these units however, the Vivitar is being phased out, replaced by the Daylab Jr.). You can also order Daylab slide printers directly from Daylab, and get further technical information; you can order the Calumet processor from either Calumet or Polaroid (see addresses below). Polaroid 669 film is readily available at camera stores. Large-size (4 x 5-inch and 8 x 10-inch) film might not be as easy to locate, but you can special-order it from your local camera store.

If you need all of the transfer supplies, you can get a Polaroid Image and Emulsion Transfer Kit. Photo-development trays are available at most photography stores, although you can easily substitute a nonrusting baking pan.

You can order Kodak color-correcting (CC) and color-printing (CP) filters and Rosco lighting-gel samplers through your local photography outlet, as well as through mail-order companies. You can also contact Rosco directly (see below).

Finally, you can purchase batteries for older Polaroid cameras through Polaroid.

Calumet Photographic, Inc.
890 Supreme Drive
Bensenville, IL 60106
800-CALUMET (800-225-8638)
Fax: 800-577-FOTO (800-577-3686)
Photographic items, including Polaroid and Daylab equipment; catalog

Daylab Corporation
400 East Main Street
Ontario, CA 91761
800-235-3233; Fax: 909-988-0715
Information on all slide-printer models, Polaroid films, and conventional black-and-white and color processing; factory-direct sales for Daylab products not available through your local dealer; complete catalog

O & ER (Optical & Electronics Research)
11501 Sunset Hills Road
Reston, VA 22090
703-471-1645
O & ER Proprinter sales and information

Rosco
1120 North Citrus Avenue
Hollywood, CA 90038
800-ROSCOLA; Fax: 213-462-3338
Lighting gels, surfaces; catalog

(If you have trouble locating any of these products, call the Polaroid Customer Care Center to find the dealer nearest you. Also, most mail-order firms that advertise in photography magazines carry these items. Purchasing film from a local camera store or other retail outlet, however, ensures freshness and proper storage conditions.)

The following is a list of some mail-order companies I've dealt with that sell Polaroid film, equipment, and photographic supplies. (This is by no means a complete listing.)

Adorama, Inc.
42 West 18th Street
New York, NY 10011
Information: 212-741-0052
Orders: 800-223-2500; Fax: 212-463-7223
Excellent prices; good service; prompt delivery; great catalog

B & H Photo-Video
119 West 17th Street
New York, NY 10011
800-947-9970; Fax: 800-947-7008
Huge inventory of new and used photographic equipment and supplies; excellent prices; prompt delivery

Freestyle Photo
5124 Sunset Boulevard
Los Angeles, CA 90027
Orders only: 800-292-6137
Friendly staff; no shipping charge in California; free catalog four times a year

Porter's Camera Store, Inc.
Box 628
Cedar Falls, IA 50613-0628
Customer service: 800-682-4862
Orders: 800-553-2001; Fax: 800-221-5329
Common and some rather unusual items; technical questions answered about products; catalog

To find refurbished Polaroid cameras, hard-to-find accessories, and custom conversions for Polaroid cameras and equipment, contact the following companies (Polaroid's Parts Department carries batteries for some old Polaroid cameras):

Columbus Camera Group, Inc.
55 East Blake
Columbus, OH 43202
Information: 614-267-0686
Orders: 800-325-7664; Fax: 614-267-1037
Advertisement in *Shutterbug;* good prices on short-dated Polaroid and other films

Four Designs Co.
20615 NE 22nd Avenue
Ridgefield, WA 98642
Technical line: 360-887-1555
Orders: 800-468-3399; Fax: 360-887-1549
Information packet

Graphic Center
P.O. Box 818
Ventura, CA 93002
Information and fax: 805-383-6864
Orders: 800-336-6096
e-mail: graphicctr@aol.com
Catalog of refurbished cameras and accessories

Art Supplies

Brayer rollers, watercolor and other types of papers and surfaces, and such handcoloring materials as pencils, paints, and pastels are available from most art-supply stores and mail-order catalogs.

Mail-order, ready-made mats and frames are a low-cost alternative to custom framing. University Products and Light Impressions catalogs are good sources for these items, as well as for archival framing and storage supplies. You can order frames and framing supplies from Graphik Dimensions and Structural Industries (see below).

The following list comprises mail-order companies that I've used or that have been recommended to me. (Once again, this isn't a complete list.)

Artists' Connection
20 Constance Court
P.O. Box 13007
Hauppauge, NY 22788-0533
800-851-9333; Fax: 800-852-9333
Good selection; great prices

Daniel Smith, Inc.
4150 First Avenue South
P.O. Box 84268
Seattle, WA 98124
Customer service: 800-426-7923
Fax: 800-238-4065
Large selection, including handmade papers; manufactures own brands; good service; extensive reference catalog

Dick Blick
P.O. Box 1267
Galesburg, IL 61402-1267
Orders: 800-447-8192; Fax: 800-621-8293
Popular catalog

Graphik Dimensions
2103 Brentwood Street
High Point, NC 27263
800-221-0262; Fax: 910-887-3773
Mats and frames, including wide variety of metal and wood frames

The Jerry's Catalog
P.O. Box 58638
Raleigh, NC 27658
800-327-8478
Potpourri of fascinating items

Light Impressions
439 Monroe Avenue
P.O. Box 940
Rochester, NY 14603-0940
Customer service: 800-828-9859
Orders: 800-828-6216; Fax: 800-828-5539
Excellent selection of archival materials for the best presentation and storage of your work; catalog

Napa Valley Art Store
1041 Lincoln Avenue
Napa, CA 94558
800-648-6696; Fax: 707-257-1111
Mail order and storefront; great prices; nice people

New York Central Art Supply
62 Third Avenue
New York, NY 10003
800-950-6111; Fax: 212-475-2513 (24 hours)
Large selection of handmade and artists' papers and art supplies

Orille Enterprises
7971 Center Parkway
Sacramento, CA 96823
916-424-8637
Custom mats; reasonable prices; quick service; ships UPS

Structural Industries
96 New South Road
Hicksville, NY 11801
800-645-3993; Fax: 516-822-5207
Good prices on frames

University Products, Inc.
517 Main Street
P.O. Box 101
Holyoke, MA 01041-0101
Customer service: 800-762-1165
Orders: 800-628-1912; Fax: 800-532-9281
Large selection of hard-to-find archival items suitable for museum presentation; products you didn't realize you needed

Manufacturers

The following companies manufacture the art supplies mentioned in the text. If you can't find the firms' products locally, call for the closest distributor. Many manufacturers have extensive catalogs of their products.

Blair Art Products (Loctite Corp.)
1001 Trout Brook Crossing
Rocky Hill, CT 06067
800-842-0047; Fax: 203-571-5430
Spray fixatives

Caba Paper Company
1310 Don Gaspar Avenue
Santa Fe, NM 87505-4628
505-983-1942; Fax: 505-988-7183
Handmade bark paper and bark-paper sketchbooks

Caran d'Ache
19 West 24th Street
New York, NY 10010
212-689-3590; Fax: 212-463-8536
Oil and water-soluble color crayons, pencils, pens, and art materials

Crestwood Papers (Willman PaperCo.)
315 Hudson Street
New York, NY 10013
212-989-2700; Fax: 212-463-7875
Artists' papers, including Arches and BFK Rives

DecoArt (Ceramichrome)
P.O. Box 386
Stanford, KY 40484
606-365-3193; Fax: 606-365-9739
Fabric paints, acrylic paints, and sealers; fine-art, craft and hobby, and school markets; contact for a list of distributors

Deka Paints & Dyes (Decart Inc.)
Lamoille Industrial Park
Box 309
Morrisville, VT 05661
802-888-4217
800-232-3352; Fax: 802-888-4123
Fabric paints; catalog

Dr. Ph. Martin's (Salis International)
4093 North 28th Way
Hollywood, FL 33020
305-921-6971
800-843-8293; Fax: 305-921-6976
Brochures; paints, inks

Golden Artist Colors, Inc.
Bell Road
New Berlin, NY 13411
607-847-6154; Fax: 607-847-6767
Artists' colors, varnishes, and protective coatings

Hunt Manufacturing Co.
One Commerce Square
2005 Market Street
Philadelphia, PA 19103-7085
215-656-0300; Fax: 215-656-3700
Brayer rollers, watercolors, pens, and inks

Krylon
31500 Solon Road
Solon, OH 44139
216-498-2300; Fax: 800-243-3075
Hotline: 1-800-4-KRYLON
Clear aerosol coatings, art sprays, and a
variety of spray paints; brochures

Lineco, Inc.
517 Main Street
P.O. Box 2604
Holyoke, MA 01041
800-322-7775; Fax: 800-298-7815
Archival supplies; matting; storage

Liquitex Acrylics (Binney & Smith)
1100 Church Lane
P.O. Box 431
Easton, PA 18044-0431
610-253-6271; Fax: 610-253-5267
In addition to Liquitex acrylics, Binney &
Smith produces oil paints, painting medi-
ums, markers, and brushes; catalog

McDonald's Pro-tecta-cote (Sureguard)
2350 114th Street
Grand Prairie, TX 75050
214-647-9049; Fax: 214-606-0098
Protective UV-inhibiting photo lacquers

ProTapes and Specialties
601 West 26th Street
New York, NY 10001
908-346-0900; Fax: 908-346-0777
Framers' tape, photographic masking
tape, artists' tape, and transfer tape

Rembrandt Colors (Canson-Talens, Inc.)
21 Industrial Drive
P.O. Box 220
South Hadley, MA 01075
413-538-9250
800-628-9283; Fax: 413-533-6554
Pastels, watercolors, acrylics, and oils;
catalog, includes Canson art materials

Savoir Faire (Sennelier & Lascaux)
P.O. Box 2021
Sausalito, CA 94966
415-332-4660; Fax: 415-332-3113
Savoir Faire also imports other art
materials from France and Switzerland;
catalog; Sennelier & Lascaux brand
watercolors, pastels, oil pastels and paints,
gouache and acrylics

Winsor & Newton (ColArt Americas, Inc.)
P.O. Box 1396
Piscataway, NJ 08855-1396
908-562-0770; Fax: 908-562-0941
Watercolor, inks, oils, and acrylics; brush-
es; watercolor papers; North American
distributor of Derwent fine-art pencils;
catalog

For additional information about trade
names, manufacturers, distributors,
wholesalers, and retailers, contact:

National Art Materials Trade Association
(NAMTA)
Membership Directory
178 Lakeview Avenue
Clifton, NJ 07011
201-546-6400; Fax: 201-546-0393
e-mail: namtanj@aol.com

Digital Sources

For inputting slides, transparencies, and
flat art into your computer, you can pur-
chase a flatbed or transparency scanner
from: a local computer store; a computer
mail-order catalog; the advertisements in
photographic digital and computer maga-
zines, such as *MacWorld* and *PC World*; or
the many online Web sites advertising
computer ware.

Service bureaus can scan the transfers,
manipulate them, and output the images
for you. Check your area; more service
bureaus are appearing all the time. But be
sure to do some research first about the
bureaus' quality, prices, and services.
Depending on how you want to output
the transfer, you might decide to ship your
transfers, or transparencies of the transfers,
to a specialty service bureau. The following
is a list of several that I've used or that
have been highly recommended.

David Adamson Editions
406 7th Street N.W. at D
Washington, DC 20004
202-347-0090; Fax: 202-347-1045
Iris prints; high-end Scitex scanner;
optimum quality; great prices

Electronic Publishing Specialists, Inc.
(EPS) and Muse X Imaging
3499 Cahuenga Boulevard West
Los Angeles, CA 90068
213-874-6141; Fax: 213-874-6330
Muse X Imaging offers digital printmak-
ing services for artists; offers Iris print-
making, digital platinum/palladium
prints, and digital Ilfochrome/Type C

prints from the Lightjet 5000; uses Lyson
fine-art inks and a UV coating for Iris
print longevity; specializes in experimental
Iris printing on a wide variety of papers,
including Japanese rice papers, Mylar,
canvas, and even velvet; provides film-out-
put services for the UltraStable process;
high-precision Hell 3300 drum scanner;
information packet on complete services

EverColor Fine Art
70 Webster Street
Worcester, MA 01603
508-798-6612; Fax: 508-757-2216
e-mail: Light@Evercolor.com
EverColor Pigment Transfer and Dye
prints; EverColor Lightjet 5000 prints;
information packet

UltraStable Color Systems, Inc.
500 Seabright Avenue, Suite 201
Santa Cruz, CA 95062
408-427-3000; Fax: 408-426-9900
http://www.Ultrastable.com
e-mail: cb@Ultrastable.com
Pigment films; pigment prints; workshops
in the UltraStable process

Urban Digital Color, Inc., and Gallery 16
1616 Sixteenth Street
San Francisco, CA 94103
415-626-1616; Fax: 415-626-8439
http://www.udc-gallery16.com
Urban Digital Color, Inc. (UDC) and
Gallery 16 collaborate with artists on edi-
tions, multiples, and artists' book projects;
UDC uses Scitex scanning systems and
several Iris 3047 printers; UDC North on
the Point Reyes National Seashore offers
artists a creative retreat with an Iris print-
ing facility and artist studio; Gallery 16
offers exhibition space to a wide range of
contemporary artists in all media

Workshops and Instruction

All across America, many photography
instructors have expanded their curricula
to include instruction in Polaroid image
and emulsion transfers. Community edu-
cation courses available through junior
colleges are a good place to look. Your
local camera store or art center might
know of or even sponsor private classes.

You can also call the Polaroid
Customer Care Center and ask for the
telephone number of the Polaroid District
Sales Office closest to you, which will cer-
tainly know about workshops in your area.
You can also contact the artists and pho-
tographers whose work appears in the
"Gallery" section; many teach workshops.

Artists and Photographers

Theresa Airey
1212 Corbett Road
Monkton, MD 21111
410-771-4318; Fax: 410-771-4432
Offers private and group photography workshops and travel workshops; accepts assignments at home and abroad; sells stock photographs; her book, *Creative Photo Printmaking* (Amphoto Books, 1997) includes sections on creative printing methods, infrared photography, hand-coloring, photo transfers using copier materials, and such techniques as bleaching and toning, coating papers with liquid emulsions, manipulating Polaroids, solarization, and more

David Aschkenas
915 North Euclid Avenue
Pittsburgh, PA 15206
412-363-3458
Offers assignment photography, stock photography, and fine-art prints for sale

Patti Bose
112 Wild Fern Drive
Longwood, FL 32779
407-869-9664; Fax: 407-869-5856; 407-869-6338
Offers fine-art photography and stock photography featuring atypical images; print sales; accepts fine-art assignments for commercial use

Emilio Brizzi
Emilio Brizzi Photography
Van Ostadestraat 43a
1072 SN Amsterdam,
The Netherlands
31-20-673-4456; Fax: 31-20-672-2983
Offers advertising photography, portraits, and experimental fine-art photography

Kathleen Thormod Carr
Kathleen T. Carr Photography
2126 Green Hill Road
Sebastopol, CA 95472
707-829-5649; Fax: 707-824-8174
e-mail: kcarrphoto@aol.com;
kcarr@mcn.org
Web-page: http://www.mcn.org/a/kcarr/
Offers workshops and individual tutoring in image and emulsion transfer in California and Hawaii; will travel to any area if sponsored; also offers stock and assignment photography and fine-art print sales; represented by the Alinder Gallery, P.O. Box 1146, Gualala, CA 95445, 707-884-4884; Fax 707-884-9124

Peter Dazeley
The Studios
5 Heathmans Road, Parsons Green
Fulham, London SW6 4TJ, England
0171-736-2999; Fax: 0171-371-8876
Offers commercial photography, including Polaroid image and emulsion transfers; represented by Sarah Ryder Richardson; for stock photography, contact Janet Stock, Tony Stone Images Worldwide, London, 0171-267-8988

Ennio Demarin
Creative Art Photographer
Via San Francesco 9
34133 Trieste, Italy
Telephone and fax: 0039-40-367224
Offers commercial and fine-art photography

Diane Fenster
e-mail: fenster@sfsu.edu
Web-page:
http://www.art.net/Studios/Visual/Fenster/ritofab_Home/fenster.html
Digital fine-art and photo illustration; for print sales, contact: Gallery 16, San Francisco, CA 94103, 415-626-7495, or Creiger Dane Gallery, Boston, MA 02116, 617-536-8088

Dewitt Jones
11 La Cresta Drive
Petaluma, CA 94952
e-mail: DewitJones@aol.com
Offers photographic seminars in conjunction with Lynette Sheppard in general-photography and Polaroid-manipulation techniques; writes a monthly column, "Basic Jones," for *Outdoor Photographer* magazine in which he discusses a variety of photographic techniques and philosophy; original artwork for sale

Randy Kaneshiro
509 Pio Drive, Apt. 208
Wailuku, HI 96793
808-242-4410
Fine-art print sales

Rob Karosis
Rob Karosis Photography
855 Islington Street, Suite 7
Portsmouth, NH 03801-4270
Telephone and fax: 603-436-8876
Operates a commercial studio with fine-art approach; offers stock photography; client base includes corporations, magazines, hotels, resorts, and galleries across the United States

Brian Kavanaugh-Jones
11 La Cresta Drive
Petaluma, CA 94952
e-mail: BrianKav@aol.com
Original artwork for sale

Diana Lee
P.O. Box 336
Forestville, CA 95436
Illustrator and fine-art painter; commissions; print sales; logo designs; portfolio available on request

Christophe Madamour
18 Rue D'Angouleme
78000 Versailles, France
Work telephone: 331-42-04-2032
Fax: 331-45-06-0304
Offers commercial and product photography; print sales; Polaroid-transfer workshops

Amy Melious
284 Redwood Avenue
P.O. Box 87
Willits, CA 95490
Telephone and fax: 707-459-9286
Offers color and black-and-white fine-art photography; accepts assignments; portraiture; stationery (manufacturer/wholesaler); print sales

John Reuter
48 Gautier Avenue
Jersey City, NJ 07306
201-333-0171
e-mail: jrphoto@pipeline.com
Web-page information:
http://pwp.usa.pipeline.com/~jrphoto/index.htm
Offers workshops on Polaroid materials and their creative applications through the International Center for Photography and the School of Visual Arts in New York City; represented by Catherine Edelman Gallery, 300 West Superior, Chicago, IL 60610, 312-266-2350

Lynette Sheppard
11 La Cresta Drive
Petaluma, CA 94952
e-mail: LynetteSh@aol.com
Offers seminars with Dewitt Jones in general-photography and Polaroid-manipulation techniques; original artwork for sale

Charles Shotwell
Shotwell & Associates, Inc.
2111 North Clifton Avenue
Chicago, IL 60614
312-929-0168; Fax: 312-929-1481
Offers advertising photography, specializing in table-top products

Steve Sonshine
Artworks
Plum Tree Plaza
61 Newtown Road
Danbury, CT 06810
203-748-0197; Fax: 203-794-0870
Offers original fine-art photography; teaches classes and seminars on image transfer and transfer services

Kathryn Szoka
ONE EYE OPEN Photographic Studios
P.O. Box 2781
152 Jermain Avenue
Sag Harbor, NY 11963
Telephone and fax: 516-725-1149
Offers image- and emulsion-transfer courses; stock photography; commercial photography; fine-art, limited-edition prints; fine-art posters

Val Valandani
Valynn Associates
360 Forest Avenue, Suite 601
Palo Alto, CA 94301
408-866-4145
415-329-1383; Fax: 408-866-6832
e-mail: valyn@pacbell.net
Offers workshops and private tutoring on Polaroid image and emulsion transfers, SX-70 image manipulations, "Art & Healing," and "Photographing the Naked & the Nude"; accepts commercial and editorial assignments; fine-art print sales; general advertising and design

Mary Walsh
CAMERA ARTS
P.O. Box 412
Volcano, HI 96785
707-542-7383 (Santa Rosa, CA)
Fax: 707-573-9006
Offers fine-art prints; commercial and stock photography; accepts multi-image and assignment work; leads photography workshops on infrared, in-camera special effects, handcoloring, and darkroom manipulation

Tina Williams
11021 Westmore Drive
Fairfax, VA 22030
703-273-7208
e-mail: tinawill@erols.com
Commercial photographer available for assignment, stock, and workshops; specializes in Polaroid techniques of all kinds; does fun, artistic, and imaginative work

Lynette Zeeng
16 Mozart Street, St. Kilda
Victoria, Australia 3182
03-9525-4930; Fax: 03-9521-2665
e-mail: lzeeng@swin.edu.au
Commercial photographer; book illustrator (photographic); lecturer

Publications

Booklets

Inspirations, A Step by Step Guide, Polaroid Corporation, 1995. Step-by-step procedures for image transfer, emulsion transfer, SX-70 manipulation, and 35mm instant films. Available from Polaroid.

Polaroid Guide to Instant Imaging: Advanced Image Transferring, Polaroid Corporation, 1991, 1994 (out of print). This 40-page booklet provides examples of and instruction in the image-transfer process.

Polaroid Guide to Instant Imaging: Creative Uses of Polaroid Film, Polaroid Corporation, 1992 (out of print). This 52-page booklet explores such creative uses of Polaroid film as SX-70 manipulation, image transfer, and 35mm instant films, with examples and a few techniques.

Understanding the Polaroid Image Transfer Process, by Christopher Grey. Informative booklet developed as a text for his classes. Available from Grey directly: 77 13th Avenue, N.E., Suite 202, Minneapolis, MN 55413.

Books

Color Photography: A Working Manual, by Henry Horenstein with Russell Hart. Little, Brown and Co., 1995. Includes Polaroid image transfers on pp. 80-83.

Creative Photo Printmaking, by Theresa Airey. Amphoto Books, 1997. Alternative photographic techniques, including infrared, handcoloring, manipulating Time-Zero film, liquid emulsions, photocopy transfers, and Polaroid image and emulsion transfers (pp. 82–111).

Exploring Color Photography, 2nd edition, by Robert Hirsch. Brown & Benchmark, 1993. This wonderful, useful book on color photography includes image transfers on pp. 99-100. Look for the new 3rd edition.

French Dreams, by Steven Rothfeld. Workman Publications, 1993. A delightful book about France, using Polaroid image transfers as illustrations.

A Garden of Earthly Delights, by Guy Mirabella. William Heinemann, Australia, 1996. An oversize cookbook illustrated with Polaroid image transfers by Lynette Zeeng.

Handcoloring Photographs, by James A. McKinnis. Amphoto Books, 1994. Includes image transfers by two handcolorists, Geoffrey Nelson, pp. 100-103, and Tim Summa, pp. 122-127. Summa shares his "recipe" for Polaroid image transfers.

Impressions, by Charles Shotwell. Self-published. This book is an exquisite portfolio of Shotwell's Polaroid image-transfer work. Available directly from Shotwell at 2111 North Clifton, Chicago, IL 60614.

Italian Dreams, by Steven Rothfeld. Workman Publications, 1996. A companion volume to *French Dreams*, this book is illustrated with Polaroid image transfers.

New Dimensions in Photo Imaging, 2nd edition, by Laura Blacklow. Focal Press, 1995. Includes a new section on Polaroid transfers on pp. 7–11.

Painterly Photography: Awakening the Artist Within, by Elizabeth Murray. Pomegranate Artbooks, 1993. This book is a portfolio of work along with instructions in Time-Zero manipulation techniques using the SX-70 and other Polaroid cameras. Also contains some instruction in the image-transfer process.

Savoring the Wine Country, compiled and edited by Meesha Halm and Dayna Macy. HarperSan Francisco, 1995. A cookbook illustrated with image transfers by Steven Rothfeld.

The Secret Language of Dreams, by David Fontana. Chronicle Books, 1994. Image transfers by Jules Selmes. This book combines a stimulating text with a new approach to dreaming, with specially commissioned images that translate unforgettably the surreal conjuring of our dreams into visual terms.

Stephanie's Seasons, by Stephanie Alexander. Allen & Unwin, Australia, 1993. This cookbook, from one of the top chefs in Australia, is illustrated with Polaroid image transfers by Lynette Zeeng.

Magazines

"The Altered Print," in *Photomedia*, January/February 1996, pp. 15-16. Describes the Polaroid image- and emulsion-transfer processes, and SX-70 manipulation, with examples by Gail Chase, Tom Haseltine, Steve LaRiccia, and Val Valandani.

"Chuck Shotwell: Commercial Photographer," in *Idea* (Japan), November 1992, pp. 72–77. Features Chuck Shotwell's image-transfer work.

"Cloth of a Different Color: The Creative Image Transfer Technique of Patti Bose," by David B. Brooks, in *PhotoPro*, May/June 1991. Explores the fashion and fine-art Polaroid-transfer work of Patti Bose, a Florida-based professional photographer.

"Complementing Traditional Portraiture," by Heidi Tolliver, in *Studio Photography*, January 1994, cover and pp. 30-32. Image-transfer portraits by Joyce Wilson.

"Creative Film/Play Carves Niche for Photography," in *Art and Design News,* July/August 1993, cover and pp. 24-25. Features Tina Williams's image-transfer portraits and SX-70 work.

"A Damaged Beauty," by Julia Lasky, in *Print,* March-April 1991, pp. 62-69. Features David Chalk's image-transfer work.

"Emulsion Transfer," (a "Basic Jones" column) by Dewitt Jones, in *Outdoor Photographer*, January/February 1996, pp. 18-19.

"Emulsion Transfer," by Peter Kolonia, in *Popular Photography*, March 1996, pp. 72-78. Features the work of Peter Dazeley, Michael Joseph, Richard Radstone, Walt Seng, Kathryn Szoka, Andy Thompson, and Val Valandani.

"The Great Manipulator," in *Commercial Photography* (Australia), November/December 1992. Features the SX-70 and Polaroid-transfer work of Australian Bernard Rosa.

"A Guide to Polaroid Art," by Howard Millard, in *Shutterbug*, December 1992. An instructional article on creating Polaroid image transfers using a slide printer.

"How Do They Do That?," in *Amateur Photographer* (Britain), April 15, 1995, pp. 28-29. Features Peter Dazeley's emulsion transfers.

"John Reuter, Contemporary Frescoes," by Lizabeth A. Johnson, in *View Camera,* September/October 1992, cover and pp. 25-31. Features John Reuter's 20 x 24-inch image transfers.

"Onirici Accostamenti in Copoa Unica Polaroid," in *Fotographia* (Italy), March 1996, pp. 42-46. Features Ennio Demarin's emulsion transfers.

"Polaroid Manipulations: Variations on a Theme," by Maggie Devcich, in *Camera & Darkroom,* December 1991, pp. 38-45.

"Polaroid Transfer," by Bobbi Lane, in *Petersen's Photographic*, August 1996, pp. 60-62. Presents the image-transfer procedure with examples of the author's work.

"Polaroid Transfers: Art for the Nineties," by Mark Harris, in *Camera & Darkroom*, July 1992. A look at the Polaroid-transfer work of professional photographers Barbara Mink, Jose Picayo, John Reuter, and Steven Sonshine.

"Polaroid Transfers: Theresa Airey's Impressionism," by Joseph Meehan, in *Photo Op*, December 1996, pp. 12-14. Features Airey's Polaroid image- and emulsion-transfer work, and includes examples of and information about her techniques. *Photo* is sent to universities in the United States. (For copies, call *Photo Op* at 212-807-0399.)

"Positive Impressions: The Art of Polacolor Transfer," by Russell Hart, in *Outdoor & Travel Photography*, June 1993, pp. 54-62. This article provides an introduction to the image-transfer process, and features the work of Russell Hart, John Isaac, Rob Karosis, Paul Loven, Tina Williams, and Joyce Wilson.

"Profile: Tina Williams," by Judith Bell, in *Photographer's Forum,* September 1994, pp. 50-53. Features Tina Williams's work.

Progresso Fotografico (Italy) features the emulsion-transfer process and includes Ennio Demarin's work on the cover and pp. 54-58.

"Ready for Lift-Off," by Peter Lester, in *British Journal of Photography*, October 5, 1994, cover and pp. 18-19. Discusses the emulsion-transfer process and provides examples of work by Peter Dazeley, Christophe Madamour, David Sayer, and David Sheinmann.

"Romancing the Tones," by Peter Lester, in *British Journal of Photography,* July 23, 1992, pp. 14-15. Features the image-transfer work of American-born Mark Bugzester, who lives and works in Paris.

"Second That Emulsion," by Nigel Atherton, in *Photo Technique*, (British) February/March, 1996, pp. 61-64. Features the emulsion-transfer work of Alastair Laidlaw and Christine Marsden, his assistant, using a Polaroid 20 x 24-inch camera.

Test is Polaroid's "instant film and equipment magazine for professional photographers." Published twice a year, this magazine features a wide variety of inspirational work that utilizes Polaroid films by photographers and artists from around the world. *Test* provides information on new products, technical advice, and examples of creative uses for Polaroid films, electronic imaging, and more. This magazine appeals to those with artistic temperaments, as well as working professionals. (For a free subscription, contact the Polaroid Customer Care Center.)

"Tina Williams: Adjusting Reality," by Judith Bell, in *The Rangefinder,* October 1993, pp. 12-14. Features Tina Williams's work.

"The Transfer of Memory," (a "Basic Jones" column) by Dewitt Jones, in *Outdoor Photographer*, November 1995, pp. 30, 106.

"The Transforming Power of Transfers," by Orna Feldman, in *Step-by-Step Graphics*, November/December 1991. Provides instruction in using an enlarger to produce Polaroid image transfers.

Zoom (Italian edition), August 1994, pp. 42-45. Features Ennio Demarin's emulsion transfers.

Zoom (Italian edition), No. 2, 1994, pp. 76-81. Features Umberto Saliti's image-transfer work.

Index